THIS END UP:

ORIGINAL APPROACHES TO PACKAGING DESIGN

RotoVision

A RotoVision Book

Published and distributed by RotoVision SA

Rue Suisse 9

CH-1295 Mies

Switzerland

RotoVision SA, Sales & Production Office

Sheridan House, 112/116A Western Road

Hove, East Sussex BN3 1DD, UK

T +44 (0)1273 72 72 68

F +44 (0)1273 72 72 69

Email sales@rotovision.com

Isdn +44 (0)1273 734046

www.rotovision.com

10 9 8 7 6 5 4 3 2 1

ISBN 2-88046-648-2

Design and art direction by Chris Kelly at Mono in association with Gavin Ambrose and Paul Harris
Written by Gavin Ambrose and Paul Harris

Production and separations in Singapore by ProVision Pte. Ltd.

T +65 334 7720

F +65 334 7721

contents

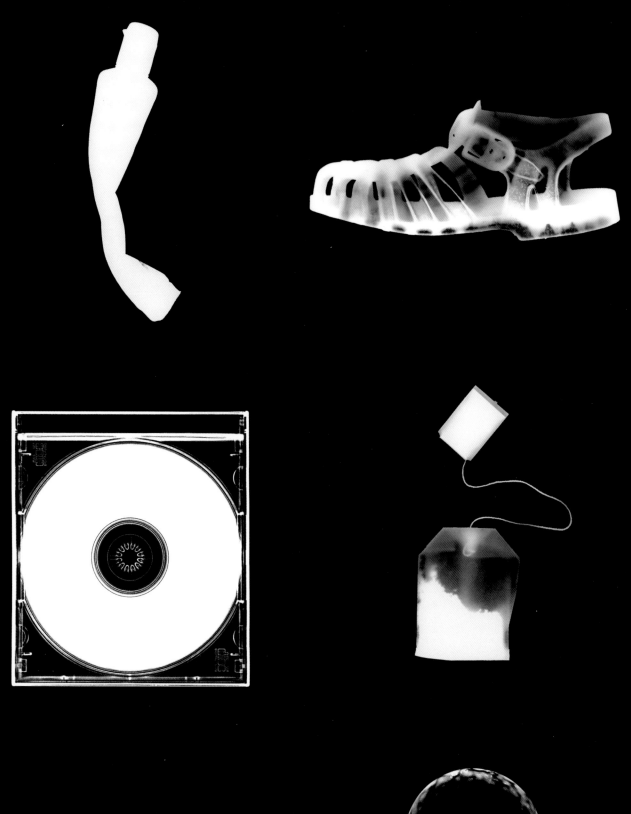

outer

Is it possible to think of a world without packaging?

Our perceptions and expectations of products are not formed by the qualities of the product alone. In fact, the raw product without packaging would be very difficult to differentiate from other similar products.

Chilli powder, for example, with its packaging removed appears as a barely identifiable generic reddish powder. But put it in a branded package and we form perceptions about its quality and usefulness; the qualities of the product become inherent and inseparable from the packaging, which in turn enables the producers to establish different price points. Take another product that is differentiated through packaging: water. The product is generic but it is targeted at different consumer groups through its only fundamental difference – its packaging. From the quick grab 'n' glug needs of the sportsman to the upmarket echelons of the restauranteur, specific bottled water products have been developed for specific needs. Packaging not only helps to differentiate existing product niches, it is central in creating new ones.

How a product is packaged and the messages that are relayed through that packaging are variable. All, some or none of a product's characteristics may be crystallised into its packaging. The fact remains, though, that packaging acts as the main vehicle for communication at the point of sale between the manufacturer and the prospective buyer.

Packaging design communicates and promotes the brand personality (or lack of it) that reinforces advertising and other promotional vehicles, and it may also form part of, or borrow from, a shared visual family with other products manufactured by the company. Virgin Cola took brand personality to the extreme in modelling its bottle on the figure of TV star Pamela Anderson, far racier than the traditional Coca-Cola bottle that was modelled on the coca bean.

Together with advertising and branding, packaging design promotes a defined, segmented lifestyle image to target consumers who will literally buy into it.

Brian Epstein, upon becoming the manager of the then unknown Beatles in 1962, took a rebellious John Lennon aside and said that the group had to dispense with its scruffy rocker look. "When it comes to packaging I know what I'm talking about," he said. "The Shadows are successful, and they wear suits." Four grey suits and mop-top haircuts later, within two years the Beatles were bigger than Elvis and had conquered America.

The packaging industry is nothing if not dynamic, with developments aimed at providing greater shelf life while reducing the amount of materials used. Advancement of technology available to the graphic arts continues to push the envelope of creative possibility, as printing systems become more sophisticated (and lower cost) and substrates and pigment development continues apace. However, with an increasingly innovative range of tools and materials at the designer's disposal it is easy to be seduced by what can be achieved and forget that it costs as much to print a good design as it does a bad one. Creative objectivity should not be wantonly sacrificed in the eagerness to embrace new possibilities.

Each season has its own swatch of colours and trends to follow and moulds to break. Packaging design draws on all these elements of popular culture and other influences. The design process necessitates a compromise between the range of competing factors that influence the outcome of the final design. The time it takes to get a product to market may make the decision to go with this season's colour erroneous by reducing the longevity of its shelf life. Its impact is realised at the cash register, where the democracy of purchasing power wields the sword of choice. The point is simple; the implications, however, are not. Packaging has become an integral and inseparable part of the retail experience – not so much a part of design as a part of life.

introduction

This End Up: Original Approaches to Packaging Design

inner

Through packaging design we are able to understand and interpret products. What does a product do? Who uses it? What is unique about it? Distinct narratives emerge as we, the consumers, glean information about a product's characteristics and its likely value. The speed with which packaging creates these perceptions in our mental environment is critical for FMCGs (fast moving consumer goods) but less so for what may be more involved purchases such as pharmaceutical products. In the highly competitive marketplace with like brands vying for retail space, packaging serves several distinct functions:

Containment

The primary function of packaging is to hold a product, whether it be gas, liquid, solid, powder, cream, paste, granule or a mixture (think Müller Fruit Corner). Loose frozen peas would be near impossible to handle so require containment in a bag. The nature of the product to be contained will determine the material from which the package is made. A bag of frozen peas would not function terribly well if it were made of paper! A plastic bag is chosen as it is impervious to the wet environment in which it has to work. Packaging has to deal with products that are perishable, flammable, toxic, acidic, abrasive and odorous. We love the taste of blue cheese but do not want to smell of it. Handling requirements, as alluded to in the title of this book, need to be considered and communicated.

While containment is a base function of packaging, the need to present a good face will override certain logical containment propositions. This becomes clear when looking at package shape. A sphere encloses a given volume with the least surface area of any possible geometry. It is thus a very efficient shape that requires the least material to contain the given volume. For boxes, octagonal and hexagonal shapes require less material than a cube, which requires less than a rectangle, yet we rarely see spheres, octahedrons or hexahedrons in the stores. Material efficiency is often sacrificed to obtain a rectangular display panel with which to present the product.

Protection

Almost inseparable from containment, packaging's protective function is to ensure that a product is delivered intact to the consumer with no deterioration in quality, in what may be a complex journey from the factory of origin. An egg carton protects its contents from mechanical shock and crushing, ensuring that our eggs are intact. Vibration, piercing or tearing also have to be protected against.

Food and other perishable products are susceptible to spoilage from less physical forces, such as heat, light or oxidisation, that will reduce shelf life. Food requries protection from all of these, from micro-organisms and from other substances that could cause spoilage; packaging is required to maintain the integrity of the product. We would be disappointed to open a carbonated drink that has lost its fizz. Plastics manufacturers continue to improve the barrier properties of their compounds to make plastic bottles more competitive with glass bottles. In the USA, beer is now available in a plastic bottle as well as the traditional glass bottle.

Protection is one area that has seen substantial advancement as a result of technological development. Aluminium foil and plastic films are now routinely combined with containerboard. This step has had a dramatic impact on the beverage sector, in particular juice cartons.

In addition to protecting the product, packaging also serves to protect the consumer, like the child-proof bottles used for pharmaceuticals, ring pull cans instead of a can opener, tamper-proof lids on glass jars, and of course instructions on the label for safe product usage.

Product transportation prior to reaching the retail outlet influences packaging selection. Packaging must facilitate the consolidation into bulk of products for ease of carriage. Weight and strength are other key considerations, particularly for low-value products.

Convenience

The physical form of packaging should make it as simple as possible to handle, giving secure stacking, and maybe capacity to be packaged in larger distribution packs. Packs should contain an appropriate quantity or volume of product both for the consumer and the retailer, and make it easy to display. 'Use by' dates should be easy to locate. For the consumer, convenience takes the form of openability, resealability and legibility. People do not want to have to search for the information they require.

Communication

Packaging has to communicate certain messages, for example warnings (which should be easy to read), bar codes and health information such as daily nutrition requirements. For perishable items the 'best before' and 'sell by' dates are important for both consumer and retailer. Labelling must meet legal requirements and be easy to find and read. Ingredients, instructions for usage, packaging disposal and recyclability information are also commonly given. As consumers become more sophisticated and enquiring, honesty and accuracy in product labelling has increased. 10 or 15 years ago few food products declared that there might be traces of nuts in them, although there undoubtedly were. With so much information to be displayed on the packaging it is a wonder there is any room left for branding or developing a product personality at all!

Packaging design can use a well-regarded brand equity to stand out from its competitors, but on the flip side, bad packaging design can harm a brand. In some product categories the brands scream for our attention as can be seen in any washing powder aisle, but a more subtle approach is usually adopted.

Supermarkets have increased competition with branded foods by improving their 'own-label' products. Through packaging, they have sought to change the consumer notion that purchasing an 'own label' is a compromise on quality for a lower price. Supermarket chain Tesco has dispelled this sentiment through its 'Finest' range, which uses packaging that is designed to a similar standard as national brands.

A package must be highly focused, be positioned to meet specific needs of well-defined groups, communicate positively to those consumers and have impact at the point of sale. Packaging design can turn an essentially generic product into something desirable, adding to its value and making it stand out from its competitors. No product category represents this better than that of bottled water, which has been described as the triumph of form over content in some quarters. Through packaging, branding and marketing, a product that differs little from what we can all obtain from a tap causes the UK public alone to spend about £900m each year.

The use of packaging instils a number of attributes to the water using stunning visual presentation to achieve differentiation. Do we even question the proposition that mountain spring water tastes better than tap water? But how many of us would actually drink from a mountain spring with all of its flora, fauna and sediment?

The benchmark in this category is the timeless green glass Perrier bottle created in 1903. Evolution of both glass- and plastic-forming technology now gives designers free reign to create appealing bottle shapes. Take a trip to your local supermarket; the variety of bottled water containers is quite amazing. From the high-neck Bordeaux-style bottle of Hildon, to Evian with its sculpted Alps design, the tall glass cone of Gleneagles or cylinders from Voss of Norway and Oxygizer of Austria, to Ty Nant's twisted club shape. But do such innovative packages translate into sales?

Technological progression also works to create challenges for the designer. The launch of the compact disc reduced the canvas from a 12" (30.5cm) square to a 12.5cm square with which to get across the all-important image that will grab a potential buyer's attention. The reduced space with which to create visual impact has led some designers to rethink the CD's jewel-box package itself, from Pentagram's injection-moulded polystyrene CD package for the Pet Shop Boys to Mark Farrow's pharmaceutical-style carton for Spiritualized (see pages 98–103).

Packaging designers have a wider array of alternatives with which to deliver the product personality. Packaging alternatives and the ability to take carte blanche with image design (something denied the visionary creators of Coca-Cola's bottle) has created a world in which, with the exception of fresh produce, the majority of products are no longer visible to the consumer. In the UK it was only a few years ago that customers were able to see crisps through their bag.

With no direct visual contact we are distanced from the product and rely on packaging to inform our opinions with regard to its quality. With food, we seem to have moved beyond asking whether something is fresh or edible. We automatically expect it to be and simply check the 'sell by' date. Packaging is replacing our ability to determine whether food is fit for consumption. We do not need to see the actual product hidden within a tin, box or bag. We do not even need to see a picture of it. Instead, we are offered evocative imagery and serving suggestions to stimulate our appetites. The jacket of a tin is able to transform its contents into a luxury item, a health and lifestyle enhancer, or represent it as the basic commodity that it is, as seen in the generic supermarket lines.

Methods of display also continue to be refined. As manufacturers now buy shelf space to more prominently display their wares, a product's packaging needs to work well even when viewed in multiples. Tessellating packs along a shelf, and on several shelves, creates a larger display area over which to spread a message and attract the consumer's restless eye.

Should we believe it?

Packaging's power to influence often elicits criticism. Legislation prohibits the use of untrue claims on packaging to prevent consumers being misled. From this legislation comes the requirement to list ingredients on food packaging. Critics of the illusions created around a product and conveyed by its packaging attack the lifestyles portrayed as unrealistic fantasy. The Canadian magazine Adbusters – Journal of the Mental Environment (Autumn 1999) highlighted packaging's potential for abuse and manipulation by citing one product's deceptive appearance that makes 'spaghetti sauce look like it's been cooked by grandma'. As consumers, we embrace this deception as an integral part of the product experience.

Packaging no longer only differentiates a product by type. Nowadays, as consumers, we are confronted by choices that go beyond the mere product and into our belief systems. Products increasingly have a mission statement positioned prominently somewhere on their package to inform us of the minimal damage being done to the environment, animals, rainforests and so on. Many companies believe they should adopt an ethical stance in order to win customers.

Are consumers looking for moral connectivity with the products they purchase? Most people would shy away from anyone they met that was constantly moralising. If consumers do not believe the statements companies adorn their products with, then could this have an effect on the products too?

By seeking some moral high ground to add to the values of a product, manufacturers hope to plug into other aspects of a consumer's personality. But if consumers do not perceive those messages as intended, the product could be compromised. Product values are interpreted both through instilled meanings (intended messages in the packaging) and accidental readings (unintended messages perceived by individuals). If a vision statement is viewed by the consumer as a cynical ploy by the producer to ingratiate itself with potential buyers, this accidental reading would run counter to that intended.

This adds another dimension to the problem-solving aspect of packaging design. The designer has to ensure that no unintended messages are carried in the packaging that may harm the product's image. This is particularly true when creating packaging for an international brand, as different cultures react differently to the same stimuli.

For a truly global product, the messages conveyed need to be distilled to a universal level of understanding. Few products can claim to have achieved this. McDonald's and Coca-Cola are two obvious exceptions, and as a result are two of the most widely recognised symbols in the world. Such success brings its own problems in the shape of rigid design parameters that perpetuate the brand image at the cost of possible meaningful regional and cultural deviations.

Through the projects presented in this book the communicative aspects of packaging design will be explored. They involve exciting solutions to withering problems that elevate packaging design from the mundane to the sublime. Whether the approach be the stark but imposing impact of keeping things simple or that of creating something truly innovative, packaging design frequently makes the product.

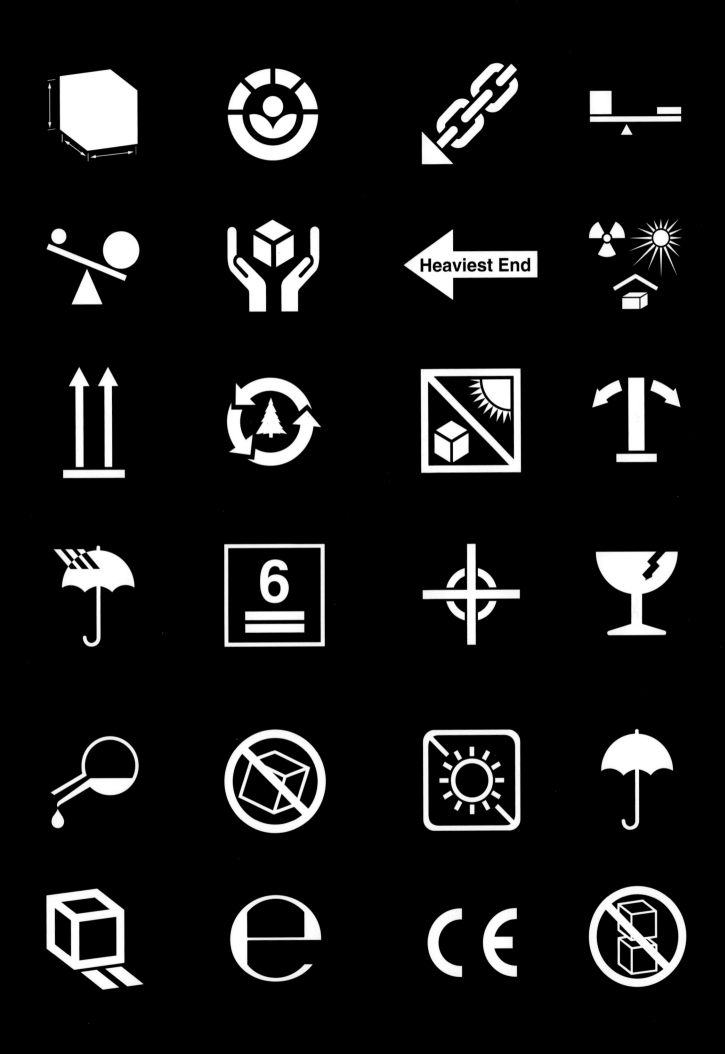

Heaviest End

project 0.1 mr lee

Food packaging impacts on our lives more than any other sector of design, with the possible exception of advertising. We have come to rely on the package to impart information about the product, and to aid us in decision-making when confronted with an increasing array of niche-targeted products. As diets have become progressively more diverse (we routinely nourish ourselves with food styles from all corners of the globe), and more specific (organic, nut-free, gluten-free etc.), packaging has developed to portray and differentiate this huge variety. Packaging for Asian and Chinese food, for example, has become a great deal more sophisticated than the somewhat stereotypical and patronising designs used by companies such as Vesta in the 1980s. Local supermarkets now contain a smorgasbord of culinary styles and global produce that we can buy off the shelf which would have been unimaginable ten years ago.

Rieber & Søn, a Norwegian food producer approached London- and Amsterdam-based design consultancy Design Bridge with a curious problem. For several years they had distributed and marketed a noodle-based snack food under the brand name 'Mr Lee'. The brand's founder, Chul Ho Lee (aka Mr Lee), had arrived in Norway as a penniless 17-year-old orphan of the Korean Civil War. He says that he 'could make noodles and polish shoes'. Fortunately for the people of Norway, there was no demand for shoe polishers in Oslo, so Mr Lee started making noodles. This was the inauspicious start of a now legendary brand.

The problem faced by Rieber & Søn was that the packaging relied on a picture of Mr Lee, who over the years had become the embodiment and public face of the product. Mr Lee is a celebrity the likes of which few countries have, and commands cult status in his adopted Norway.

Ironically, past success of a brand is potentially problematic to future growth, particularly when it is so closely aligned to a real person. Currently the product is only sold in Norway, however the export potential is such that it is likely to become a European (if not global) brand. Still active in all aspects of the company, Mr Lee's time commitments would increase if the product range expands or export markets are targeted. At 65, though, it can be expected that he would want to retire at some point. The high profile of Mr Lee (the man) that has benefited Mr Lee (the brand) considerably over the years could also damage it if he were to suffer adverse publicity for any reason.

Design Bridge worked on the project for three years, a large proportion of which was devoted to research groups and brainstorming sessions. Many ideas born of these sessions are still being developed at time of press, including brand extensions as diverse as clothing stores, as Mr Lee is nearly as famous for his shirts as for his noodles, a detail that has been cleverly incorporated into the packaging design. The packaging Design Bridge created, as the following case study demonstrates, looks simple, but when compared with similar products it is actually extremely sophisticated.

Critically, the packaging remains faithful to the product and its founder, rather than making the product appear healthier or fresher than it actually is. That said, Mr Lee, who after all started as a chef, has ensured that his noodle products are better than similar products. His daughter has also gained fame, from working at London's The Pharmacy restaurant, to achieving celebrity status as a chef in Norway.

The Mr Lee packaging has gone on to be recognised with the prestigious Clio Award (USA), Mobius Gold Award (USA) and a Design Week Packaging Award (UK). It has also been included in a book by the UK's D&AD and has been a finalist in the New York Festival. These awards are testament not only to the benefits of succinct packaging, but also a recognition of the results of working *with* a client, not *for* one, and for having the courage to be different. Both the agency, and indeed Mr Lee have challenged the norm of snack food packaging.

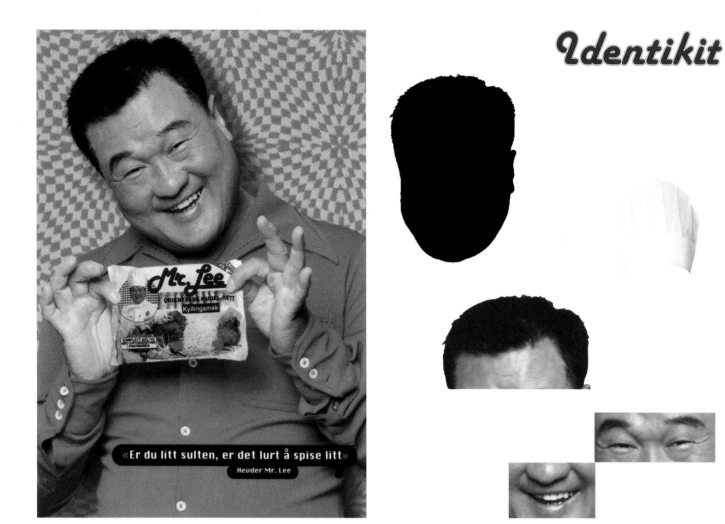

0.1 original packaging ↗

The original packaging uses photographic imagery, depicting both the product and its founder. Although the redesign brief was simply to replace the existing photograph with an illustration or a graphic device, it was decided to address the overall package styling. Reproduction of food photography is sensitive to colour balances and can make food look unappetising. This was identified as a specific problem inherent in the original packaging, and it was thought that any improvement could only be achieved through a complete redesign.

0.2 elements ↗

Retaining the presence of Mr Lee was of paramount importance, as his popularity instils integrity in the product, despite the decision to abandon the photograph route. Alternative design options would protect the brand from any potential future adverse publicity and facilitate brand development by extricating it from a reliance on Mr Lee's availability, and cater for the unfortunate fact that products often have longer life-spans than their founders.

Early in the development process, research was undertaken to establish which of Mr Lee's characteristics were the active signifiers of his personality that consumers warm to. Once isolated, these would form the basis of the final caricature.

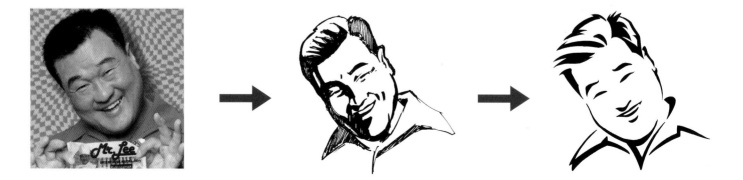

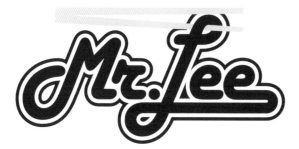

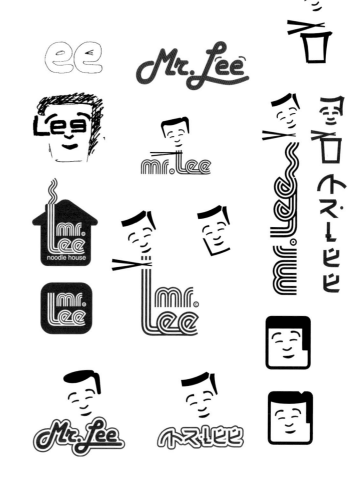

0.3 old logo / new logo　　　　　↗

On the inherited packaging artwork Design Bridge found that the font resembled the shape of noodles. Although unintentional (the original design is from the 1970s and is consistent with typographic stylistics of the time), it was felt that this element could be easily adapted for the redesign. Including an iconic pair of chopsticks not only rationalised the typography, but also served as an important signifier of the nature of the product, as well as enhancing its authenticity.

When adapted to different languages, the brand remains recognisable and readable, as the Korean text above demonstrates. This is an important consideration for expansion into other world markets.

0.4 development sketches　　　　　↗

Combining the typography and the Mr Lee icon, Design Bridge experimented with a range of logos to revitalise the brand. Even at such an early stage the logo was developed beyond its primary packaging application, and incorporated into signage for food outlets, a future possibility for the company.

0.5 transformation　　　　　↙

This simple transformation diagram shows how the engaging characteristics of Mr Lee were retained through a progression of illustrative interpretations. By removing superfluous elements, a simple, evocative icon was created that distilled the important elements of Mr Lee's personality.

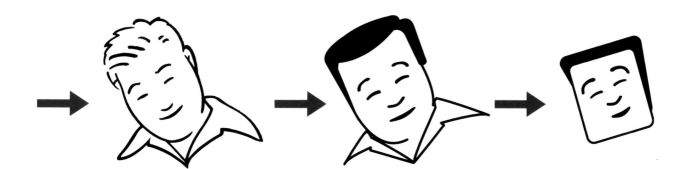

0.6 characters

In developing the character of Mr Lee, the team at Design Bridge explored several potential incarnations for the icon. Without dramatically changing the basic characteristics, secondary personalities and extensions of the master marque were developed.

Although few of the developed sub-characters will ever make it into production, they demonstrate the flexibility of the Mr Lee character. As Design Bridge's recommendation was based on a consolidated simplification of the brand, the studio had to prove that simplicity would not become restrictive.

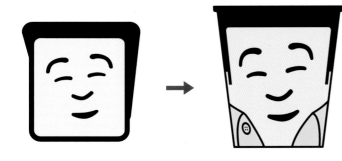

0.7 application ↗

Once the character had been developed, the illustration was transferred onto a simple pack design. The logo appears on the lid, an unusual departure for a food product that when shelved is predominantly viewed from the front. This is testament to the strength of the striking Mr Lee character and brand identity that ensures in-store product recognition (see following page). Steve Elliott (creative director) explains, "You have to ask yourself how much personality has your brand got, and this has got loads." Later developments see the pot design appearing on the sachet packet. "The strength of the brand lies not only in the graphics but in the pot itself – like the application of a traditional cola bottle on a can of Coca-Cola, reinforcing authenticity," says Ian Burren (designer).

0.8 situations ↙

Once the characterisation of Mr Lee was near completion, a series of tests were undertaken to assess the future possibilities of the brand. Although designed primarily for existing products, it was important that the design was flexible enough to function well in different sectors. The result was a variety of incarnations of 'Mr Lee'. 'Mr Cool' could soon be adorning ice cream or frozen produce. 'Mr Hot', who came to represent the chilli variety of the product, was tested for the heat-in-the-microwave market, and 'The King' found its way onto the king-size pack of noodles. There was also a 'Mr Seafood', a 'Mr Tourist', a 'Mr Steam' and even a 'Mr Rubbish' to highlight the flexibility of the packaging design.

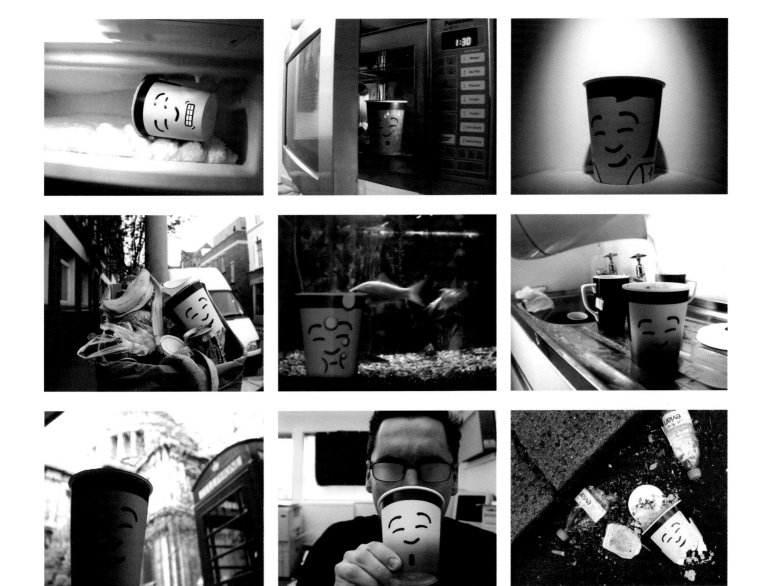

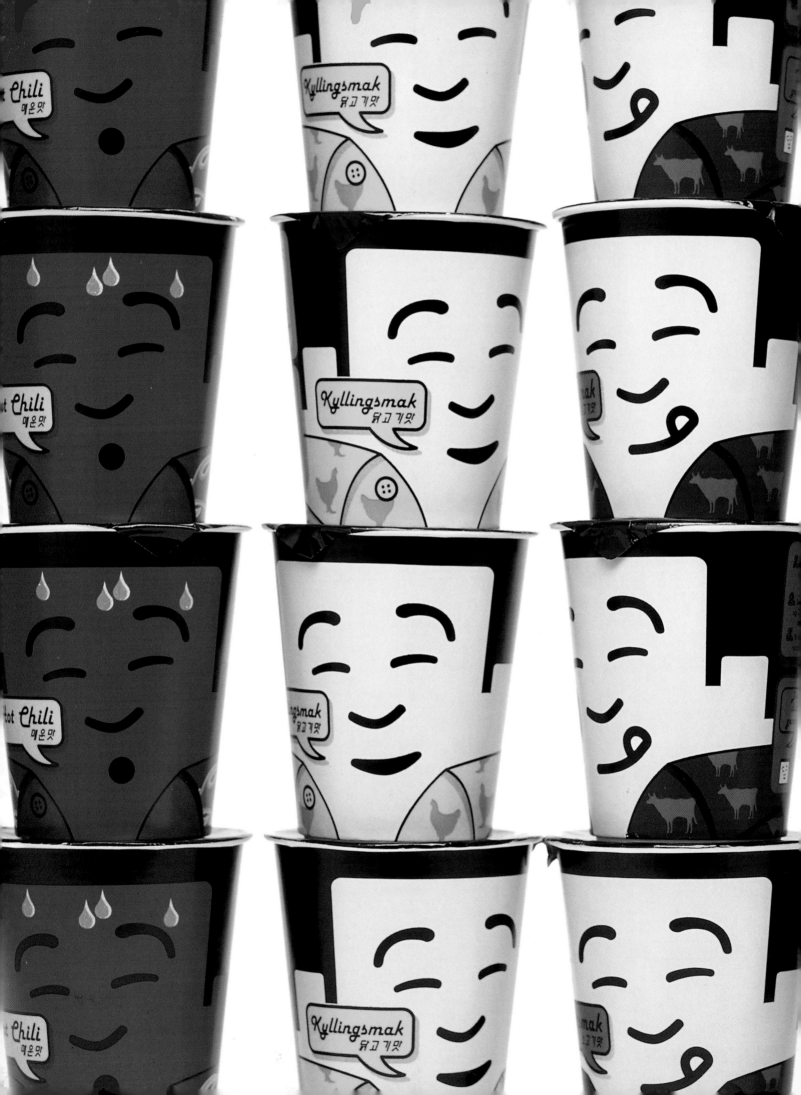

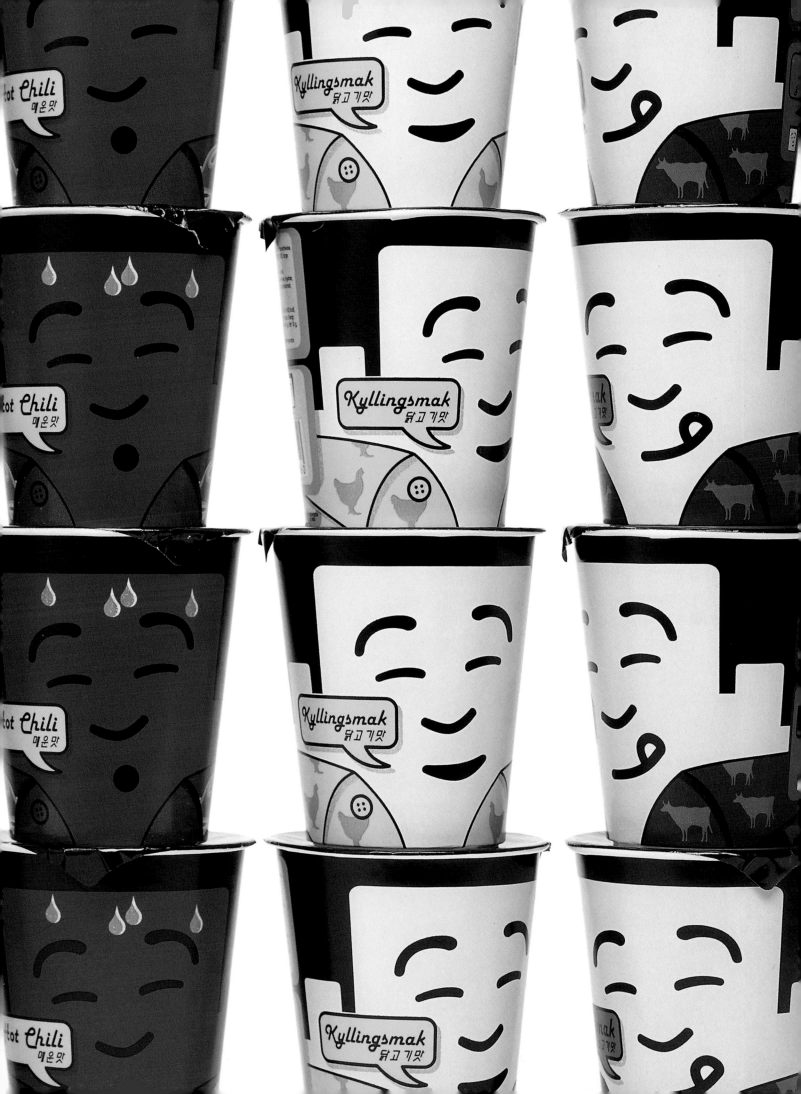

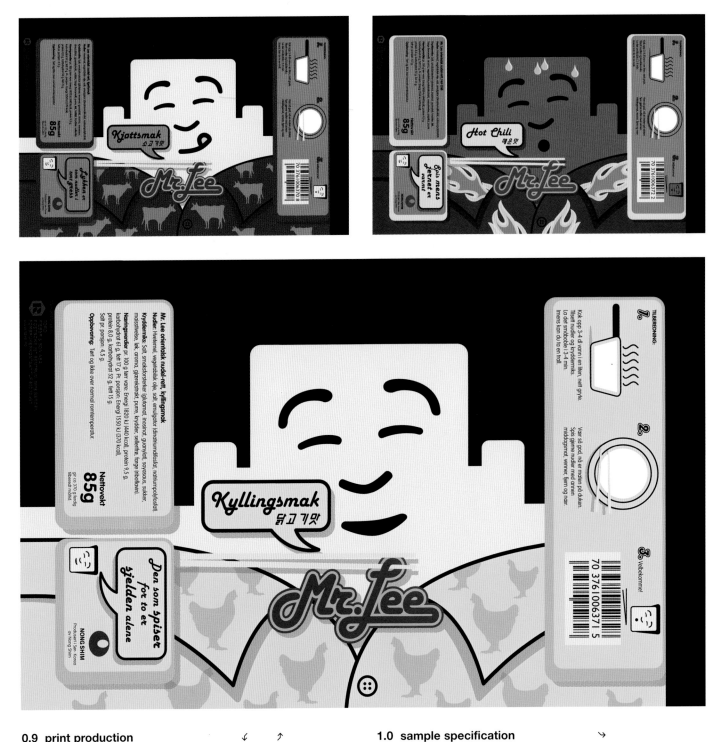

0.9 print production ↓ ↑

All aspects of the packaging were carefully specified for print production. Working closely with packaging manufacturers, templates were developed to mirror the shapes of the final three-dimensional packages. Tolerances were incorporated to account for trim and fold variations in print manufacture.

1.0 sample specification ↘

References like font usage and colour breakdowns are given for all elements that create the final packaging. Underpinning the simplicity of the finished package is a series of complex specification sheets and proofs for the manufacturers to refer to.

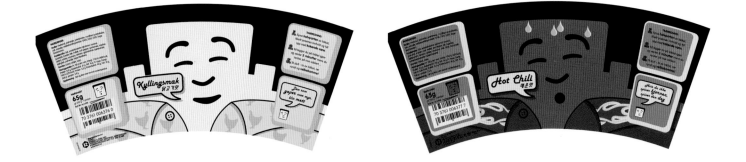

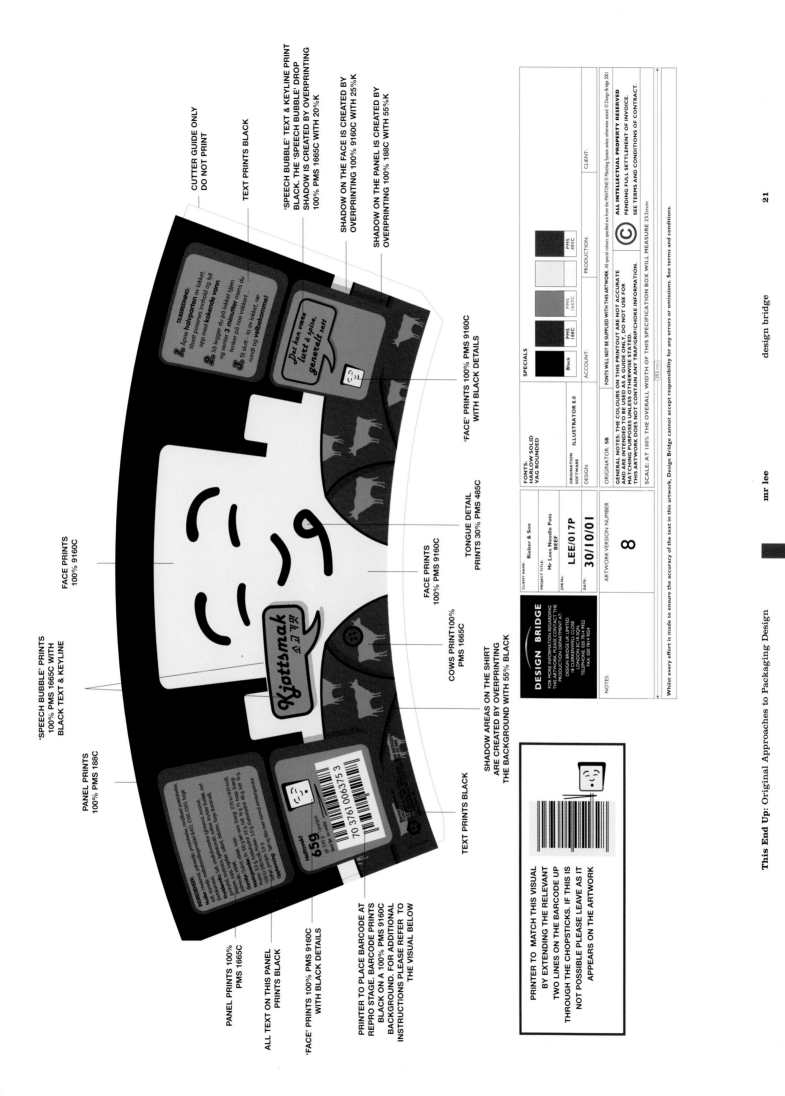

This End Up: Original Approaches to Packaging Design

mr lee

design bridge

21

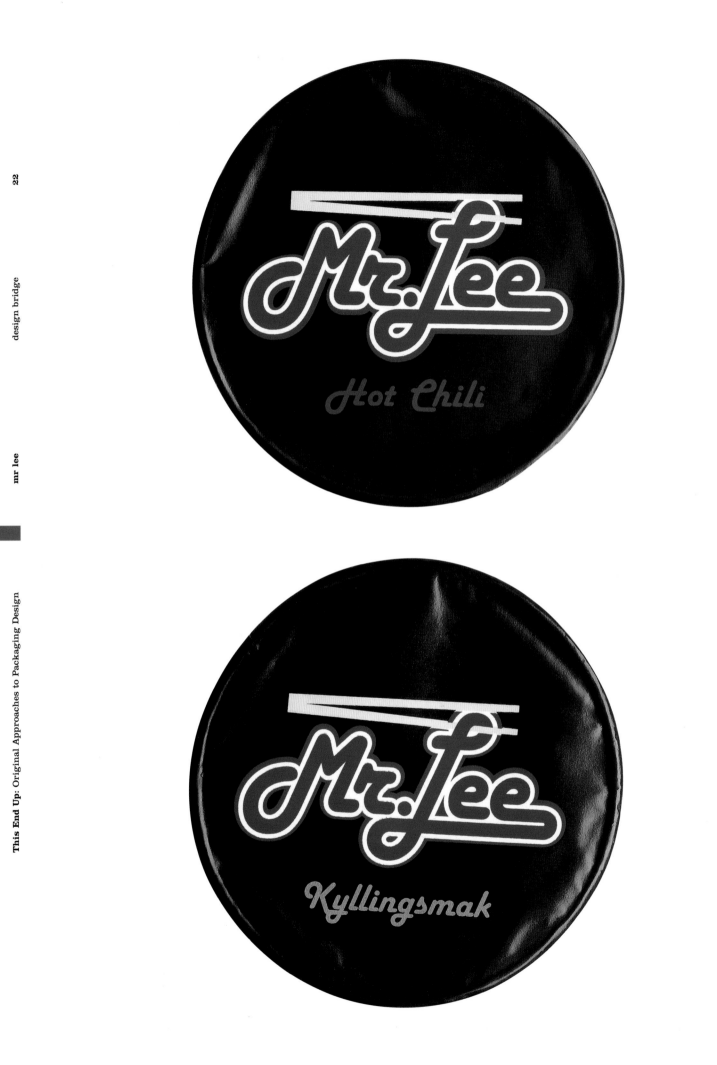

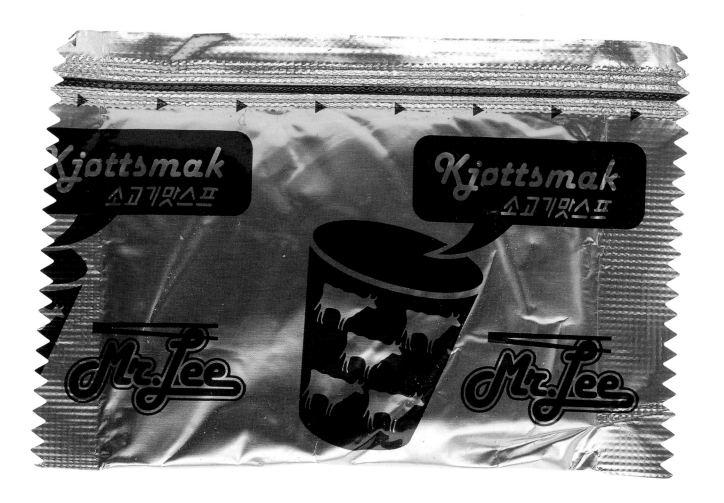

1.1 branding ↖

Branding on the pot is conspicuous by its apparent absence, a circumstance made possible by the strong visual image created on the fronts of the packs. The brand is presented on the pull-top along with the flavour in a simple, bold and effective form. Only when the packaging is removed from the shelf does the branding become visible.

1.2 secondary packaging ↙ ↗

The central role of the pot as a branding device is reiterated with its appearance on the packaging of the flavour sachet. Its use provides cohesion and reinforcement of the key elements of the packaging design: the pot, the Mr Lee character, the logo and the colour scheme.

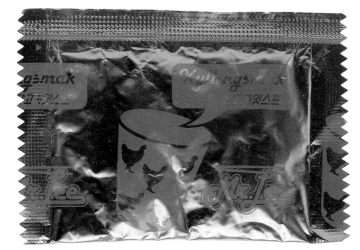

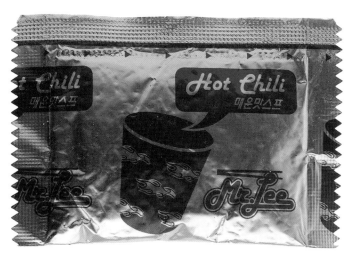

1.3 information

Mandatory legal requirements are both clear and visible. All ingredients are listed in descending order of weight, in addition to the legal requirement of stating the flavourings and additives used.

The packet also has to carry the manufacturer's name and address, a datemark, instructions for safe storage and an indicated weight. Net quantities of pre-packaged foodstuffs must be given in metric units, followed by the imperial equivalent if so desired.

Background prints are used to signify the flavour of the product, with illustrations of cows, chickens and flames adorning the packaging. On the pots, these motifs can be found on the shirt worn by the 'Mr Lee' character, providing another link to the product's founder.

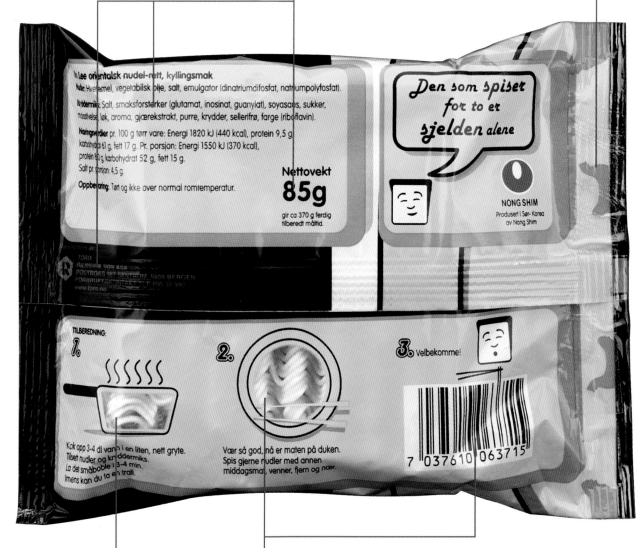

Transparent windows in the sachet packet allow the product to be seen and sidestep the potential coloration problems of using photographs of food. The product becomes an integrated part of the packaging through the interplay of printed and transparent substrates. The instructions are simple yet playful, progressing from noodles in an illustrated pan, to a plate and ultimately being eaten. Even the bar code is infused with 'Mr Lee's' personality.

Bar codes

European packaging conforms to a standardised (Universal Product Code) system consisting of 13 digits within the bar code. The US UPC system, while only using 12 digits (in common with their binary system), is compatible, allowing regionally manufactured produce to be exported.

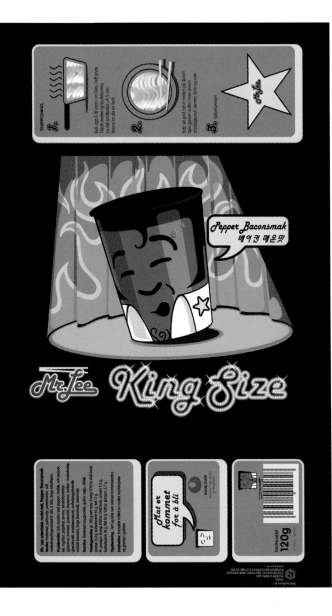

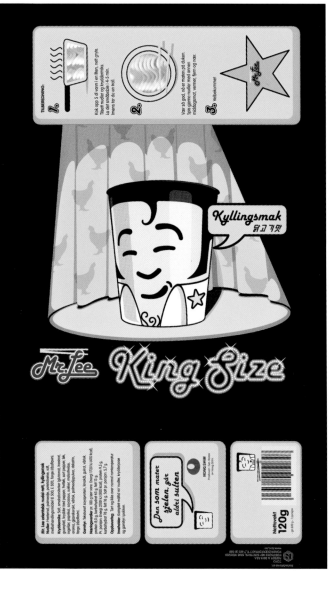

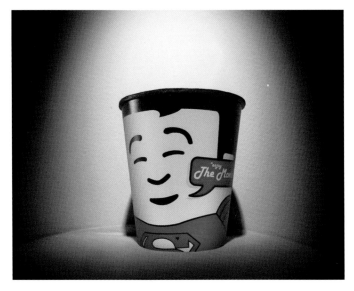

1.4 endorsement ↑ ←

Specific product endorsements or associations – in this instance Elvis Presley – can be advantageous if they make a credible contextual connection in the consumer's mind. Mr Lee noodles are packaged as a fun and exciting product. The analogy to Elvis Presley has a light-hearted, yet powerful synergy for the king-size package. Other possibilities easily come to mind, such as a 'Mr Superman' snack targeted at the cinema-going market. As brand extensions, these 'celebrity' packages have great value. Not only do they explain the contained product, they could become collectable items in their own right, as in Norway Mr Lee commands celebrity status. While there are examples of popular fictional figureheads such as Kentucky Fried Chicken's 'The Colonel', it is hard to think of other real-life examples to rival Mr Lee's celebrity status.

The website (www.leemail.com) has been designed with an intentionally 'home-made' feel and promotes the idea that Mr Lee is personally involved in its production.

Upon seeing the redesigned packaging Mr Lee commented, "I can live forever", so expect to see Mr Lee on a shelf, in a refrigerator or at a cinema near you soon.

project 0.2 unavailable

Throughout history the design of the perfume bottle has been exploited to great success to sell 'style'. From the timeless Chanel bottle to designs by Salvador Dali and the highly seductive designs of Gaultier, Issey Miyake and Comme des Garçons, the perfume bottle is inextricably linked to style and good taste. Unopened bottles of early Chanel designs and specially commissioned bottles by artist Allen Jones sell for incredible prices. The bottle is no longer a mere container but a signifier of stature. This, in turn, leads us to expect something more from perfume packaging than we expect from the packaging of other bottled products such as cough medicine, shampoo or nail varnish remover. In the words of one of the world's greatest exponents of popular culture:

"I'm not exactly a snob about the bottle a cologne comes in, but I am impressed with a good-looking presentation. It gives you confidence when you're picking up a well-designed bottle."

Andy Warhol – From A to B and Back Again

Mitch Nash from Blue Q (a fragrance manufacturer and distributor) approached Sagmeister Inc. with an idea for a perfume called Unavailable. The concept was to develop a package consisting of perfume and an accompanying book, written by Karen Salmansohn, explaining the philosophy of 'unavailable'. Salmansohn had devised 15 principles that explore the relationship between women and desirability (see page 36), which were an expansion of the theory that desirability is heightened through unavailability. The intention was to design a packaging system concerned with narrative as opposed to style, seemingly in contradiction to the established rules of perfume presentation.

This may seem to be a brief that a designer would jump at, but Stefan Sagmeister originally had several reservations. At the top of his list was that the packaging would not manage to fulfil the intentions of the philosophy. "Since so many perfumes are sold in gift packs where the customer gets a little bullshit item like a vanity case or a shower scrubber or a whatnot extra, I was very wary of the attached little book, thinking it would only become another throwaway item." Sagmeister's reservations were well-founded given that there have been waves of products that pertain to have a philosophy at their core, yet deliver little more than surface graphics and gimmicks.

Sagmeister's initial inspiration for the packaging design was derived from a project he had previously worked on. "Ten years prior I was involved in a project in Hong Kong involving hidden, custom-made glass eyeballs in a die-cut of a notebook. That idea came to mind again. It allowed us not only to combine book and bottle tightly, but have the book become the packaging, the philosophy wrapping the scent tightly." The idea extended to other packaged items such as easily damaged soaps, which thereby enabled the extension of the philosophy. Through the philosophy of the 'unavailable' principles, Sagmeister formed the basis of a philosophy for the packaging.

UNAVAILABLE
UNAVAILABLE
UNAVAILABLE
UNAVAILABLE

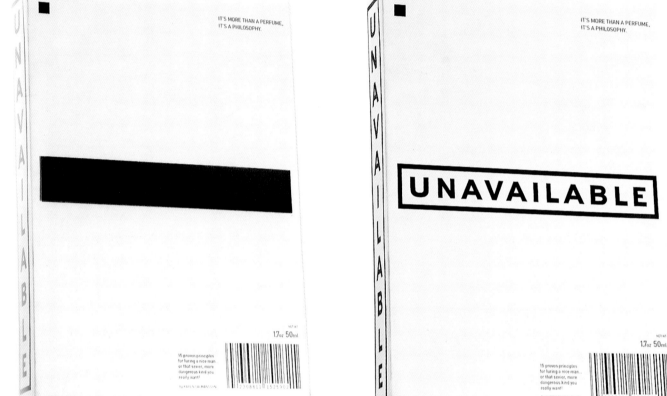

0.1 censored ↗

Playing with various connotations of something being unavailable, Sagmeister arrived at censorship, an action that makes both text and images unavailable. It also has connotations of vice, illicit activity, sexual promiscuity and of hiding identity to protect the innocent. Applying this to the packaging, he used a black bar as a visual device on a clear outer sleeve to censor the perfume's name. The title of the 'unavailable' perfume-book is only revealed by the removal of the outer sleeve. "The black bar over the type was a rather obvious choice, influenced by censorship bars, information that is not available. The book comes in a transparent sleeve which has the black bar screened onto its surface," explains Sagmeister.

0.2 inside the book ↘

The book itself consists of 36 die-cut pages to securely hold the perfume bottle. The 15 principles are printed individually on the facing pages.

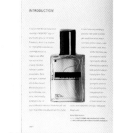
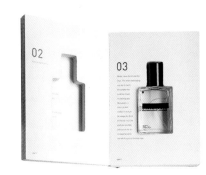

As the 'Unavailable' philosophy is revealed

by the turning of each page

the perfume bottle is itself wrestled

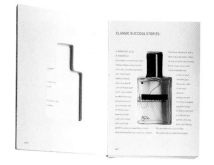
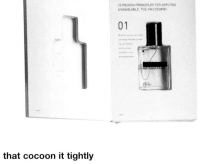
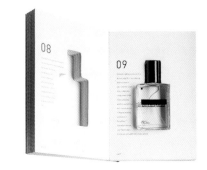

from the grasp of the die-cut pages

that cocoon it tightly

and make it Unavailable.

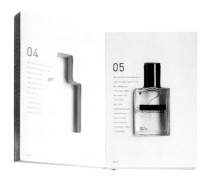
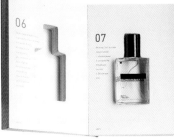

As the consumer is prepared mentally

to put into practice the principles of Unavailable,

the scent that will aid her,

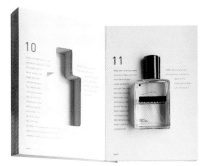

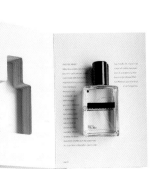

like the man she hopes to snare

by being Unavailable,

will be ready for the taking.

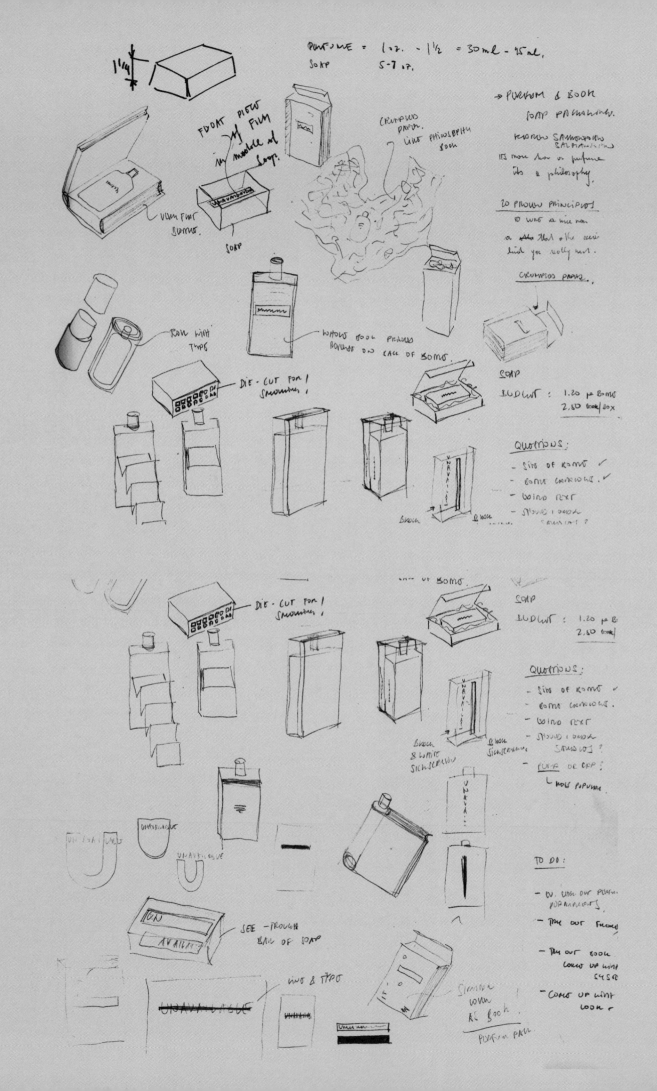

0.3 development

Development of a unique bottle shape is both time-consuming and expensive, and was beyond the reach of this project. "In designing the layout we tried different more elaborate schemes, only to return to the simple stuff again. The bottle itself is a classic stock bottle (we neither had the budget nor the required minimum to design a custom bottle)," explains Sagmeister.

Faced with the restrictions of a commodity bottle shape, Sagmeister needed an innovative solution. He employed the same tactic that he had used for the clear sleeve for the book, to censor the name of the product. The name of the perfume was printed on the back of the bottle, where it could be obscured by a black bar printed on the front. The name of the perfume remains out of sight until the bottle is tilted to reveal it from behind its bar of censorship. The packaging relies on, and invites interaction by the consumer to complete the narrative.

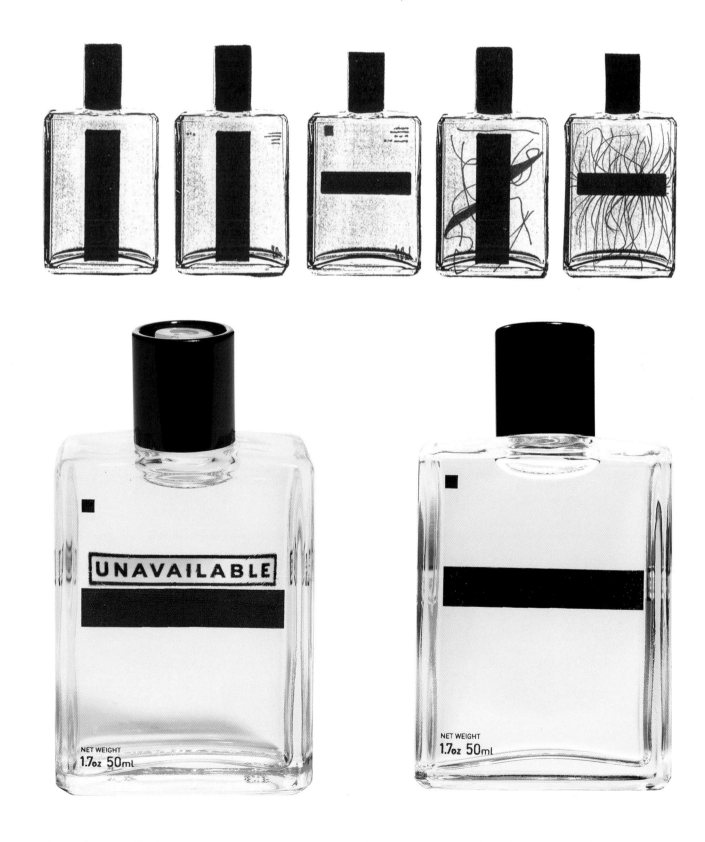

15 proven principles for applying Unavailable, the philosophy:

Principle #1
Don't fake orgasm, but do fake call waiting. Multiple call waiting. Let him know you're a woman in demand – not a demanding woman.

Principle #2
Viva La Indifference.

Principle # 3
Never, never (ever) call the man. The more challenging you are to catch, the greater the pride he'll take in catching you. Remember, a man's primal instinct is to hunt; he enjoys the thrill of the kill. You'll be glad you resisted, and so will he. It's an opportunity to tap into his primal hunting urge.

Principle #4
Women take longer than men to get ready for parties. Men take longer to get ready for relationships. Neither like to be rushed.

Principle #5
Be mysterious and vague about your time apart. Learn to use the androgynous "my friend" and/or the nondescript "they" when describing whomever else you spend time with. Your man need never know that "my friend" + "they" = "my mother".

Principle #6
The best way to find a man is to already have one – or seem as if you do. To set the stage for the part you are to play, include props like a filled-up file-o-fax calendar should he, per chance, stumble upon it (open) on your desk.

Principle #7
Never say "yes" to a date request without: **1.** a notable pause **2.** an audible flip through your calendar **3.** a 24-hour lead time

the women you've slept with. (Go figure.)

Principle #12
As an Unavailable woman you are different than the typical woman that John Gray describes as being from the planet Venus. YOU are uniquely from the more distant, unexplored planet, Mercury. Your culture promotes the Mercurial Seduction Dance: **1.** One step forward. ("Hey, sailor, I'm available.") **2.** A half step backward. ("Then again, maybe not.") Mmmmmm... mixed messages. They drive men crazy with desire.

Note: Perhaps PMS is actually nature's way of keeping a relationship from getting too staid and boring.

Principle #13
As an Unavailable woman you must remember: A truly smart woman is careful about how quickly she reveals how smart she truly is. By not being completely mentally available to your man, you can create a safe atmosphere that allows him to talk freely, without fear of your insightful analysis of him. Meanwhile, you can be gathering important details about him that will, well, help you in your insightful analysis of him. Then, in the same way a bank robber first gathers crucial information about a potential crime scene, you can determine how best to steal his heart.

Principle #14
When in doubt about how much and what to say, always keep in mind. It's walaaaly more important to be aloof than alert. Unfortunately, although many men claim they want a woman who's smart

vocabulary you share, the more you can remain a mysterious, alluring babe (and the less you'll be able to pass each other off).

Principle #9
Consider dating someone in a distant city. Or, if you already desire a man in your local tri-state area, simply try using some of the most seductive words a woman can ever use on a man: "I may be moving to Siberia in November." Casually mention your future departure plans and watch the magic unfold.

Principle #10
If you ever wanna hear "I do," you have to say a few "I don'ts." The harder you are to win sexually, the bigger your estimated prize value. Yes, unfortunately, even in this modern age, no man wants to belong to a club that has touched his member's ... the Dr. Ejaculate/Mr. Hide Syndrome. So, always adhere to the three-date-minimum rule for sex. And keep in mind that men have a three-

date maximum. **Note:** To enhance sexual willpower, don't shave armpits or legs for a few days before a date with a hunky guy... unless he's European.

Principle #11
Never tell a man how many men you've slept with. And never show off your sexual acrobatics too soon. Basically, men want a woman who knows what she's doing, but never having done it before. So, in the beginning, fake being less fabulous in bed than you really are. **Note:** , yesterously, men don't seem to mind hearing about all and funny, what they truly want is a woman who is less smart and funny than themselves. It's the ol' "Smart Woman, No Choices," and its sequel, "A Mute Girl Is A Cute Girl."

Principle #15
As an Unavailable woman, you must always remain a bit out of reach, leaving him wanting more. This means: **1.** leaving parties while your belle-of-the-ball curve is on the up swing. **2.** ending all phone conversations before they've reached their full throttle fun. In fact, consider getting off the phone before you've even finished your....

Principle #8
Don't be in a hurry to unpack your emotional baggage. Always travel light with whom you don't share a native language. The less into a relationship.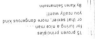

Manufactured and distributed under exclusive license by BLUE Q, Pittsfield MA. Made in U.S.A

NET WEIGHT .26oz/7.26g

By Karen Salmansohn

15 proven principles
for luring a nice man
– or that sexier, more dangerous kind
you really want!

Design: Sagmeister Inc., New York.

©2000 by Karen Salmansohn

It's more than a perfume,
it's a philosophy.

UNAVAILABLE

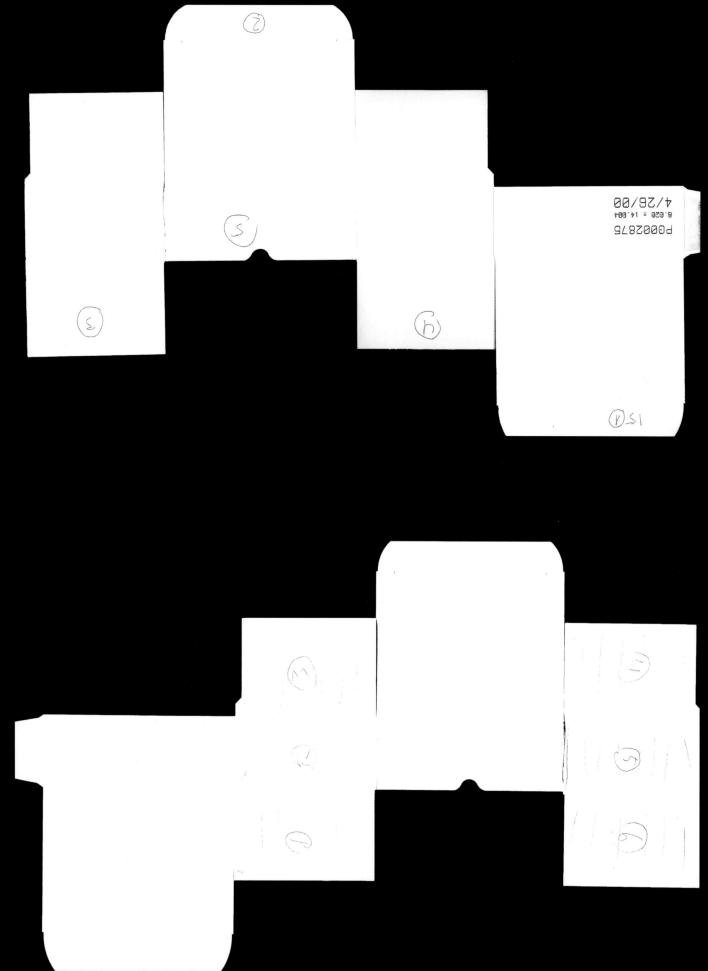

0.4 prototype

Shown on the previous page are early net developments for the Unavailable soap packaging. Text is pasted onto the panels to ensure that the statements are of the desired orientation after folding. The 15 principles are shown on the following page.

0.5 soap

A different approach was needed for the Unavailable soap product, although the need to incorporate the 15 principles and continue the clandestine factor remained. Warming to the theme, Sagmeister quickly got the idea for the soap: "The soap was an easy solution, printing the entire book inside the cardboard box, again the philosophy wraps the scent. The 'Un' of Unavailable is only embossed half as deep as the rest of the word, making sure the user does become, with repeated use, available." The idea is delightfully succinct and was devised by Stephan Haas, an intern at Sagmeister Inc., and its subtlety mirrors Principle #13, which states 'A truly smart woman is careful about how quickly she reveals how smart she truly is.'

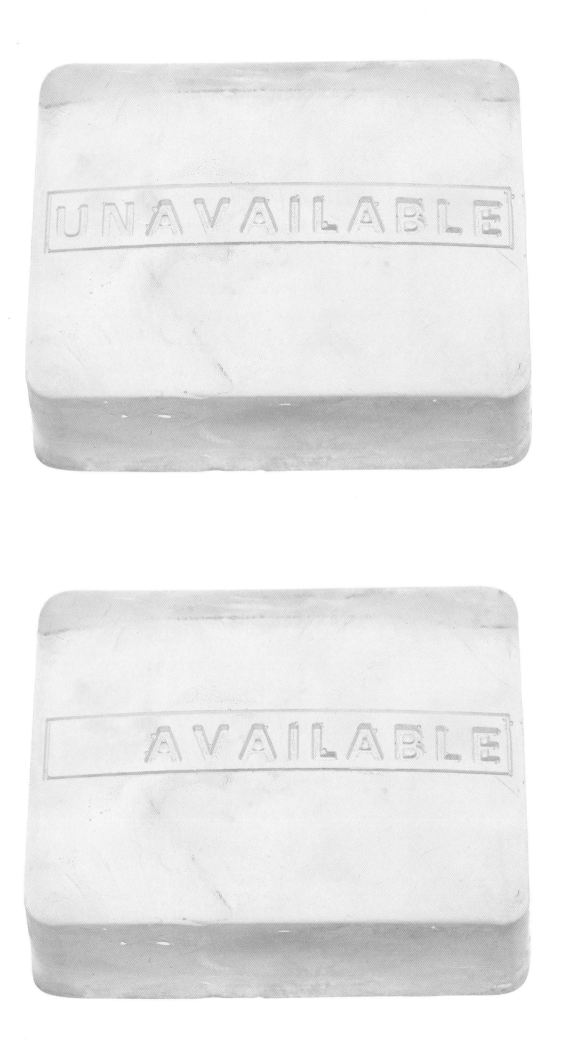

sagmeister inc.

unavailable

This End Up: Original Approaches to Packaging Design

Principle #1

Don't fake orgasm, but do fake call waiting. Let him know you're a woman in demand – not a demanding woman.

Principle #2

Viva La Indifference.

Principle #3

Never, never (ever) call the man. The more challenging you are to catch, the greater the pride he'll take in catching you. Remember, a man's primal instinct is to hunt; he enjoys the thrill of the kill. You'll be glad you resisted, and so will he. It's an opportunity to tap into his primal hunting urge.

Principle #4

Women take longer than men to get ready for parties. Men take longer to get ready for relationships. Neither like to be rushed. Don't be in a hurry to unpack your emotional baggage. Always travel light into a relationship.

Principle #5

Be mysterious and vague about your time apart. Learn to use the androgynous **"my friend"** and/or the nondescript **"they"** when describing whomever else you spend time with. Your man need never know that:

"my friend" + **"they"** = **"my mother"**.

Principle #6

The best way to find a man is to already have one – or seem as if you do. To set the stage for the part you are to play, include props like a filled–up file-o-fax calendar should he, per chance, stumble upon it (open) on your desk.

Principle #7

Never say "yes" to a date request without:

1. A notable pause

2. An audible flip through your calendar

3. 24-hour lead time

Principle #8

Consider dating someone with whom you don't share a native language. The less vocabulary you share the more you can remain a mysterious alluring babe (and the less you'll be able to piss each other off).

Principle #9

Consider dating someone in a distant city. Or, if you already desire a man in your local tri-state area, simply try using some of the most seductive words a woman ever used on a man: "I may be moving to Siberia in November." Casually mention your future departure plans and watch the magic unfold.

Principle #10

If you ever wanna hear "I do," you have to say a few "I don'ts". The harder you are to win sexually, the bigger your estimated prize value. Yes, unfortunately, even in this modern age, no man wants to belong to a club that has touched his member. It's the ol' Dr Ejaculate/Mr Hide syndrome. So, always adhere to the three date minimum rule for sex. And keep in mind that men have a three date maximum.

Principle #11

Never tell a man how many men you've slept with. And never show off your sexual acrobatics too soon. Basically, men want a woman who knows what she's doing. Without ever having done it before. So, in the beginning, fake being less fabulous in bed than you really are.

Principle #12

As an Unavailable woman you are different from the typical woman that John Gray describes as being from the planet Venus. You are uniquely from the more distant unexplored planet, Mercury. Your culture promotes the Mercurial Seduction Dance:

1. One step forward. ("Hey, sailor, I'm available.")

2. A half step backward. ("Then again, maybe not.") Mmmmmmm… mixed messages. They drive men crazy with desire.

Principle #13

As an Unavailable woman you must remember: A truly smart woman is careful about how quickly she reveals how smart she truly is.

By not being completely mentally available to your man, you can create a safe atmosphere that allows him to talk freely, without fear of your insightful analysis of him. Meanwhile, you can be gathering important details about him that will, well, help you in your insightful analysis of him. Then, in the same way a bank-robber first gathers crucial information about a potential crime scene, you can determine how best to steal his heart.

Principle #14

When in doubt about how much and what to say, always keep in mind: It's wa(aaa)y more important to be aloof than alert unfortunately, although many men claim they want a woman who's smart and funny, what they truly want is a woman who's smart and funny – as long as she's not more smart and funny than themselves.

Principle #15

As an Unavailable woman, you must always remain a bit out of reach, leaving him wanting more. This means:

1. Leaving parties when your belle-of-the-ball is on the upswing.

2. Ending all phone conversations before they've reached their full throttle fun. In fact, consider getting off the phone before you've even finished your…

UNAVAILABLE

15 PROVEN PRINCIPLES FOR APPLYING UNAVAILABLE, THE PHILOSOPHY:

...ou've ever felt as if you were wearing "KICK ME!" sign on your heart, you are ot alone. Thankfully, there is a solution or finding that ever-elusive, seemingly exclusive, happily ever-after love you've been craving. And that solution is called Unavailable. Time and again, a woman who makes herself Unavailable (socially, emotionally, sexually, intellectually, geo-graphically, or any combination there-of) finds herself reeling in men from virtually all over the planet. It's as if she were emitting a powerful sixth scent that men can smell from miles away – even from another coast... especially from another coast. Now, for the first time, you can enjoy the satisfying, magnetic affects of being Unavailable in both soap and phi-losophy form. Once you start applying this synergistic combination, you will quickly find yourself surrounded by nice men... or (even better) that sexier, more dangerous kind you really want!

Good L...
ARE...

CLASSIC SUCCESS STORIES

A. ROMEO AND JULIET
B. CINDERELLA

Unavailable is an irresistible scent that has helped women lure men 'since, well, since the beginning of time. If you need a celebrity endorsement, they abound. Just ask Romeo about Juliet. Juliet had that enviable Unavailable family lineage working in her favor. "Oh no, Romeo, I can't meet you tonight!" Juliet told her man. When she finally agreed to a date, she stood him up. Guess what? Romeo still thought Juliet was to die for.

Then there's Cinderella. With a dead-end career and an embarrass-ing home life, she still knew how to snag a prince. How?
1. She flirted profusely.
2. She excused herself to go to the powder room.
3. She never returned.
And just who did the Prince (a popu-lar guy who stood in for Chinese...

14

15

UNAVAILABLE

NET WEIGHT 7.25

0 92657 60801 2

project 0.3 dragonfly

Consumer tastes continue to develop and become more sophisticated. So too do people's appetites. Higher levels of foreign travel, to more distant and exotic locations, educate people to an increasingly broad array of produce that they look for in supermarkets and speciality foodstores upon their return. As tastes develop, product categories are split into more and more well-defined niches, to the extent that it seems there is a product targeted at every conceivable taste. Tea is no exception, with an array of speciality teas that complement more traditional brands. With a seemingly endless variety of products available, differentiation becomes more difficult to achieve; establishing a unique visual identity is imperative.

Wistbray Ltd has a history in the tea business and successfully introduced the South African Rooibos variety of tea into the UK market. This brand's success led Wistbray to realise there was demand in the UK for rare, unusual and modern teas from high-end speciality, wholefood and healthfood supermarkets. After extensive research around the world Wistbray developed an innovative range of organic teas, blended by international experts, targeted specifically at these outlets. The choice of name, brand identity and packaging played a crucial role in the successful launch of this unique range. The international design firm Pentagram was invited to create these.

In terms of its dimensions and materials – a containerboard carton holding individually wrapped teabags – Pentagram created standard speciality tea packaging. But how do you make the product stand out from the plethora of other teas available? Pentagram focused on the communicative aspects of the packaging to achieve differentiation. The firm used a simple design concept to provide an eye-catching visual identity that extended and amplified the limited display surface of the package to great effect. Dragonfly was chosen as the brand name for the UK market, and Dragoncloud for the US market for regulatory reasons. The visual identity was the same for both markets.

The visual concept is centred on the use of the product; tea served in a teacup from an overhead viewpoint set against a minimalist white background that is simple and conveys a feeling of exclusivity.

Differentiation of the flavours in the Dragonfly tea range is achieved through a colour-coded modification to the general design. A different colour is used for the tea in the teacup on the packaging to represent each tea. Colours were selected to harmonise with the variety of tea they were to represent: red for Cape Rooibos, a South African tea with a rich red colour; a warm brown for Mountain Honeybush, also from South Africa; and green for Green Tea grown in China, for example. These assigned colours were used for other visual elements such as the name of the tea, the logo and the back panel containing information about the product and its origin. A consistent colour scheme was also used for the envelope in which the individual teabags are packaged.

Early dummies show the development of the concept and how a teacup illustration was positioned to wrap around the side of the package. Folding the teacup around the package allows the use of a larger image than can be accommodated on one side panel. The importance of this is seen when two packages are placed together; the two halves of the image unite to create the full image of the teacup. This device amplifies the visual presence of the product on the shelf and effectively differentiates it from other organic teas.

The packages need to be orientated in a certain way so that the two halves of the teacup match. This increases the time required to put the products on the shelf to achieve this, which may not happen in a large supermarket that requires rapid stock replenishment. But as Dragonfly Teas are sold via speciality food stores, appropriate care is taken to display the packages to their best effect.

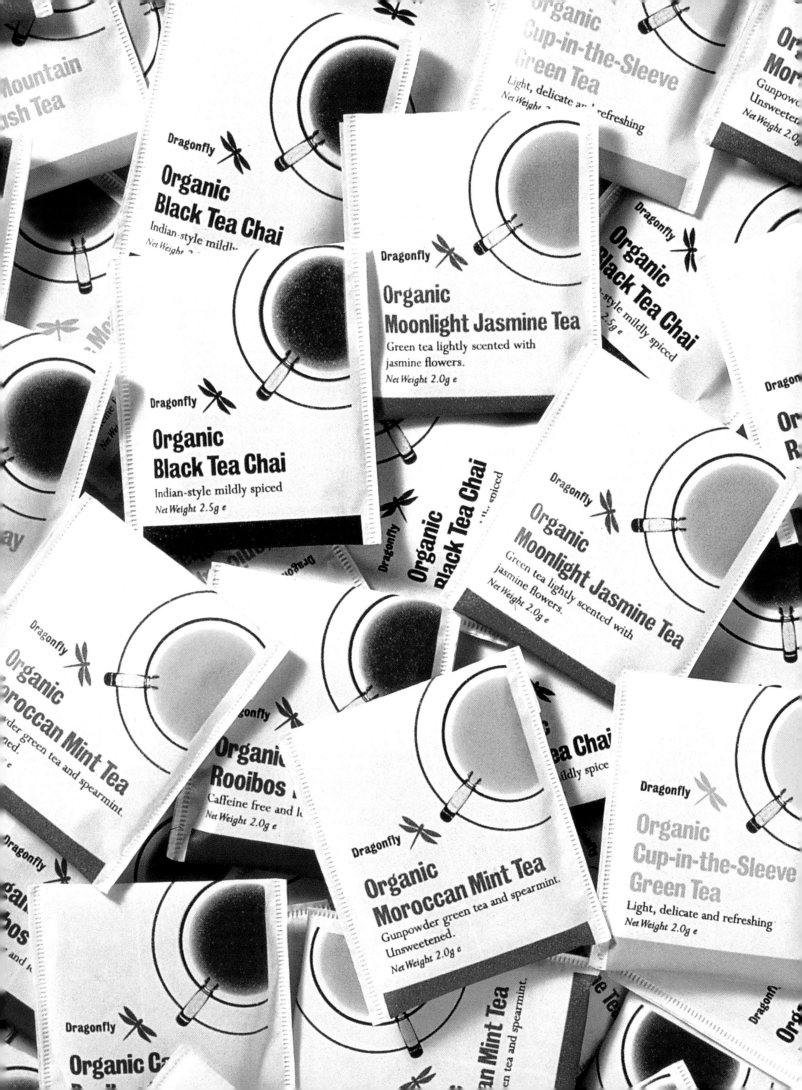

Caspa

Honeybush tea

This is a delicious, soothing tea, harvested
by hand and cured naturally in the sun.
20 sachets 40g e

0.1 packaging development

Early mock-ups of the packaging's outer carton considering colour,
illustration size, placement, typeface selection and orientation.
The development to the final packaging is evident in these early
stages, and there is a clear indication of colour-coding. Other options
were considered, including the monochromatic photograms (opposite),
a visual language perhaps incongruous with the delicate nature of
the speciality product.

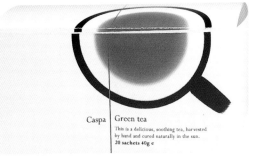

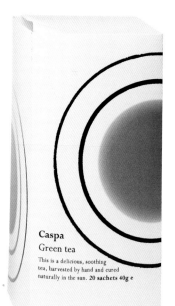

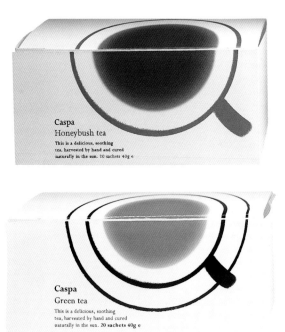

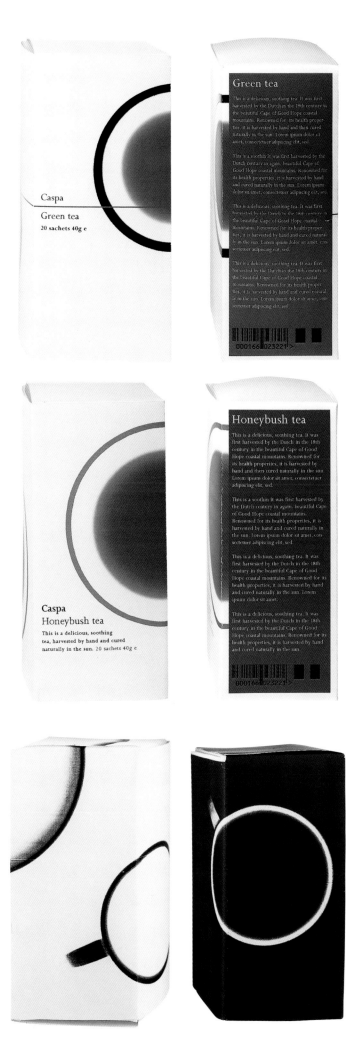

Caspa

Green tea

20 sachets 40g e

Green tea

This is a delicious, soothing tea. It was first harvested by the Dutch in the 18th century in the beautiful Cape of Good Hope coastal mountains. Renowned for its health properties, it is harvested by hand and then cured naturally in the sun. Lorem ipsum dolor sit amet, consectetuer adipiscing elit, sed.

This is a soothin It was first harvested by the Dutch century in again, beautiful Cape of Good Hope coastal mountains. Renowned for its health properties, it is harvested by hand and cured naturally in the sun. Lorem ipsum dolor sit amet, consectetuer adipiscing elit, sed.

This is a delicious, soothing tea. It was first harvested by the Dutch in the 18th century in the beautiful Cape of Good Hope coastal mountains. Renowned for its health properties, it is harvested by hand and cured naturally in the sun. Lorem ipsum dolor sit amet, consectetuer adipiscing elit, sed.

This is a delicious, soothing tea. It was first harvested by the Dutch in the 18th century in the beautiful Cape of Good Hope coastal mountains. Renowned for its health properties, it is harvested by hand and cured natural ly in the sun. Lorem ipsum dolor sit amet, consectetuer adipiscing elit, sed

000166 023221 >

Caspa
Honeybush tea

This is a delicious, soothing tea, harvested by hand and cured naturally in the sun. 20 sachets 40g e

Honeybush tea

This is a delicious, soothing tea. It was first harvested by the Dutch in the 18th century in the beautiful Cape of Good Hope coastal mountains. Renowned for its health properties, it is harvested by hand and then cured naturally in the sun. Lorem ipsum dolor sit amet, consectetuer adipiscing elit, sed.

This is a soothin It was first harvested by the Dutch century in again, beautiful Cape of Good Hope coastal mountains. Renowned for its health properties, it is harvested by hand and cured naturally in the sun. Lorem ipsum dolor sit amet, consectetuer adipiscing elit, sed.

This is a delicious, soothing tea. It was first harvested by the Dutch in the 18th century in the beautiful Cape of Good Hope coastal mountains. Renowned for its health properties, it is harvested by hand and cured naturally in the sun. Lorem ipsum dolor sit amet.

This is a delicious, soothing tea. It was first harvested by the Dutch in the 18th century in the beautiful Cape of Good Hope coastal mountains. Renowned for its health properties, it is harvested by hand and cured naturally in the sun.

000166 023221 >

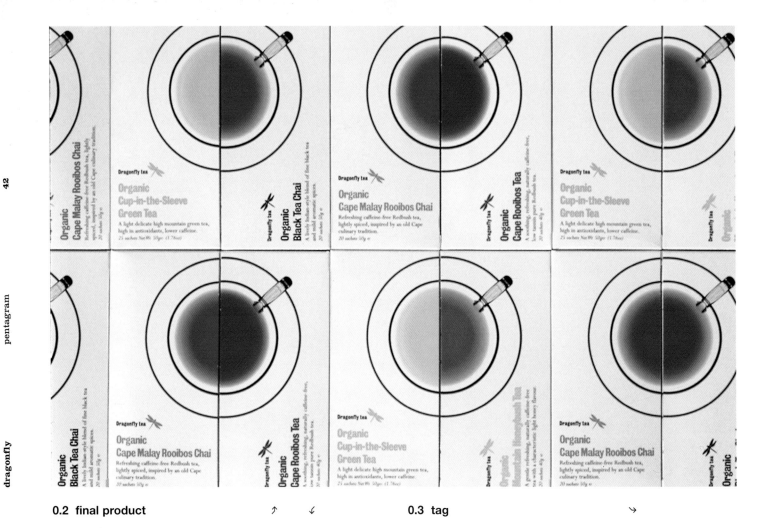

0.2 final product ↑ ↓ ## 0.3 tag ↘

The visual scheme at work: various packages stacked as though showing a tray of teacups (above). Even if different varieties are stacked together, the visual scheme is maintained. The range of visual elements can be clearly seen with the image of the teacup wrapping around the side of the package on its line of symmetry (below).

The teabag packaging mirrors that of the box: a paper pouch displaying the variety, colour coding and the overhead illustration of the ubiquitous teacup. The tag of the teabag simply comprises the variety colour with the logo and variety name reversed out in white with the Dragonfly brand name printed in black.

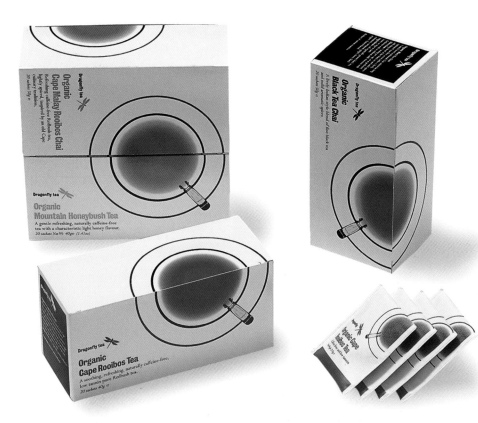

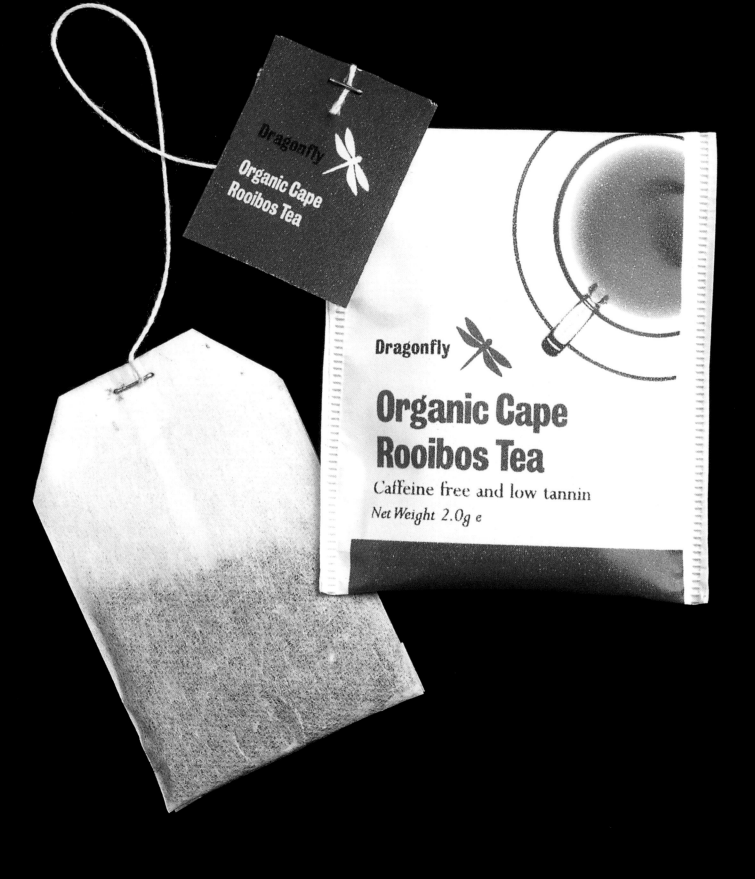

project 0.4 little orchestra

This book deals with innovative approaches to packaging. For the majority of the case studies, the packaging created comprises a novel solution produced from existing material systems and concepts. There is little that is innovative in the literal sense, in terms of the creation or invention of something new, something untried. This volume shows other examples of innovative packaging for CDs, such as the Spiritualized package that incorporated a relief of a sculpture (see pages 98–103). Whilst a creative departure from the norm of CD packaging, it essentially functioned in the same manner as the generic jewel case.

Elisabeth Kopf, an Austrian artist, can truly be said to have created innovative packaging. To produce music from a CD case, as Kopf proposed, had not been done before, and as you shall see, Kopf produced something nonpareil. That she was able to succeed in her commission with such spectacular results is illustrative of the many factors that influence the creative process. Hard work and determination are givens, but among the requirements for true innovation, as evidenced by this case study, there must be vision and desire, research, good fortune and the ability to ignore those who say that something cannot be done.

Kopf's achievement is impressive: handmade plexiglass CD boxes that play a piece of music using the air flow produced through their opening and closing, that together comprise a full orchestral composition. Stefan Sagmeister, a designer whose work also features in this book (see pages 26–37), explained why this award-winning design is such a success: "In a field where the usage of a hip typeface or the application of a new Photoshop filter is often misunderstood as innovation, it is becoming increasingly rare for a piece of design to truly excite me." Sagmeister said that because the package makes music it creates "a conversation between design and content I have nowhere else experienced so elegantly."

Kopf was asked to create a limited special packaging edition of the Vienna Art Orchestra (VAO) for a limited edition CD to celebrate its 20th anniversary. Her client was a jazz band, the musicians of which predominantly played wind instruments; in essence, they used the movement of air to produce sound. Kopf decided she would also use the movement of air to create sound, but as she had no packaging precedents to follow, she had nothing to guide her other than her own belief and desire, which were to stand her in good stead throughout her many tribulations with the project. Admittedly not a designer (at the time), she began by asking questions about packaging and identified the concepts covered in the introduction (see pages 6–11) of this book concerning the essential functions of packaging. Armed with this information, she posed herself the question that was to steer her away from traditional approaches to CD packaging: how can packaging show that music is inside? Kopf wanted "to show a little bit of music", rather than pictures of musicians – "I don't package musicians."

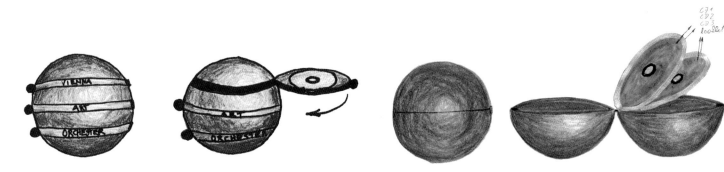

0.1 sketches (sphere) ↗

With an intrinsic focus on music, Kopf's thoughts transcended the usual trappings of music packaging. She sketched various concepts such as a sphere that represented music as a world, a universe: "The ball not only stands for the planet but also for sphere, atmosphere; a perfect body of volume (packaging). The CDs suspended inside the ball CD case are metaphorical slices of the musical universe," she says.

0.2 sketches (soundbox) ↙

Another idea packaged the CDs in a screw-top container that would produce sound when the top was unscrewed. While the top half is rotated (in the process of opening or closing) flexible metallic sticks would glide over fixed naps inside the case to produce sound. The length of the stick would determine the tone of its sound, and the positioning of the naps would determine the timing of the stick's vibrations. "Think of a musical clock, a toy piano or a barrel-organ (hurdy-gurdy) producing music this way," says Kopf.

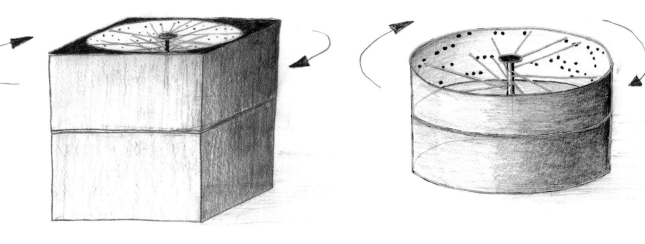

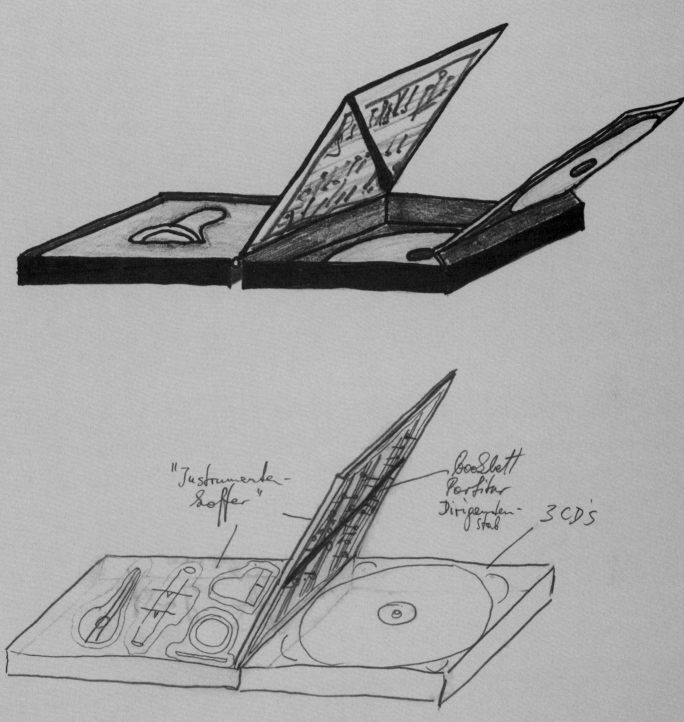

0.3 sketches (instrument case 1) ↗

In a more literal interpretation, she considered packaging parts of old musical instruments or tiny handmade instruments in a case lined with velvet, similar to a real instrument case. She thought tiny instruments could be made such as a little flute with two holes, a little drum for one beat, a trumpet with one valve, a violin with two strings and so on, that could be played together and perform as an orchestra. The leader of the VAO would have been expected to write a composition arranged for the tiny instruments, the score of which would be printed in the booklet.

0.4 sketches (instrument case 2) ↗

Or the CD cases could contain parts of instruments formerly used by members of the VAO in each case, such as a saxophone mouthpiece, a violin string, a piece of drumstick, a piece of conductor's baton etc.

Kopf says that the client was fascinated by the musical concepts she produced and responded particularly well to the idea of the package making sound, asking her to continue work on the idea. Kopf thought sound was the right way to go, although she was reluctant to abandon the orchestral concept. Instead, she decided to fuse the two musical concepts. Having established the direction she would take, Kopf knew she had to explore the mechanical options to produce sound before worrying about what the end result would look like. "Everything still looked quite ugly and didn't impress as a CD cover at all," she said, "but it was not the time yet to think of the design."

The use of electronics may have been a natural first choice as a sound generator for many people, but Kopf dismissed this approach as gimmicky. She wanted something that would make music as instruments do, rather than simply through circuitry. Kopf thus set

about using the motion of opening and closing the CD case to make music. Fortune provided an opportunity at this point in the shape of a fair for old instruments that was to take place in Vienna. "For three days instrument makers from all over Europe were in town, exhibiting not only their handmade instruments but also giving a performance of their handicrafts," she says, "it was just what I needed." Kopf attended and met many leading instrument-makers, although she found that they were not too keen to reveal the secrets of their respective trades. Worse still, when explaining her idea she encountered resistance. "They called me out of my mind to believe it would be possible to ever make a CD cover produce music," she recalls, but instead of diminishing her desire, the flood of discouragement she encountered saw her become more steadfast and grow in enthusiasm for the project. "The determination to succeed grew with the scepticism of the professionals," she says. "I had a strong vision. I wouldn't listen to people who told me what was not possible, but instead only to people who told me what was possible," she says.

0.6

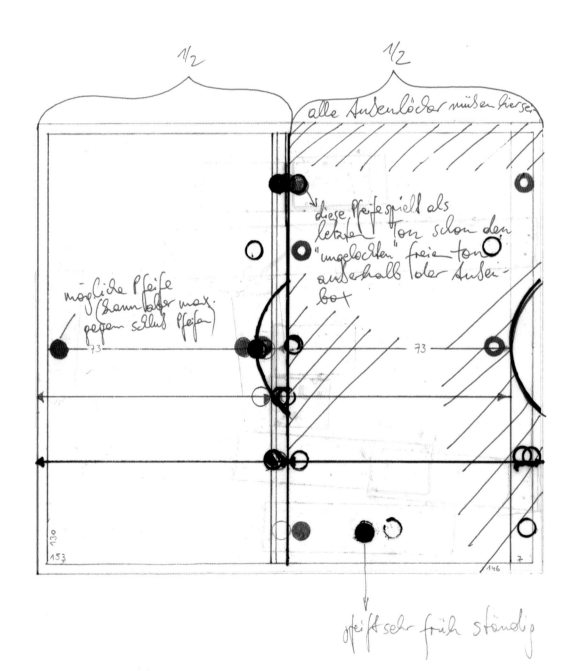

0.6 – 1.1 sketches ↙ ↘

Kopf developed various sketches while exploring the relationship sound was to have with the packaging design. In sketches 1.0 – 1.1 the languets used in the final design can be seen. The scientific nature of these working drawings manifests itself as a graphic resolve for the final design of the cases.

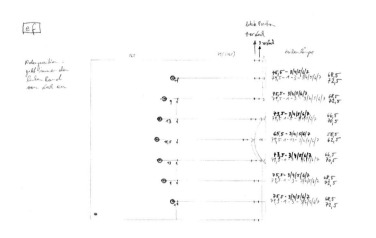

0.8

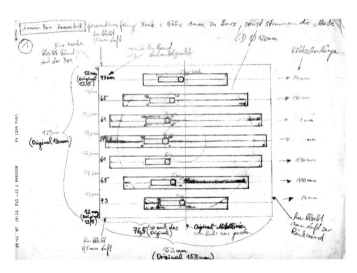

1.0

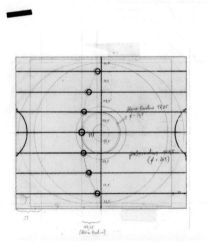

0.9

1.1

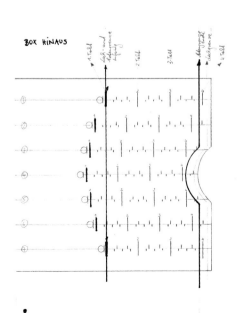

1.2 first dummy　　　　　↗

Kopf had decided that she wanted music to be composed for the CD cases rather than simply letting any sound be produced, which reduced the number of musical techniques available to her; the mouthpiece of a trumpet, for example, which produces a tone by the pressure of the lips. "I needed a technical element which would produce a constant and reliable tone," she recalls. At the end of the first day of the fair Kopf had learnt to differentiate the various techniques of producing sound through the movement of air, and knew which method she needed to use, which she explored further during the second day. "There was a nice guy from the Schwarzwald who was the maker of church organs. He also didn't believe that it was possible to make a CD cover from what he makes big organs from, but he was giving me straight answers to my questions," she says. Kopf had a friend in Styria who was an organ-maker who agreed to show her the components inside an organ-pipe that produces sound when air flows through the pipes. "He sent me a big box, and when I opened it I was quite shocked: the organ parts he sent definitely were too big to pack into a CD case. I had to find a little brother of an organ," she recalls. Kopf quickly commandeered her son's toy harmonica. "I didn't tell him that I was going to destroy it, but I was desperate to look inside. I cracked the plastic when my son was sleeping, and there it was: the baby brothers of the organ's sound-makers. I then bought two real harmonicas, one for my son and one for my research," she says.

Kopf disassembled the harmonica and peeled out the parts that she needed, the tiny stops that control different sets of reeds, i.e. languets, available in any pitch, that sound via air movement. She now had to find a way to make the languets produce sound or remain quiet, and control the timing of the air movement. She remembered that her father had a machine that used punch cards. Each punch card contained patterns of holes to give the machine commands. Having decided upon the use of holes, Kopf set about constructing a prototype to see if the mechanism would work. "I was still stuck with the idea of a cube, so I designed the first musical box with the dimensions of a cube. It was a monster, very ugly, but it made sound," she says. Although this dummy did not provide any means for controlling the air movement, it enabled Kopf to explore the basic mechanics of the concept.

1.3 development　　　　　↙

Kopf had accidentally mounted one of the languets upside down, which meant it would not produce a sound upon the opening of the box. A minor setback, but, "what a great surprise," says Kopf, "it made sound on closing instead. By chance I had found out how to loop the musical tune of the box." From this discovery she developed a system of holes to let air in and out of the case. When the air enters or exits through the holes it passes the brass components, causing them to vibrate and produce sound. The positioning of the holes allows control over the timing of the vibrations (rhythm and melody). The dimensions of the brass components determine the tone and pitch of the sound. The results of testing in terms of the sound produced by different sized holes and their positioning obtained with the first dummy are illustrated below, with Kopf's analysis of the maximum possible tone and pitch. From these results she was able to determine the maximum range of hole positions. With hole positions established, Kopf addressed the issue of time through a graphical representation of time bars to show hole positioning as the box is played both when pulling out and pushing in. One time measure pulling out equals one time bar of 16/16 time, producing one tone that can be heard 16 times, "like a little gunfire", explains Kopf.

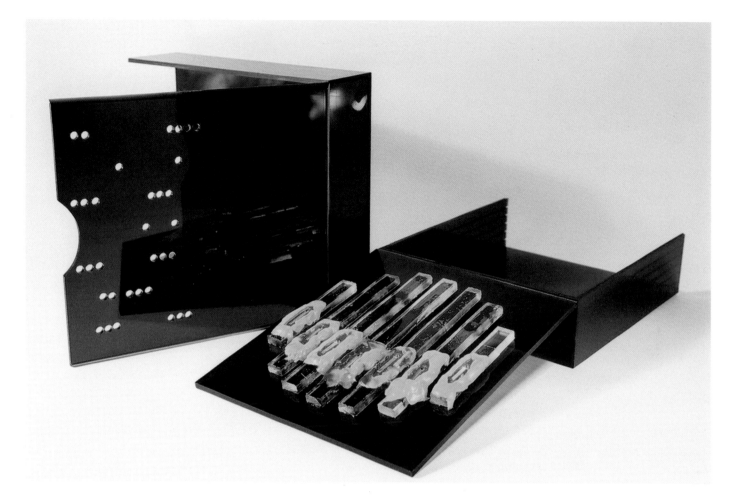

1.4 second dummy ↘ ↑

Armed with a good idea of how to position the holes, Kopf began to address the design of the shape to give it the dimensions and look of a CD package. "I had never done design before, but by now I was so deeply involved with the idea of the musical CD cases, and it was so exciting to have come so far, that I was dedicated to make this thing not only work as a CD case but also look like a CD case," said Kopf. The second dummy saw a fundamental progression towards the final item; it contained advanced mechanical components and some of the visual design elements. Kopf wanted the case to be transparent so that the CDs could be seen while inside the case.

The dummy was sealed with tape so that it could be re-opened to test different sets of languets in the inner box, and have different tops to trial various hole patterns in the outer box. Plasticine (the yellow substance in the pictures) was used to fix the languets temporarily to the box and make accurate testings of the musical box programme. The finished boxes, by contrast, were airtight, had permanently fitted languets, and each had a unique pattern of holes.

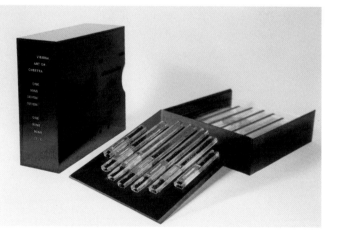

	DECKEL	BODEN	OBEN	UNTEN
9/30	2,8 2,8 (V) 2,8 2,8	3,4 3,4 (V) 3,4 3,4	70 90 3,25 (V) 3,25 70 -0,5 82	08 80 75 08 80 80
10/30	2,8 2,8 (U) 2,8 2,8	3,35 3,3 (U) 3,35 3,25	70 70 70 70	70 70 70 67
11/30	2,9 2,9 (T) 2,9 2,9	3,1 3,1 (T) 3,1 3,05	65 85 (N) 60 85	90 85 (0) 89 85
12/30	2,9 2,8 (S) 2,85 2,85	3,2 3,0 ohne Folie (S) 3,15 3,0	70 65 59 (n)(E2) 70 70	70 09 60 (Z7) 70 09 60
13/30	3,0 3,0 (R) 3,05 3,05	3,0 3,0 (R) 3,1 3,0	96 89 (U) 96 89	85 90 3,3 (M) 3,3 80 -0,5 80
14/30	2,9 2,95 3,08 (Q) 2,95 2,95 Deckel	3,0 3,0 3,14 Boden (Q) 3,03,06 3,03,09	70 80 ... 0 77 86	70 76 U (L) . 71 83
15/30	2,95 2,9 (P) 2,95 2,95 Deckel	3,0 3,0 3,1 (3,05) (P) 3,05,0 Boden3,0 3,05	60 74 (M). R 70 80	84 75 L (E) 85 73
16/30	3,0 3,0 (O) 3,05 3,0 Deckel 3,0 3,1	3,0 2,9 3,0 3,1 Boden (O) 3,03,0 3,03,04	94 91 (Y) 90 92	90 92 (Z) U 85 92

1.5 catastrophe

"The dummy was perfect," says Kopf, "there were no difficulties at all. It would play any tune we wanted, and the handling of the opening and closing was very smooth." With success seemingly within reach, she ordered the cutting of the plexiglass for all 30 boxes that were to be produced, according to the measurements of the second dummy. Unfortunately, her choice of plexiglass was to cause one of the biggest problems. "When they cast the big plates [of plexiglass] it would not solidify as a straight surface but in waves that cause different thicknesses of the material," explains Kopf. This was a catastrophe, as it meant that the parts of the boxes did not fit together. "The inside cases didn't fit into the outside cases because they were too thick, or the inside cases were too loose, and the air flow couldn't be controlled anymore," she says. To resolve this was a laborious task. Kopf had to measure all side parts of each outer case (four parts to each box equals 120 parts in total) and all four corners (480 corners in total) to find parts that were complementary to compensate for their deviations during assembly. However, most parts needed to be corrected via grinding, although the small project budget meant that Kopf could not use a specialist. "I still don't know how to explain this," she says, "I just know I worked like a mad calculator for many weeks. Eventually (after a hell of a lot of pressure and three months measuring/calculating/grinding) I managed to get all 30 boxes to fit right," she says.

elisabeth kopf

little orchestra

This End Up: Original Approaches to Packaging Design

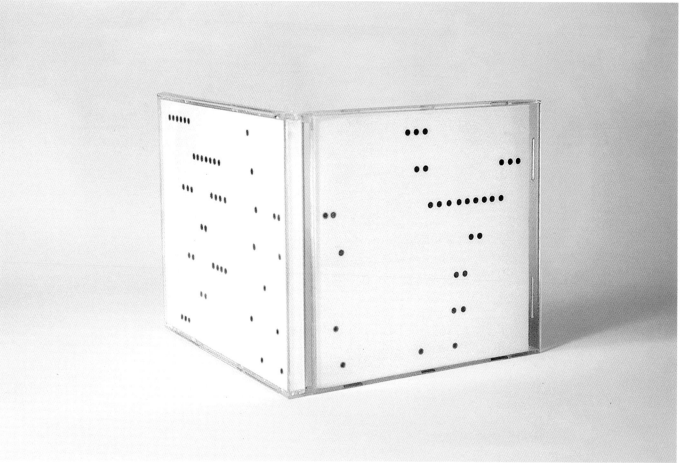

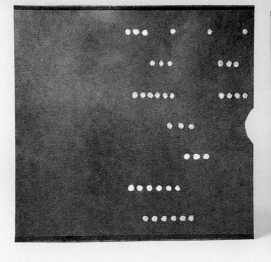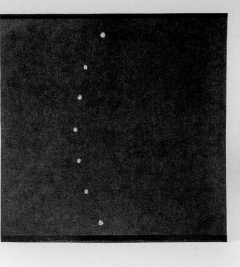

1.6 dummies ↗ ↖

Several colourways and graphical treatments were developed, an amalgamation of which later formed the basis of the final packaging.

1.7 cd production ↙

The visual arc used for the arrangement of the holes on the CD covers was used for the design of the CD graphics, but in this case the track listing was curved. Both the CD covers and the CD labels illustrate the design and mechanism of the musical CD boxes.

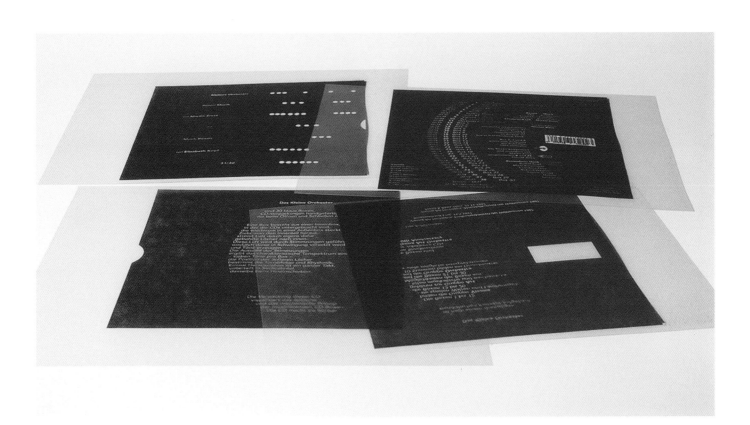

elisabeth kopf

little orchestra

This End Up: Original Approaches to Packaging Design

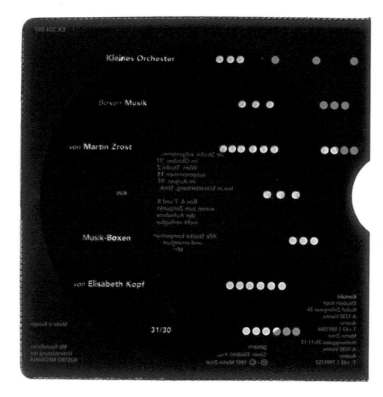

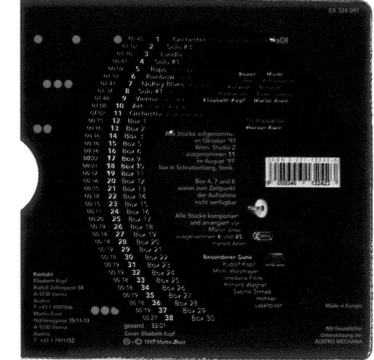

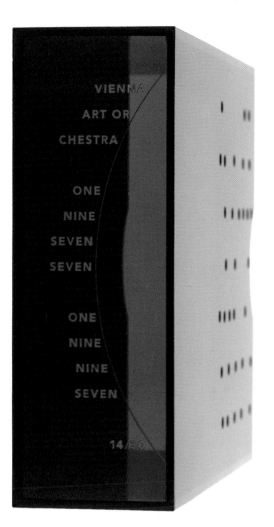
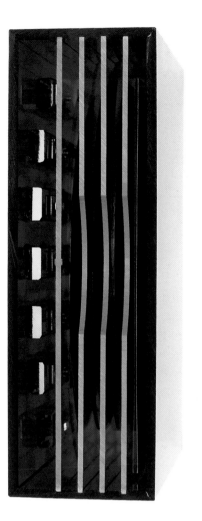
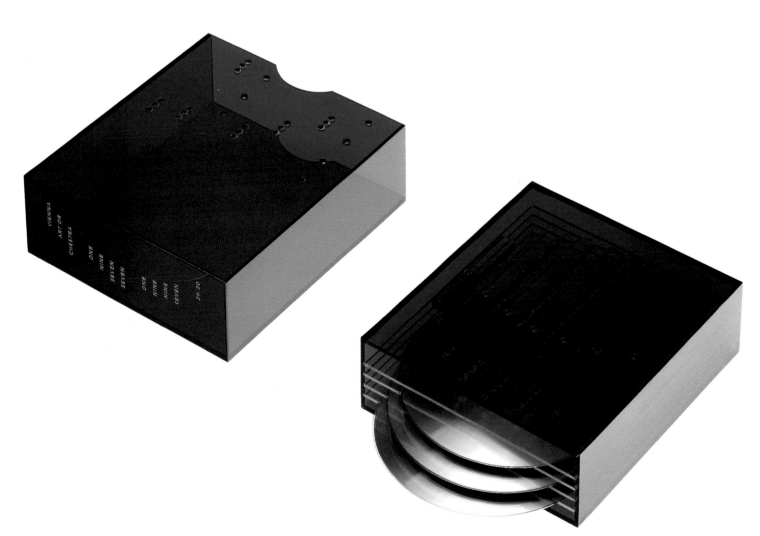

project 0.5 levi's®

Red tab? These two words spoken to a teenager would probably elicit the response, 'Levi's®?' Levi's® 501s have been the most powerful brand in denim jeans for decades. They are something of a post-war icon that are discovered afresh by each succeeding generation. 501s are almost part of the family, a stylish and durable must-have in any discerning teenager's wardrobe. In the fickle world of fashion they have remained a mainstay due to their inherent qualities and a stream of evocative, sexy, stylish commercials that are accompanied by a killer soundtrack, inevitably resulting in a number one single.

The 501 jean is identifiable by the discreet red label that pokes out from the rear pocket. Subtle, distinctive and instantly recognisable, that little tab of red material, scarcely bigger than a fingernail, has played a pivotal part in the success of the garment, the brand and the company. It is the keystone around which the brand was built and that enabled the company to elevate the humble blue jean from a generic wardrobe staple into an essential item. It instantly communicates the qualities of the brand – style, endurance, dependability and sex appeal – and possesses the type of brand equity that marketers die for. The 501 brand created the value-added blue jean market blazing the trail that others, such as Diesel, have followed.

However, this is not a book about brand development or marketing, but packaging. In a world where we typically buy clothes off the peg, we rarely encounter packaged clothes. Think about it. A shirt may be boxed if manufactured by an exclusive designer; underwear may also receive this treatment, but for the most part, clothes are typically displayed on great racks or neatly folded upon a shelf to allow the potential consumer to get hands on, to touch the fabric, to hold it up to themselves while they gaze into the mirror: little primary packaging is used for clothing.

Product packaging typically provides a surface that allows a producer to capitalise on a brand at the point of sale. Clothing devoid of packaging is unable to harness brand strength in this manner. How to provide branding benefits to an unpackaged product is quite a challenge and one that UK-based Farrow Design overcame with what is typically a minor, or overlooked, packaging element: labelling.

In its work for Levi's® Farrow Design questioned why certain clothing products should not be packaged. Zip-lock bags and die-cut boxes that create a physical barrier between the consumer and the garment may initially seem a mistake in the touchy-feely world of clothes shopping. The use of primary packaging commoditises wardrobe staples such as the plain white or black T-shirt, products so familiar that they require little thought in their purchase other than obtaining the correct size. The shopper is invited to grab and go with their wardrobe basics, and move onto the serious business of trying on jeans and jackets. However, Levi's® has developed into such a well-known and trusted brand that we are comfortable turning a clothing tenet on its head.

The following case study shows how Farrow Design used the red label, and other quintessential elements of the Levi's® brand, to create a packaging and presentation system for a variety of Levi's® clothing products that enhances exclusivity and reinforces the brand values.

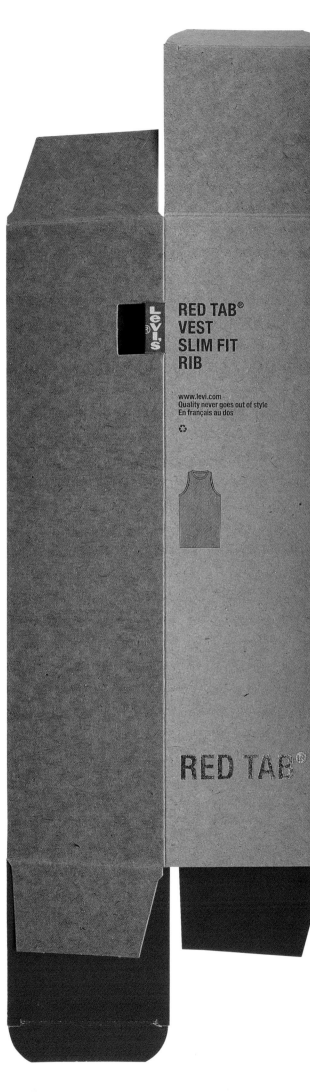

RED TAB®
VEST
SLIM FIT
RIB

www.levi.com
Quality never goes out of style
En français au dos

RED TAB®

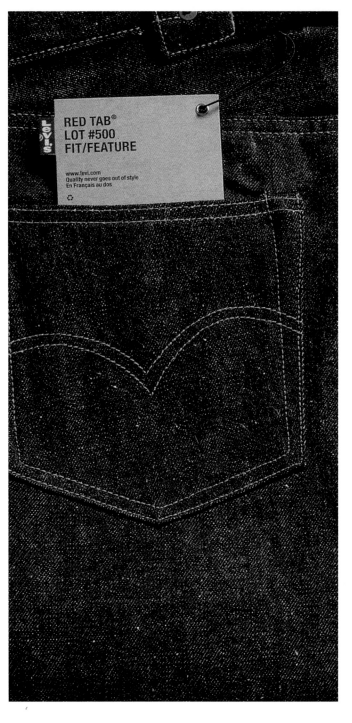

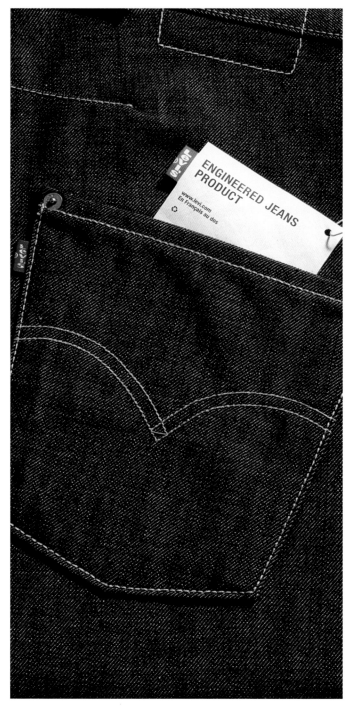

0.1 labelling system ↗

Levi's® approached Farrow Design with a view to rationalising its label system for the European market. The existing labelling had developed over time and was not very consistent. It had many different shapes and styles across the entire range that resulted in a lot of labelling and wastage.

Farrow Design looked at the variety of labels and stripped them down to the basic information, and suggested that the company capitalise on its core brand of the red tab and dispense with the 'batwing' motif. The designers wanted to mirror the physical red tab on 501 jeans in all the product labelling, to give a consistent form for all labels.

Levi's® had four product ranges that needed labelling, but each required its own identity, feel and heritage. These were Red Tab®, the core range; All Duty™, work wear; Sta-Prest®, more preppy; and a new range called Engineered Jeans, new cuts, designs and denim.

Farrow Design suggested that differentiation of the four ranges be achieved through the label material, the design process and applications that follow. For example, at all times, the red tab was used in the corporate red and white livery.

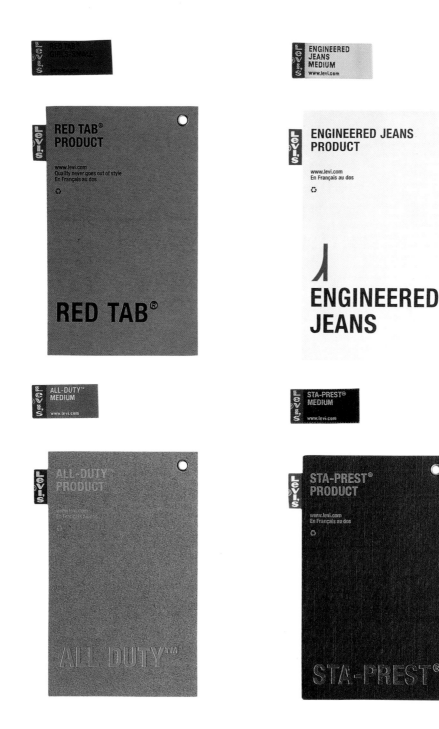

0.2 labelling breakdown ↗

Red Tab® – The label is made from boxboard that resembles the leather patch sown onto the rear waistband of the jeans. A bronze foil block was used to mimic the rivets used on the jeans for the brand name. All other text appeared in black.

All Duty™ – A pale blue stock made from recycled denim was used to reflect the work-wear feel. The brand name appears in gunmetal foil block with other text overprinted with a double hit of white.

Sta-Prest® – A textured, slick and slightly shiny stock was used with the brand name in gold foil block. Other information was printed in gold.

Engineered Jeans – A modern stock called Tyvek that cannot be torn was used. The brand name appeared in a high gloss blue to contrast with the matt nature of the substrate. Other information was printed in matt blue.

When these labels were applied to a pair of jeans they were attached by a cord through a belt-loop and inserted into a back pocket. The size of the label allowed product information and the red tab to appear outside the pocket, giving the ancillary benefit of allowing the wearer to see their bum when trying them on. "This had been a real problem with the previous labelling," comments Jon Jeffrey of Farrow Design.

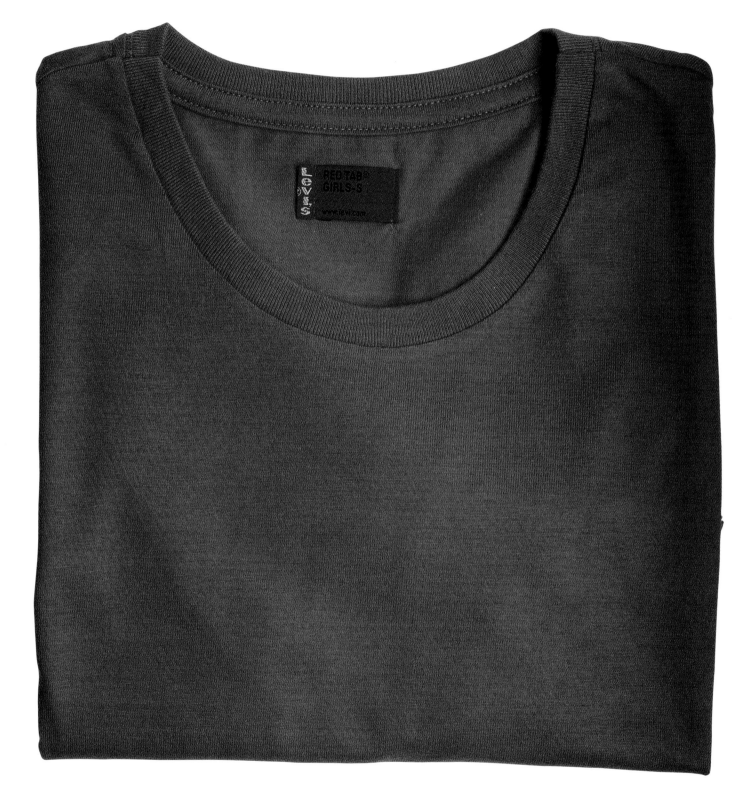

0.3 t–shirt labelling ↖

The red tab idea was extended to in-garment labelling, with a red tab added to the end of the label that is sewn into the garment. Type styles and colours are the same as for the external labelling.

This modification of the in-garment labelling was originally intended for use solely in Europe, but once Levi's® Head Office saw it, it was decided to use it worldwide.

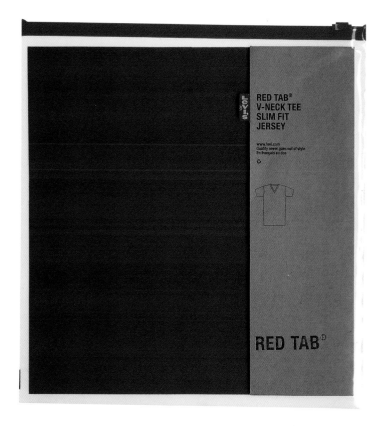

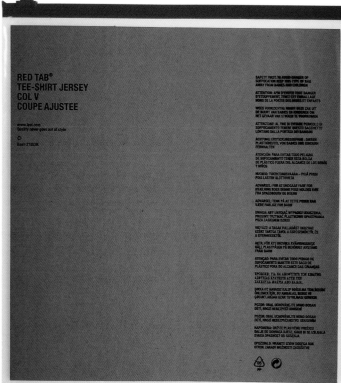

0.4 t–shirt packaging ↗

The basic v-neck and round-neck T-shirt is now a commodity item that does not need to be tried on in-store, as customers have a pretty good idea of what they are buying. The T-shirt was packaged in a zip-lock bag with a card inserted and folded around the contents, falling short of total coverage on the front in order to show the garment and allow

the red tab to appear consistent with the entire labelling system. The card was a continuation of the jeans labelling, and used the same stock and foil-blocking for the branding.

0.5 underwear packaging

An alternative package is used to identify underwear. A similar idea was used as for the T-shirt zip-lock bag, except that the card insert was turned into a box to hold the garment. The box is made from the same stock as the jean labels, with the Red Tab® brand name in bronze foil-block.

The red tag printed onto the box was die-cut so that it would stick out prominently when the box was folded into shape. The cut in the stock that this was made from was extended to create a bigger hole in the side of the box, to allow the shopper to see the colour of the garment inside. Both underwear and T-shirt packages picture a line diagram of the garment in black.

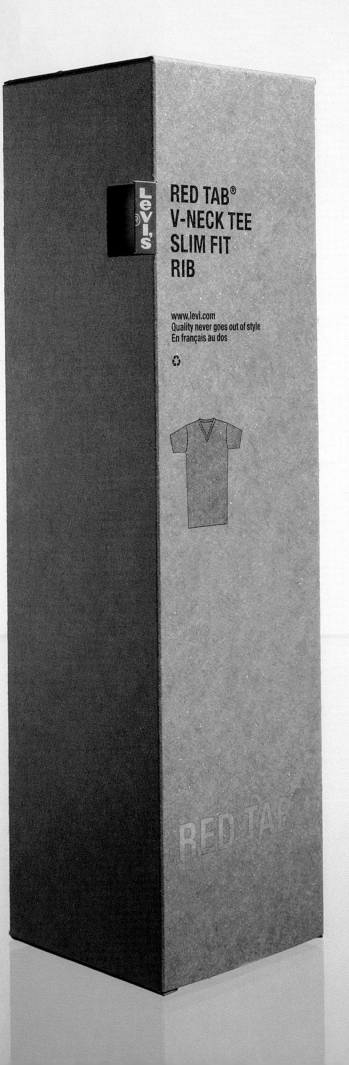

RED TAB®
V-NECK TEE
SLIM FIT
RIB

www.levi.com
Quality never goes out of style
En français au dos

21286K

3 STAGE T-SHIRT
SLEEVE: SHORT/CAP/VEST
NECK: ROUND/V NECK
HEM: STRAIGHT/CURVED

TEE-SHIRT MULTIFONCTION
MANCHES: COURTES/
SEMI MANCHES/DEBARDEUR
ENCOLURE: RAS DU COU/COL V
REVERS: DROIT/COURBE

UNISEX

UNISEXE

GIRLS

FILLE

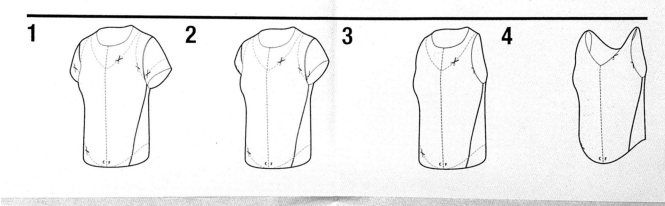

ENGINEERED
JEANS™

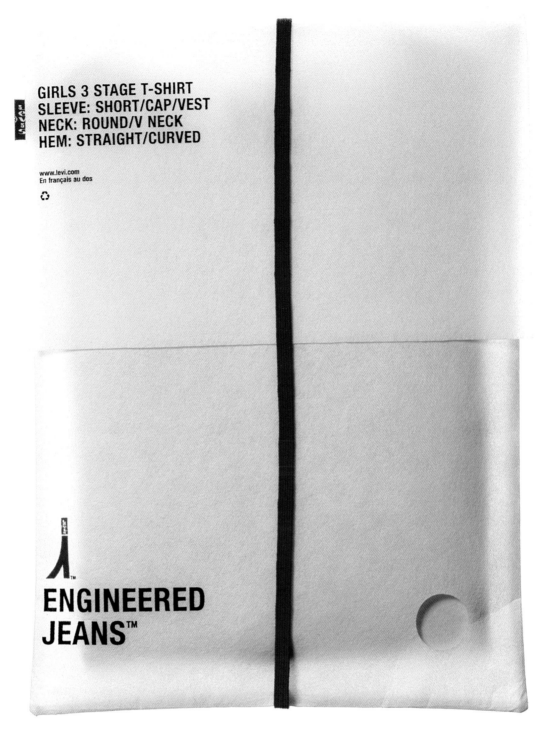

GIRLS 3 STAGE T-SHIRT
SLEEVE: SHORT/CAP/VEST
NECK: ROUND/V NECK
HEM: STRAIGHT/CURVED

www.levi.com
En français au dos

**ENGINEERED
JEANS™**

0.6 bespoke

The packaging for the Engineered Jeans T-shirt followed a different approach. The garment is purchased as an unfinished long sleeve T-shirt. The consumer can finish the T-shirt in various ways, as printed on the packaging. The package contains an instruction leaflet, printed on bible paper, that indicates the various options.

This is a more adventurous product and hints at bespoke tailoring, although the consumer will perform the alterations. The tailored feel is underlined by the 'interlining' stock – used in suits – from which the packaging is made. This has a hole cut to reveal the colour of the garment, and the reverse side has a template for a pocket that can be cut out and used with the off-cut material. The package is sealed with an elastic strap.

This is a unique approach to the packaging of a T-shirt. Remember, T-shirt packaging is usually encountered in the form of a cellophane bag that wraps three department store own-label T-shirts. The interlining by comparison is light, delicate, gives the impression of exclusivity and suggests to us that the T-shirt is bespoke.

project 0.6 guldkorn 1999

The advertising world is not against self-promotion. Indeed, self-promotion is an important activity that keeps an agency's capability in the minds of the paymasters who commission the work. It is common for agencies to put together clip-reels and portfolios of photographs that showcase some of the commercials or advertisements they have created. Invariably these become lost or forgotten over time, left in a pile to gather dust. At the end of the last century, the Danish advertising agency Creative Circle wanted to celebrate the changeover to the next millennium with the publication of a book, showcasing a selection of work produced for the Danish market, but with a different approach to be used for its design. Creative Circle wanted the book and the accompanying video of clips to be included in the same package and not as separate items, as in the past.

2GD, an award-winning design agency from Denmark, used the word 'registration' around which to build a solution, as achieving registration is a core requirement of colour printing. If the different colour inks are not deposited in registration, what would result would be an unintelligible mess. This concept has parallels in the functions of advertising. If advertising is not in 'registration' with the brief, product, service, other marketing and promotional activities or the target consumers, then it will have little effect. Additionally, as the book is a showcase of advertising produced, it serves as a register of creative output. The catalogue, called Guldkorn 1999, features work using a variety of media, including event promotion, display advertising, billboards, television commercials, radio commercials, websites, direct mail, product artwork, interactive multimedia and graphic design from a number of leading agencies and production companies. It is included in this volume as a novel approach to the packaging of creative output.

What 2GD produced is a catalogue in standard four-colour A4 hardback format with a sewn binding. What is not standard, though, is the block of grey foam adhered to the front cover that has a central section cut out to house the accompanying videocassette of show-reel clips. The total package is inserted into a transparent plastic bag for containment. The use of foam was pragmatic, although not without drawbacks. It allowed the A4 dimensions of the book to be maintained by beefing up the size of the video to the same. Simply mounting the video on the cover would have created an irregular shape. Foam is also lightweight so does not load extra weight to the product, which the video does. With foam it was possible to cut a hole to the precise dimensions of the video, and, given foam's springy nature, it grips the cassette tightly enough to hold it in place and thus secure it. Placing the video on the outside front cover of the book provides convenience, in that both items are together and one can easily access the video to play in a VCR and/or browse through the book. While functional, the overall package does not score highly on the aesthetic or communication front, an unfortunate corollary of the use of a foam housing. The video is labelled 'Guldkorn 1999' and has no other visual references. Yet, in its way, this creates a unique visual presence. The absence of an elaborate or sophisticated design, in an age in which we are accustomed to fussy design, catches the eye. It was a bold move, however, as the design is remarkable because of its incongruity. The only other markings are the embossed title of the book on the front and back of the book's cover.

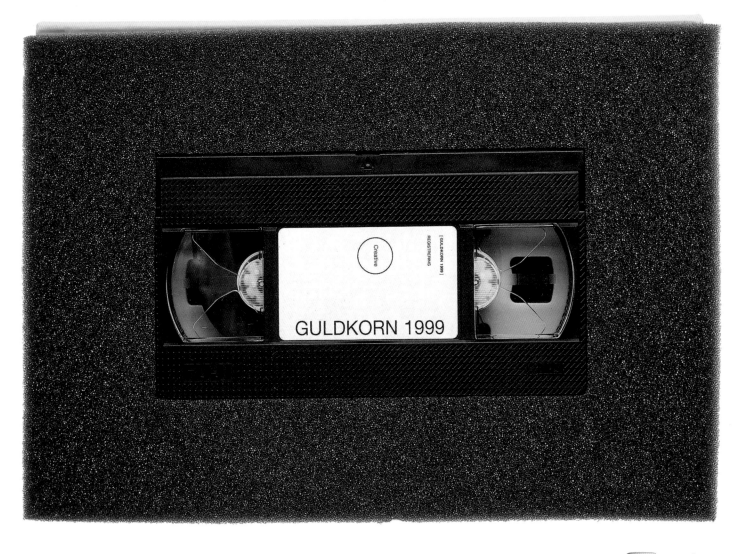

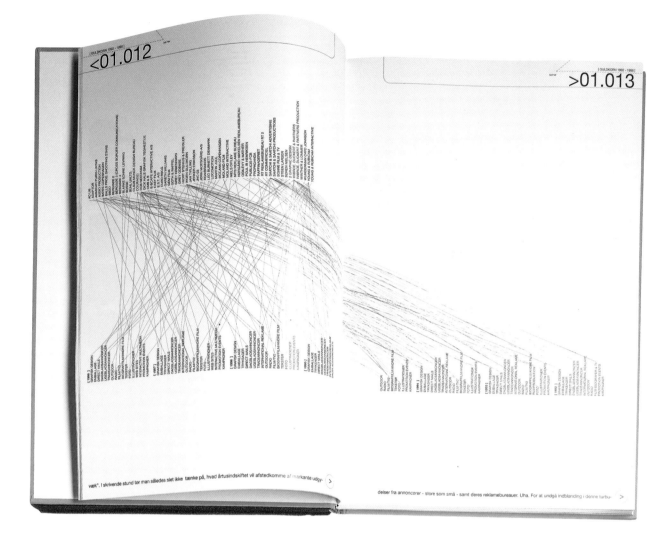

0.1 package

The construction of the package is almost painfully simple. A die-cut foam outer is literally glued to the front of a traditionally bound book, which contains an accompanying video. Having the video 'stuck' to the front of the book reminds us that advertisements – the content of the video – aren't always static, and need to be viewed rather than read.

Removing the video from its recess reveals the name of the publication, subtly embossed in the coverboard of the book beneath. The laser-printed video label becomes the main identifier for the publication, again reinforcing the importance of the tape.

Although you would expect the resulting package to be clumsy, it is actually a succinct and sensible design. The cover opens in the same way as a traditional cover would, without the tape becoming a hindrance, and the video, due to the tight fit of the foam, doesn't fall out. Perhaps most importantly, the video and the book are kept together for future reference.

0.2 index

The vernacular of information design is appropriated to cross-reference creative agencies against the categories of the brochure.

The strong visual identity of the catalogue successfully accommodates a wide spectrum of work (see following spread), with examples showcased in a clear and varied way.

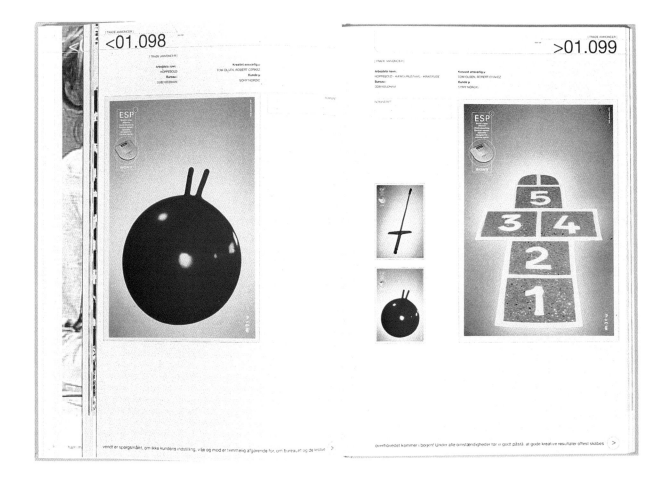

Børge D. Madsen, Det var bare reklame :

Kampen mod "huller" har i årtier været temaet i reklamen for Colgate tandpasta. I 70'erne hed det "Nul huller" og "Mor, mor, han borede slet ikke". I 1981 var det "Hærder tænderne og beskytter mod huller". Og i 1993 var temaet "Colgate. I stedet for huller".

[HISTORISK ASPEKT 1.1-2 1979]
BD.M. OVER.
Kunde :
COLGATE
Bureau :
D'ARCY-MACMANUS & MASIUS

[UGEBLADSANNONCER]

»Nul hul

[DIRECT MAILS]

Arbejdets navn :
FOLD UD MAIL
Bureau :
DDB NEEDHAM

Kreativt ansvarlig :
TONI LADEGAARD, CHRISTIAN IVERSEN
Kunde :
TELE DANMARK MOBIL

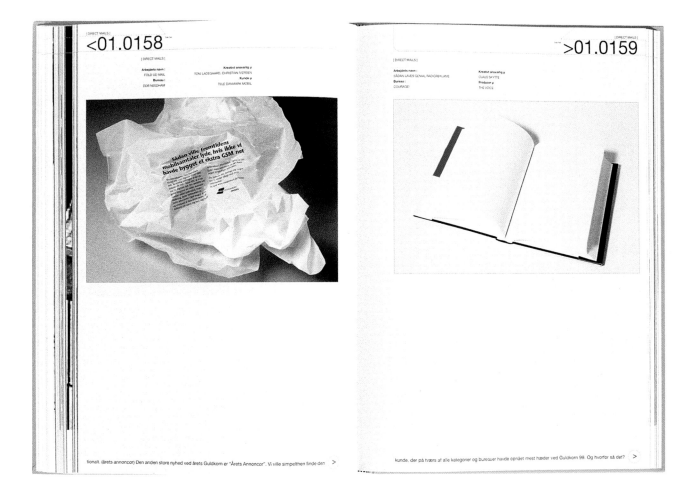

[DIRECT MAILS]

Arbejdets navn :
SÅDAN LAVES GENIAL RADIOREKLAME
Bureau :
COURAGE!

Kreativt ansvarlig :
CLAUS SKYTTE
Producer :
THE VOICE

project 0.7 aroma sutra

The creation of a gift pack allows the packaging designer's artistry to come to the fore, as all of the main packaging requirements are amplified. Gift packs are usually impulse purchases and therefore have to present an adapted communicative message to potential consumers. A gift pack typically offers the consumer several diverse but related products in one purchase, giving additional convenience at a more generous price. The package itself is a piece of secondary packaging that contains and protects the individual units that comprise the offering. The result can often be an elaborately crafted package, and in this case, one that draws on the arcane art of origami. This chapter shows design house Époxy's design for cosmetic producer Fruits & Passion, for a gift box of various aroma-based products.

As a piece of secondary packaging its performance requirements usually amount to containment and protection. Époxy had to design packaging to contain five cosmetic products: incense cones, bottles of massage oil, bubble bath, lover's perfume and a perfumed candle. These all had their own packaging, with the exception of the incense cones and the candle. The agency created a complex but highly effective package that not only stores the individual products, but allows them to be displayed once the consumer has taken them home. Époxy's solution was a pentagonal cylinder.

The construction consists of five triangular cylinders in series that roll up to form a pentagonal cylinder package. Each triangular cylinder has a die-cut recess into which one of the five products is placed. The recesses are consistent in their dimensions, but as each of the five products has different dimensions, the means by which they are held in the recess varies. The bottles of massage oil and bubble bath are the largest items and served as the benchmark for the recess dimensions in terms of length and depth. These are such that they are held in place by the recesses. The candle and the perfume bottle both have a diameter of just over 1cm and are held in place by a small collar die-cut from the walls of the recess. The most complex paper mechanics can be found in the shelves created for the three incense cones. For these, a cardboard shelf was inserted into cuts made into the sidewalls and glued in place. This sounds like unnecessary detail and effort, but the display of the five products in the opened package is striking. Each product is also held securely.

In this state the package would simply flop open: something else was required to secure it. This was simply and cleverly achieved with a belly wrap, a collar of card that fits tightly around the rolled-up core. Although essentially a functional element of the overall packaging design, it was styled to enhance the visual presentation. It was die-cut in a shape reminiscent of the arches of Indian pavilions, consistent with the eastern theme of the visual identity upon which the product offering is based. Each of the cosmetic items represents a particular spiritual element complete with name and symbol: Mamaki, Locana, Pandara, Tara and Ishvari. The artwork is rendered in relaxing yellows and browns, with a line illustration of an Indian deity, mystical symbols and an Indian stylised typeface.

Packaging's many functions extend to the containment of odour. This package fails to contain the aroma of the candle and incense cones, but this is deliberate. Releasing the aroma of the products the pack contains works with the visual elements to entice the customer.

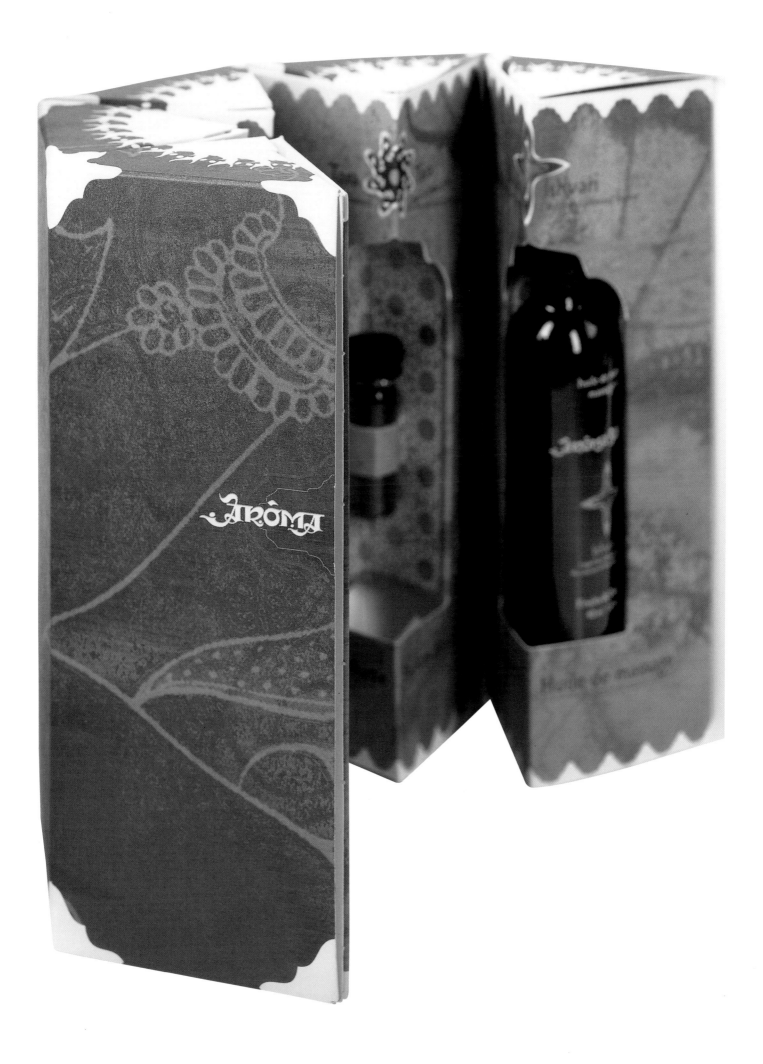

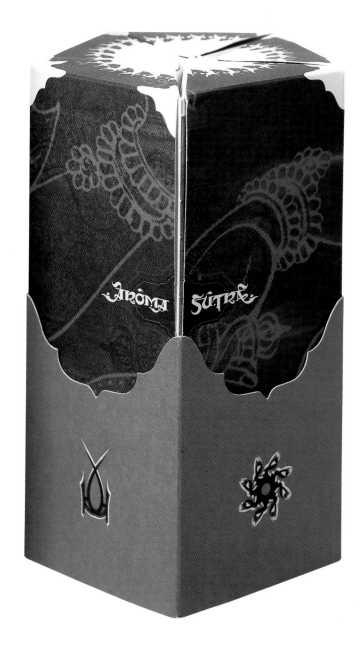

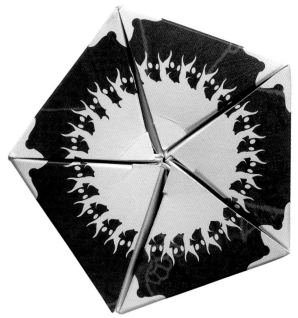

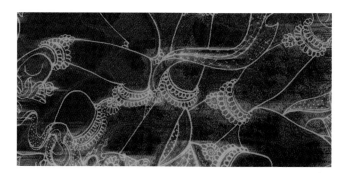

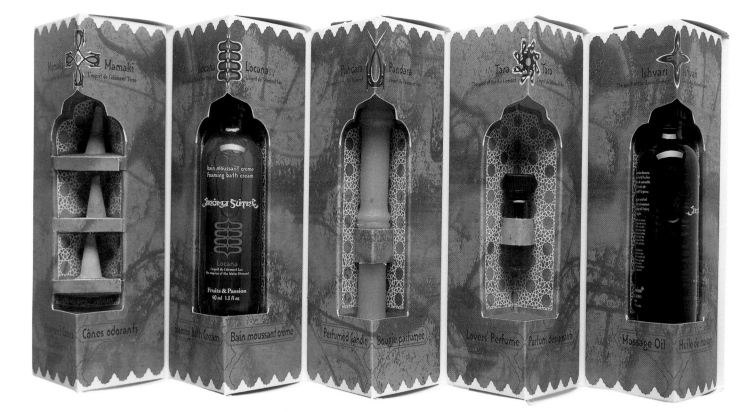

0.1 box

A 'print' is rendered as a Photoshop file that is then 'wrapped' around the exterior of the pentagonal cylinder. The printed belly-wrap is then placed over the box to prevent the triangular cylinders unfolding prematurely.

The Pandora's box style of opening is particularly effective. The space-saving pentagonal shape disguises the amount of products contained within. In the context of 'gift' packaging this is of particular importance, being both surprising and exciting to 'discover' the 'treats' within.

0.2 products

Upon opening the casing we find the products: fragrant cones; bath cream; a perfumed candle; lovers' perfume; and massage oil. The products are associated with different 'spirits' which relate to the five senses: 'Mamaki', spirit of the Earth for the cones; 'Locana', spirit of water for the bath cream; 'Pandara', spirit of fire for the candle; 'Tara', spirit of the air for the lovers' perfume; and 'Ishvari', spirit of space for the massage oil.

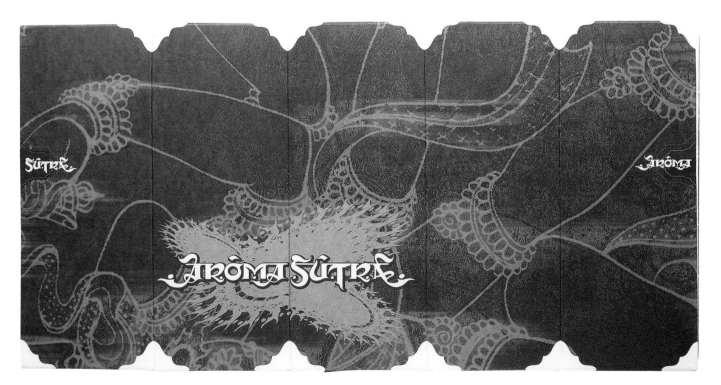

0.3 guides

↑ ↙

Belly-wrap print and box guide.

0.4 developments

↘

Sketch book development of the logos for the five 'spirits', drawing influence from traditional Eastern graphic illustration styles. The resulting icons are successful as they retain traditional elements but are reproduced in an original contemporary form.

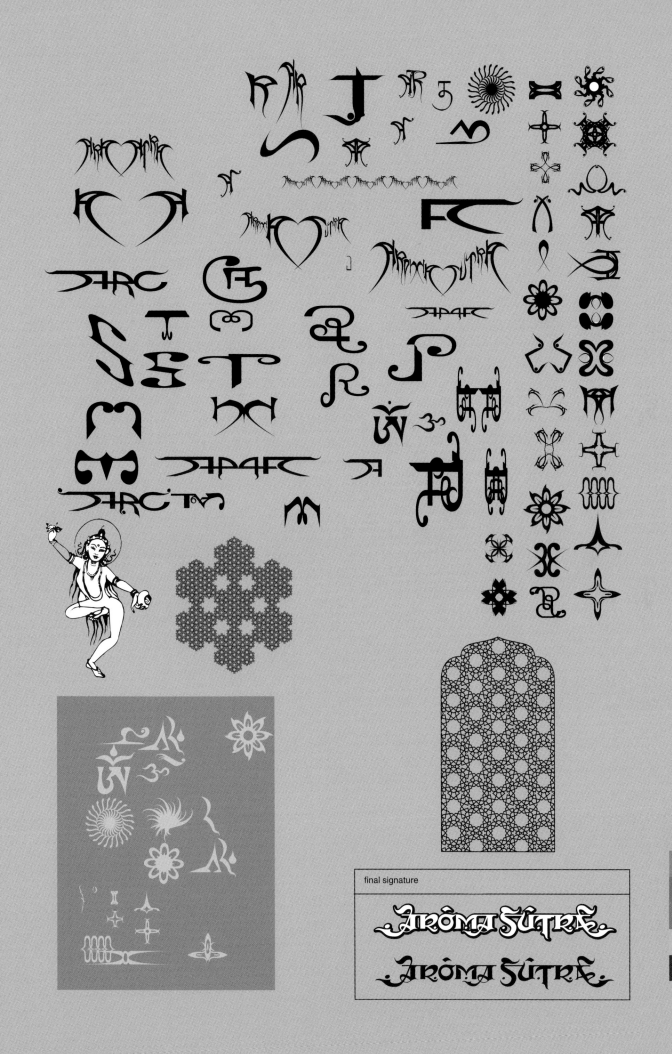

final signature

aroma sutra

This End Up: Original Approaches to Packaging Design

project 0.8 ren

Cosmetic products are created to improve our appearance and safeguard the health and condition of our skin, hair, nails, eyes and so on, and have become some of the most vigorously promoted and marketed of products, utilising branding that attempts to connect directly with consumer self-perceptions and aspirations. Promotional activity can be lavish, with the use of catwalk models to trade on the wannabe/wannahave urges of the consumer, suggesting the style and glamour that can be ours through use of the cosmetic in question. All too often these claims go unfulfilled. Cosmetics are also frequently presented with a traditional French look or twee floral designs like those of Crabtree & Evelyn. An alternative approach is the 'less-is-more' philosophy that produces a brand and packaging that is intentionally utilitarian, like Muji, CK One or Kiehls.

REN is a comparative newcomer to the world of cosmetics. It was formed in 1998 by Antony Buck and Robert Calcraft, formerly account planners of London-based advertising agency BMP. After leaving the agency they established a consultancy to advise and conduct research on the launch and management of brands. That quickly led them to the thought, 'if we're so good at brands, then why don't we create one'. The pair decided to launch a range of cosmetic products under the brand name REN, which is Swedish for 'clean', and sold it through the company's own Liverpool Street store in the heart of the City of London, as well as outlets and concessions throughout the country, and in hotel-size versions.

For the packaging, they invited four design agencies they had worked with during their agency days to pitch for the commission. A Swedish designer who was working with a friend of theirs was also invited to pitch. They received a predictable collection – an array of flowers, herbs and other cute designs, except for the pitch by the Swede. He presented an own-design typeface that Buck and Calcraft felt expressed a modern, yet mainstream, approach.

Using this typeface, a visual identity for the packaging was created that embraced the Scandinavian feel for simplicity. Although the design was to appeal primarily to women, the male market was not ignored. Creation of packaging with a generic, utilitarian feel was important, so that men would be comfortable using the products. Market research had shown that men, while they may not buy cosmetic products, use those purchased by their (female) partners. Making the product an asexual one was therefore necessary.

A simple system of colour-coding was developed using a palette of pastel colours to maintain the Scandinavian feel. Four different skin types are represented by four different colours, which are used for both moisturisers and cleansers, a total of eight products. The other 38 products in the range are colour-coded sympathetically to the key constituent ingredients. For example, a lavender-based product has a lavender colour. In this way the colour bar on the label is used more as an overall identity than a specific identifier. The colour scheme was applied to other elements of the brand, such as the bags for the company's store.

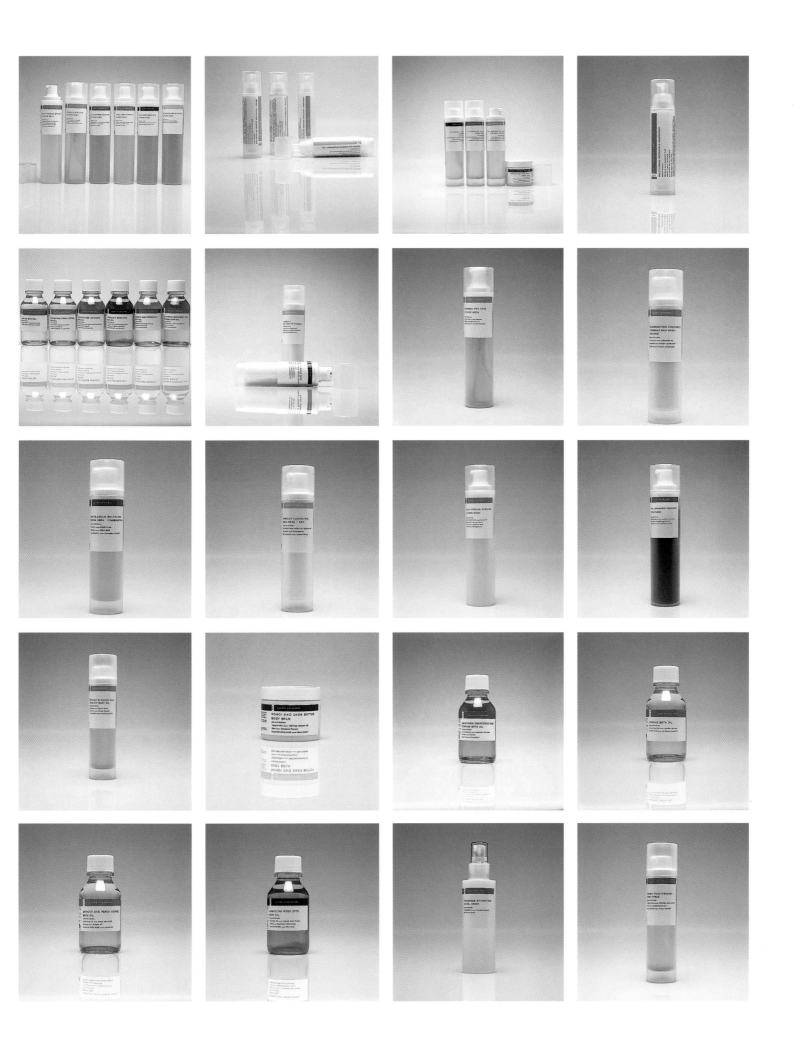

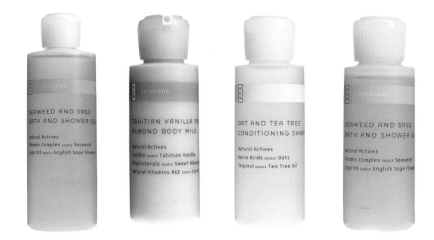

0.1 early prototypes ↗

The original design for the label had the brand picked out with a black line around the logo. A printing error meant that this did not print, but upon reflection, this was preferred and the black line was dropped from the design. This can be seen on the early prototypes above.

Off-the-shelf bottles were chosen to contain the products, but unlike the Unavailable perfume project (see pages 26–37) that used an off-the-shelf bottle due to its low cost, REN selected readily available bottles to draw together all the design aspects: simplicity, utilitarian product functionality and asexuality. Differentiation from the purely generic bottle was achieved by using different tops. A generic bottle also allows the consumer to see how much product is left in the container.

In an age of multi-colour printing and substrates that can dress a container up in any way desired, the consumer is faced with an explosion of colour. One of the most striking things about labelling for the REN range is that it has been restricted to the minimum possible to provide the smallest sight barrier between user and contents.

The polypropylene label is thicker and more expensive to produce than those typically adorning cosmetic bottles, and is applied with a heavy-grade adhesive to prevent lift. These materials provide permanence and maintain the integrity of the packaging throughout the product life; an important consideration given that it is likely to be kept in a steam-filled bathroom.

0.2 oil ↙

All the packaging items have been selected to allow the user to see the product as clearly as possible. Branding is minimised and hard to find, being hidden in the labels' colour bar that indicates the nature of the contents. The whole presentation is very clean and straightforward. Simple and effective.

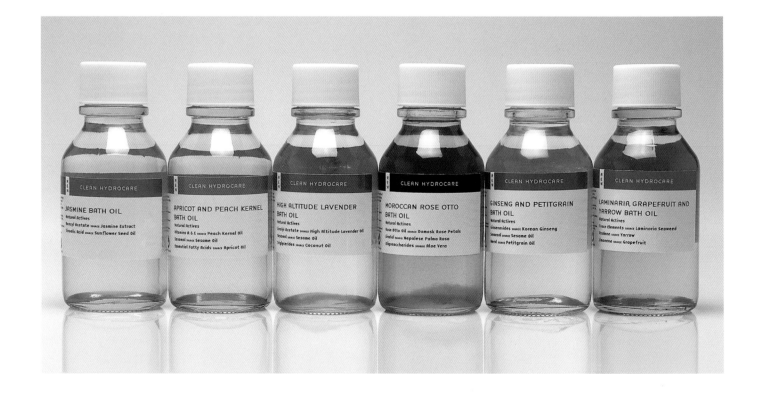

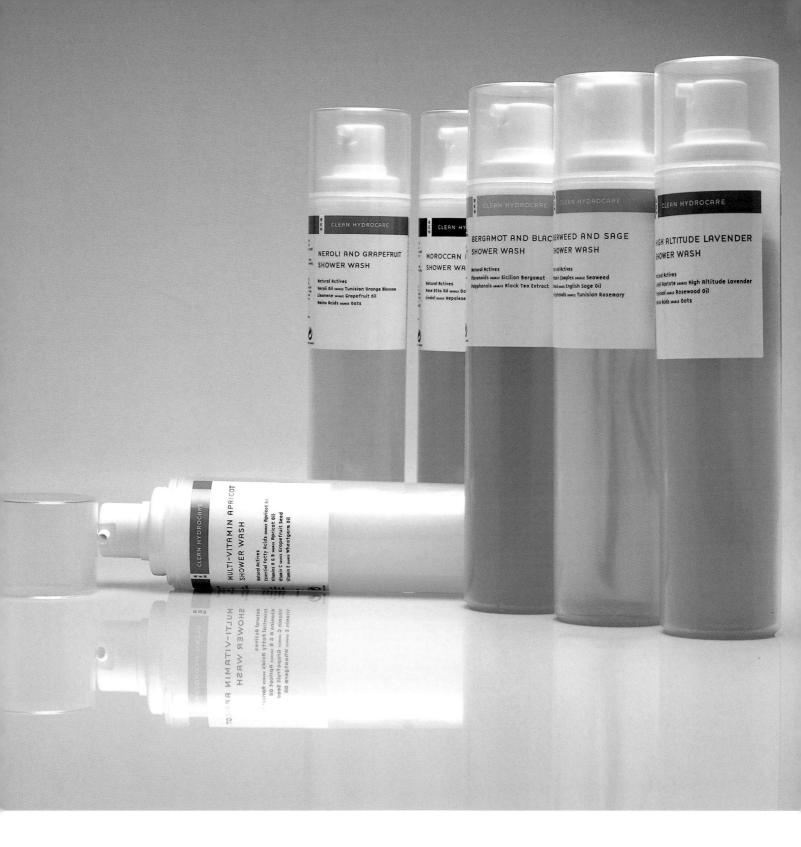

0.3 colour coding ↗

REN packaging in all its simplicity. The off-the-shelf bottles look spartan compared to the array of over-designed packages we are used to seeing from cosmetic producers. Above, we can see the different facial washes, with the product within clearly visible, and the colour-coding of the upper banding serving as identification.

The products may look ascetic and austere, yet the uniform approach to the packaging of all the products provides cohesion and homogenisation to the whole range.

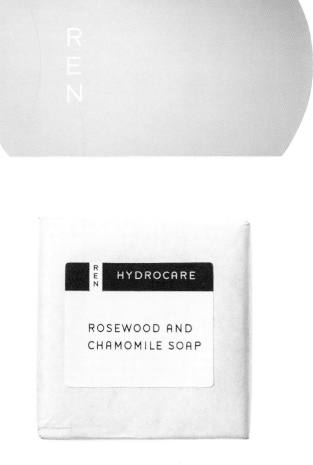

0.4 accessories ↑ ↗

Accessories, such as this gift bag and flat-pack gift box, follow the same principles of simplicity. While the products and their packaging are minimalist, the bag is more traditional in its boutique style and the gift box signifies the simplicity of REN products, which are none the less produced for a sophisticated clientele. The pastel colour is consistent with product labelling and the underlying Scandinavian approach, with the brand name REN subtly reversed out in white.

0.5 new soap packaging ↑

Packaging for new products like this rosewood and chamomile soap is minimalist in the extreme. The soap is wrapped in paper with a label that serves to identify the nature of the product and nothing else. But look again and one sees the pastel colour bar (that hints at its ingredients) and the subtle REN logo branded out of it.

0.6 preservation ↗

Inside each bottle is a bag containing product. Sealed airtight, these pouches collapse as the product within is used. As it has two distinct benefits, the pouch design has become an integral part of the development of future ranges. The pouch mechanism prevents contact with the atmosphere, and more importantly direct contact while handling the product. Contamination through handling necessitates the use of preservatives, as each time the product is removed, contaminants are left behind. The pouch design prevents contact with hands and therefore reduces that need, a central aim of the REN company.

The pouch design allows almost all the product to be used, as there are no recesses or corners where residue can remain. Although not selected for this reason, this design minimises product wastage, offering another consumer benefit. The design always appears clear and new as the product does not cling to and cloud the outer pack.

project 0.9 great

Generic, minimalist designs that focus on simplicity have great currency and are highly effective (at least until society becomes awash with them). It is ironic that upmarket products successfully harness low-market, anti-branding approaches, which are necessarily` low cost. International retail consultancy Rodneyfitch were commissioned to redesign and rebrand various food-packaging items. The generic visual identity the consultancy created was eventually extended to package every facet of a mall branded 'great' in Hong Kong's Pacific Place, one of many high-rise office developments, including the in-store experience, communication language, employee uniforms and delivery trucks. Rodneyfitch created the concept that 'great', which opened in 2000, should cater to the eating requirements of an upmarket clientele, both in terms of eateries and grocery stores.

'Great' is intrinsically simple as a brand name, but, like many simple things, it is highly effective. It uses the popular device of word doubling, where one word is picked out in contrasting typography from the longer word from which it is formed; in this instance 'eat' from 'great'. Separately, both words refer to and describe in basic language what one can expect. To paraphrase a well-known advertising slogan, the brand is exactly what it says. From 'eat' it can be surmised that food is on offer, from 'great', the claim of the brand's owner and a message that the offering will have to live up to. Combined, the message to the consumer is that good food is available both in terms of quality and variety.

The association of these two words is so powerful that no images were needed to illustrate product packaging. Instead, the idea of the packaging telling the consumer exactly what the product is was extended to all aspects of the makeover. The result is labels that read like a word association workshop about food: 'Pasta rice sushi pizza soup bread pastries sandwiches…' and so on, ending with the name of the actual product, for example 'Pasta sauce tomato'. This labelling system includes important product qualifiers through the inclusion of words such as organic where appropriate, and more about the 'great' concept and experience: 'Daily groceries organics wine champagne beer spirits cigars flowers eat-in take-away delivery everyday'.

The design is clean, simple and strictly controlled. Every facet has been created to exist as part of the collective experience. The colour schemes, typography, styling, proportional spacing, signage, the food courts and retail areas, even car parking information are consistent: everything is homogeneous. The level of detail entered into and the overall pervasiveness of the design concept with which the mall is packaged continuously reinforces the brand and the upmarket qualities that it represents.

Packaging 'great' in this manner provides protection to the brand through strength in numbers, and avoids any possible dilution that could occur by sub-branding the diverse elements of the mall. Consumers are provided with the convenience of knowing they can expect all 'great' product offerings, whether in an eatery or one of the retail areas, to be of the same quality. The scale and scope of the development also provide the convenience of providing a high level of choice in one location.

ERS EAT-IN TAKE-AWAY DELIVERY
SS TASTE NOODLES PASTA RICE S
AT POULTRY GAME FISH SHELLFI
TABLES DAIRY GROCERIES ORGANI
EAT-IN TAKE-AWAY DELIVERY EV
S TASTE NOODLES PASTA RICE SU
E NOODLES PASTA RICE SUSHI PIZ
Y GAME FISH SHELLFISH OYSTERS
GROCERIES ORGANICS WINE CHAMPA
WAY DELIVERY EVERYDAY ORGANI
S PASTA RICE SUSHI PIZZA SOUP BR
SH SHELLFISH OYSTERS DELI CHE
IES ORGANICS WINE CHAMPAGNE BEE
RY EVERYDAY ORGANIC GREAT CH
CE SUSHORGANIC GREAT CHOICE Q
HI PIZZA SOUP BREAD PASTRIES S
STERS DELI CHEESE HERBS/SPICES
CHAMPAGNE BEER SPIRITS CIGAR
ORGANIC GREAT CHOICE QUALITY
OUP BREAD PASTRIES SANDWICHES
CHEESE HERBS/SPICES FRUIT VEG
BEER SPIRITS CIGARS FLOWERS

Abstract

Abstract	Abstract
Cornucopia	Heat
Elements	Cube
Axis	Plenty
360O	Stacks
N.Y.C.	Plump
Pacific	Variety
Yum Yum	Delight
Stuff	Red Dragon
August	Import
Lemon	Harvest
H20	Catch
Seed	Escape
Pod	x2
Access	Hot & cold, wet & dry
Excess	Secret
Carrot	Here
Sensation	Rare
Temptation	Ideal
Utopia	Flair for flavour
Oodles	Infinite
The Mix	Infinite eating
M.I.U.	Most
Vital	More
Saucy	Sunrise
Fuel	Good place
All	It
Carbon	Ah
Every	SO
Everything	So – below
Potential Energy	SO! gourmet, So! noodles etc
Joules	Stir
Swallow	Other
Satisfy	Eureka
Glutton	Titanic
The Pot	Massive
Core	Signature
The Bank	Ultimate
Ku-Ku	Choice
Tastebud	First choice
Total.	Palate
Ample	Ecstasy
AKA	Nice
Fusion Blue Blue Heaven	Fine
Green	Options
Mass	Ginger
Sense	Root
Essence	Kum (orange)
Yessence	Ala (seed)

1 Word Location
2 Descriptive / Food Based

1 / 2 Location & Descriptive	Food Based	The Shortlist
1		Time 2 …eat, shop, drink
From the Earth	Theatre	Eight (8)
Foodtopia	The eatery	Eat@8, drink@8,shop@8
Soul Kitchen	Recipe	Fine 8
World KItchen	Blend	Infine8
Ingredients	Specialist	One gourmet
Four Corners	Stew	Fusion
Earth Produce	Plum	Taste
Earthright	Consume	Panamana
pi (mathematic Symbol)	Foundation	So!
Paradise	Urban food	be – better eating
Avalon	IF – ideas on food	go – eat, drink
Earth gourmet	ei – eating ideas	Eden
AXIS	fi – food ideas	Oasis
HKFA	Bee - better eating	Gourmet village
(Hong Kong Food Authority)	experience	Earth Kitchen
Food planet	ge – gourmet eating	Gastrome
Urban garden	oc – original cooking	Gourmetro
Metro	trEAT	Metro gourmet
Pacific	bEAT	Metro cuisine
ew - East/West	nEAT	Feed
NSEatsW	hEAT	(fresh eating experience
First place	mEAT	destination,
Full circle	Panamana	food experience every day)
Earth pantry	Nosh	Menu
	Good food	be-lo
2	The collection	Fresh cellar
Soul food	Stop	Daily plus
Gastropolis	Live	Food is…
Gastro	Source	Fresh EDS
Gourmet delicatessen	Survival	(fresh eating, drinking
Gourmet foodhall	Spring	& sharing)
Gourmet theatre	Element	Fres.co
Gourmet forum	Plus	(the fresh food company)
World food forum	Positive	Egg
The gourmet food experience	Reveal	(enjoy Global gourmet)
The larder 'n kitchen	Dig	
Global cuisine	Pure	
Earth's kitchen	epic (eating pleasure in the	
Metro kitchen	city)	
Harvest kitchen	enuf –	
Stockmarket	experience new urban food	
The Source	EGG –	
World-wide cuisine	enjoy global gourmet	
Great world dining hall	Dish	
Experience	Platter	
Eat well	Ocean	
Well being		

0.1 naming exercises ↗

Rodneyfitch initially generated a wide selection of possible names around the themes of food and location. Abstract possibilities, like Fuel, still retain a positive relationship to the activity of eating.

0.2 final selection ↙

A final selection of five names, most of which incorporate a sub-heading, were chosen for development.

The final 'great' identity can be seen at this stage in one of the simplest forms of graphic differentiation: gr- in Roman and the connecting -eat in Italics.

Final selection

be	**fres.co**	**earth kitchen**	**gr*eat***	**eight**
better eating	fresh food company		foodhall at Pacific Place	positive gourmet

0.3 be development

Development of ideas for be; better eating. The focus was on a no-nonsense, positive approach to the lifestyle the package was intended to embody.

0.4 earth kitchen development

Development of ideas for earth kitchen, emphasising the wholesome ingredients of the produce, and offering a visual link to the natural.

0.5 eight development

Mirroring the eight different foodhalls within the mall, the identity development utilised the positive connotations of eight being a lucky number.

0.6 fres.co development

Development of fres.co, an identity linked to the web-presence of the brand. Typography is intentionally authoritative, vivid and fresh.

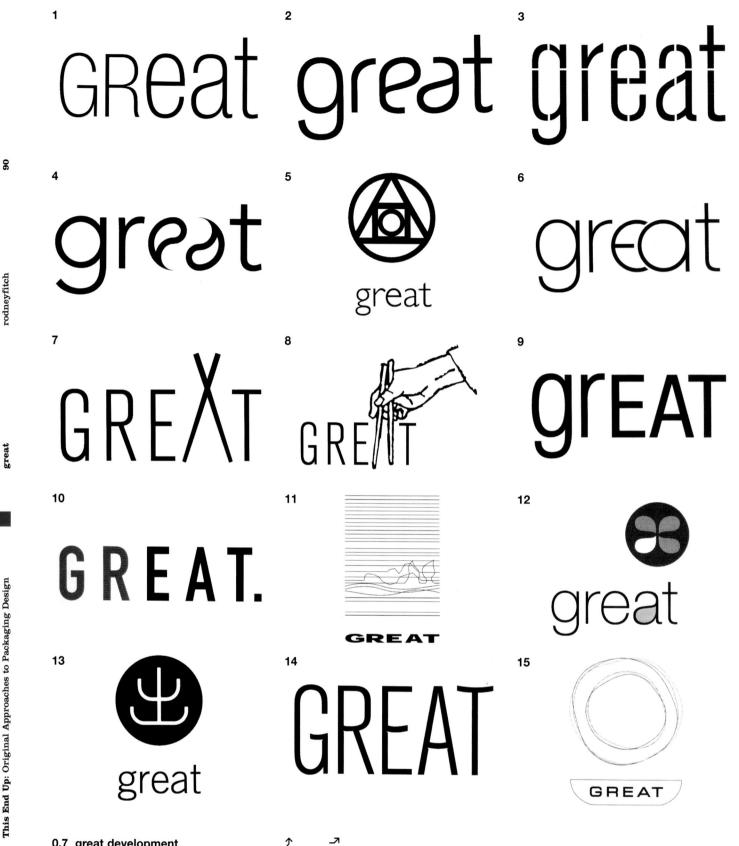

0.7 great development

1 Emphasis created using two weights of one typeface. **2** Based on yin/yang symbol. **3** Stencil type derived from food crates. **4** Second version based on yin/yang symbol. **5** Symbol representing the four elements: water as the small inner circle; earth as a square; fire as a triangle, and air as the outer circle. **6** Suggestion of eating. **7** Chopsticks are used to create the A, creating a link with a Western name and Eastern eating utensils. **8** Pure type combined with an illustration taken from a guide to using chopsticks. **9** Combination of upper and lower case emphasising the word 'EAT'.

10 Punctuation is used to reinforce a proposition: great food. Period. **11** Abstract interpretation representing the four elements: earth, fire, water and air. **12** The counter of the A is used to represent eating and drinking. **13** An ancient pictogram of a sprouting plant. **14** The characters, in particular the A, have been drawn to suggest a smiling face which relates directly to the eating experience. **15** A bowl shown from above to represent the Sun and the Earth.

0.8 great development

16 E has been modified to suggest a fork. **17** Chopsticks used as a secondary device. **18** Extraction of the counter from the A to form a logo. **19** Symbol originally meaning food. **20** Italicised E representing speed of service. **21** Abstract interpretation of the contours of Hong Kong. **22** The A is based on 'kou', an ancient pictograph of the mouth, and the T is representative of the points on a compass.

23 A symbol derived from ancient travellers; the star with a line to its left represents the eastern hemisphere, while a star with a line to its right represents the western hemisphere. Symbolic of west meeting east and also visually representative of two people sharing a table. **24** Universally understood pictogram meaning the Sun, which when used small is also representative of points on a compass. **25** Influenced by Chinese calligraphy. **26 + 27** Upper- and simultaneously lower-case g, encouraging double reading.

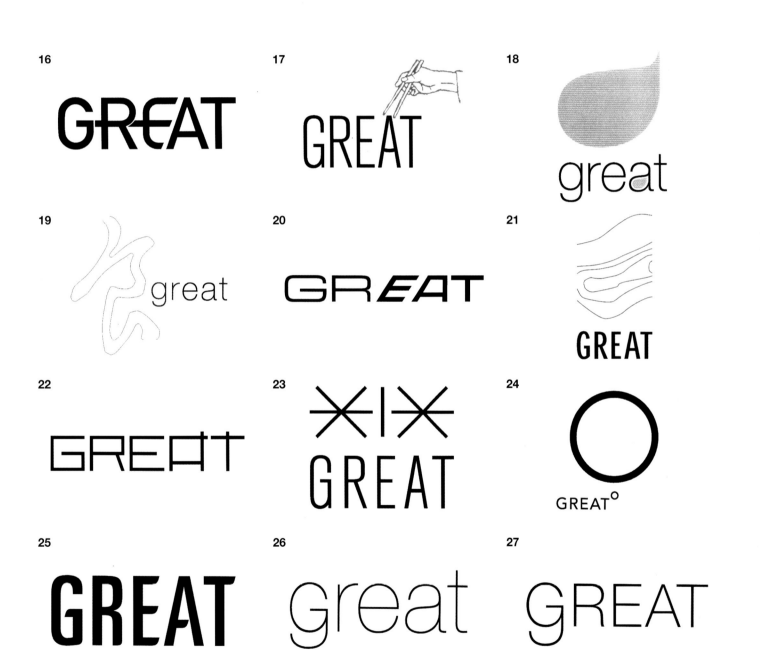

great
pacific place

0.9 logo ↑ ↘

Final logo with related colourways, designed to be flexible for use on a variety of applications. A positive version for use on white, a negative version to be used out of colours, and a mono version for use with colour-restrictive print processes.

great pacific place great pacific place great pacific place

great
pacific place

ORGANIC GREAT CHOICE QUALITY FRESHNESS TASTE NOODLES PASTA RICE SUSHI PIZZA SOUP BREAD PASTRIES SANDWICHES MEAT POULTRY GAME FISH OYSTERS DELI CHEESE HERBS/SPICES VEGETABLES DAIRY GROCERIES ORGANICS WINE CHAMPAGNE BEER SPIRITS CIGARS FLOWERS EAT-IN TAKE-

great great
pacific place

1.0 hot dog packaging ↑ ↘

Packaging for take-away hot dogs using the final graphics and colour scheme.

1.1 cake packaging ↓

Box used for packaging cakes with alternative print graphics.

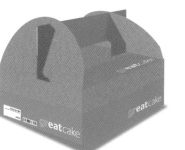

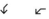
Soup box packaging and label system that can be applied to different containers and multiple products.

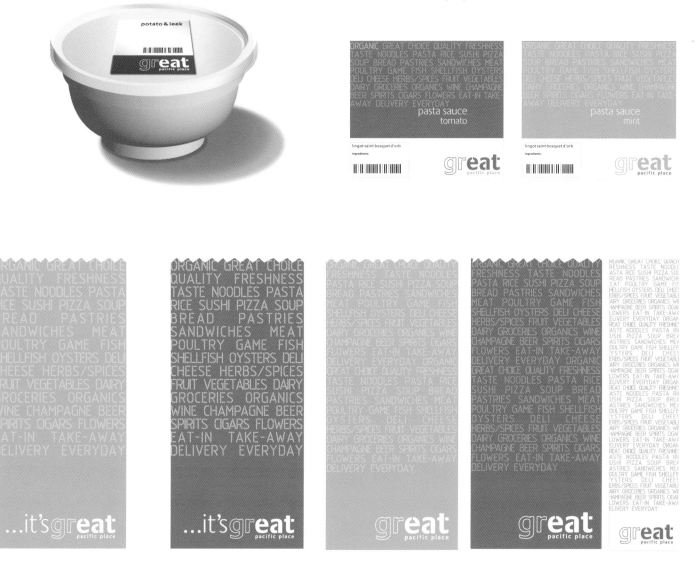

1.3 sandwich bags ↑

Generic bags designed for sandwiches that can also accommodate other product types.

1.4 cups ↓

Development of cups, primarily for beverages, that are also used for take-away soups etc. Alternative products have a label applied.

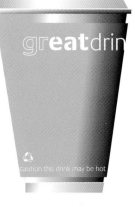

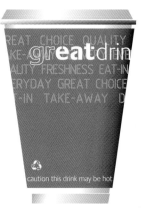

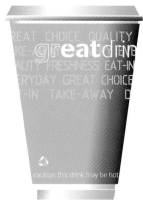

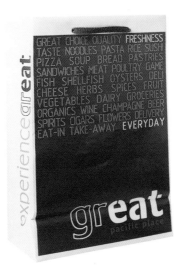

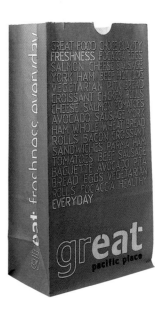

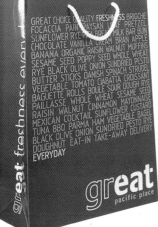

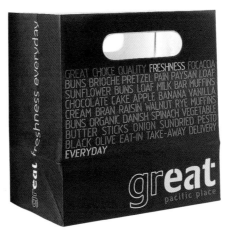

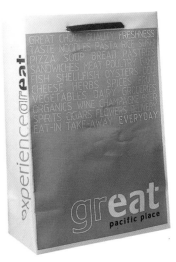

1.5 bag variations ↑

Various bag sizes and styles are produced for use within the eight retail sectors of the mall, ranging from a basic (economy) sandwich bag to more luxurious carriers for delicatessen purchases.

1.6 sandwich boxes ↙

Generic flat-packed sandwich packages in two sizes.

1.7 interiors ↘ ↗

Colour visuals of the complex interior, drawing inspiration from the simplicity of the packaging graphics.

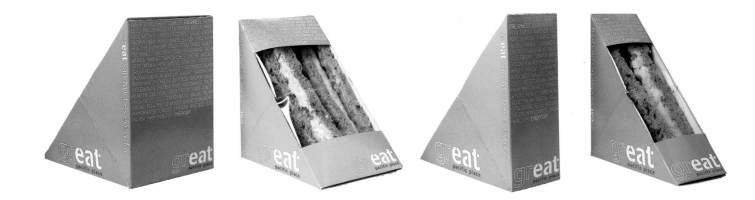

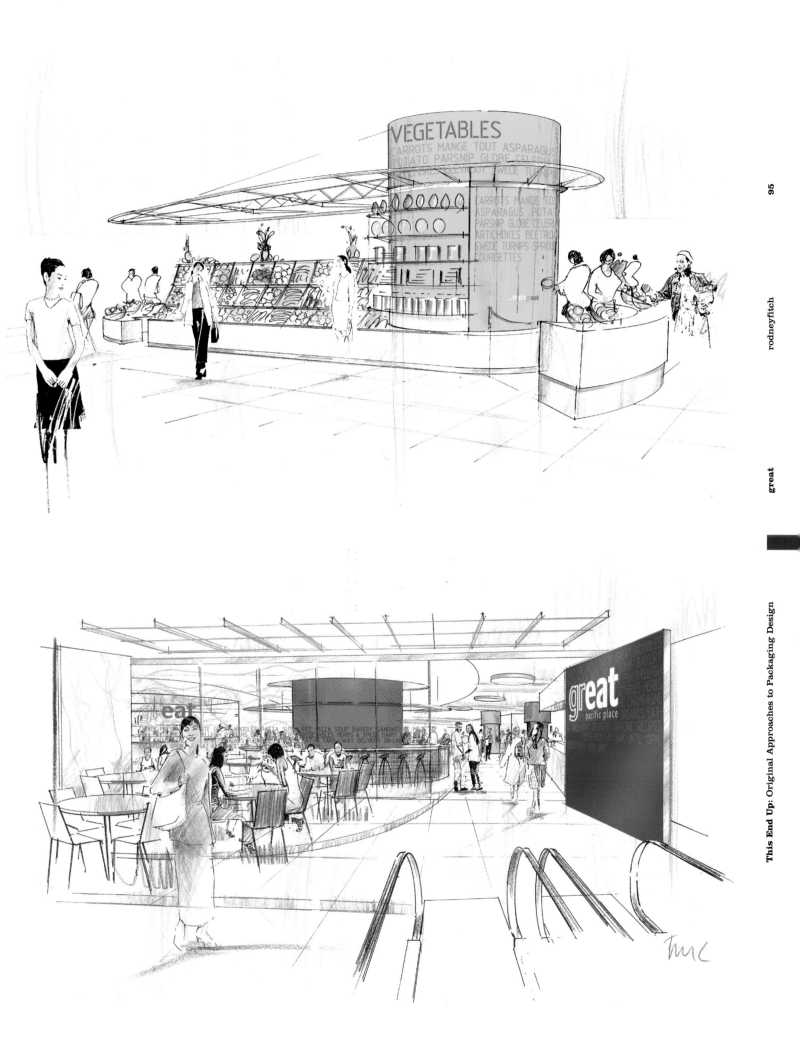

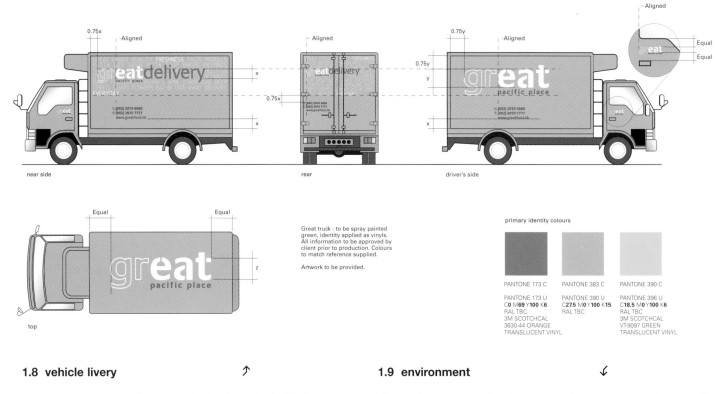

near side rear driver's side

top

Great truck - to be spray painted green, identity applied as vinyls. All information to be approved by client prior to production. Colours to match reference supplied.

Artwork to be provided.

primary identity colours

PANTONE 173 C	PANTONE 383 C	PANTONE 390 C
PANTONE 173 U	PANTONE 390 U	PANTONE 396 U
C0 M69 Y100 K6	C27.5 M0 Y100 K15	C18.5 M0 Y100 K6
RAL TBC	RAL TBC	RAL TBC
3M SCOTCHCAL		3M SCOTCHCAL
3630-44 ORANGE		VT-9097 GREEN
TRANSLUCENT VINYL		TRANSLUCENT VINYL

1.8 vehicle livery

The identity developed for the packaging is applied with the same simplicity to vehicle liveries. The versatility of the marque is evident in the myriad of applications it has to suit.

1.9 environment

The retail environment showing wall graphics, uniforms and an overall synergy between the various components of the identity.

2.0 placemats

Placemats printed with contour lines inspired by earlier experimentation of the identity development.

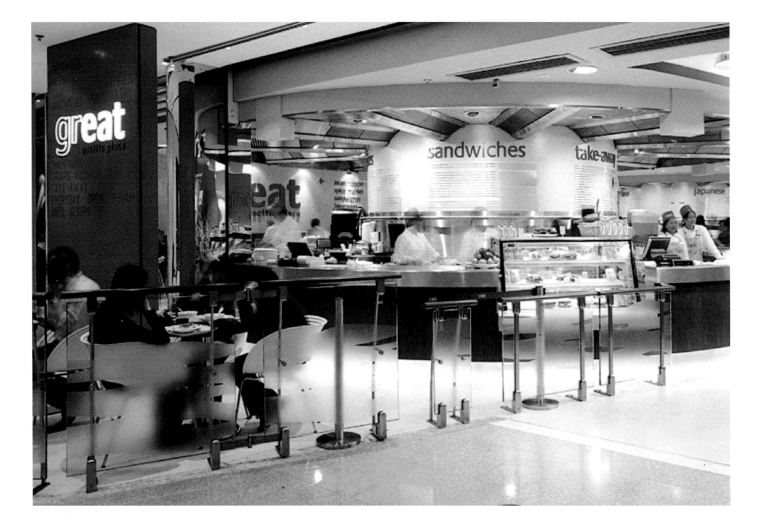

This End Up: Original Approaches to Packaging Design

project 1.0 let it come down

Popular music today is a highly packaged product. Some would say it has always been this way. 'Packaged' pop acts have usually been fabricated and styled to fit a given niche in the pop universe – think the ubiquitous, well-groomed, immaculate pop bands like N-Sync, the Spice Girls, or Steps for example. The lineage of the packaged pop act extends back to the birth of pop in the late 1950s and early 1960s: the Monkees, the Archies, Elvis Presley. Even the Beatles and the Rolling Stones, who rebelled against the saccharine pop presented to the record buying public, were themselves packaged to a certain extent.

But what of the packaging of the physical music product? The first great development occurred in the 1960s, when the plain cardboard sleeve made way for the picture sleeve. This was an explosive opportunity for graphic designers, artists, photographers and illustrators, and paved the way for cover art to develop into an art form that reached its zenith with the LP record gatefold album sleeve. Cover art carries the entire identity load of the record.

Music is closely related to image, a fact that did not escape designers of cover art, who strove to create eye-catching, even iconic imagery to entice the consumer. It's a sad fact that poor music sells in great packaging, but great music does not sell in poor packaging.

The biggest development in music packaging in the last 20 years concerned the introduction of the CD as a music format that occasioned the decline of vinyl. CD packaging quickly attained its apotheosis with the jewel case. The CD is, after all, a simple product to protect. The 12cm disc in a box little bigger is easy to ship and store (both for the retailer and the consumer). Consequently, the jewel case adequately satisfies many of the functions of packaging identified in the introduction: containment, protection and convenience. The CD package is far superior to the album sleeve for vinyl that was prone to damage and offered little protection to the record.

However, the display face offered to designers by CD packaging is inferior in size to that of vinyl. Designers saw their canvas shrink from 12" (30.5cm) square to about 12.5cm square. Browsing through racks of vinyl records was a voyage of discovery and wonder, with the constant flow of striking images in a format size larger than most glossy magazines. Browsing through racks of CDs is a less visually stimulating experience, as the jewel case, while very practical, constricts the visual presentation. The small size of lyrics and liner notes, and interference from other graphical devices, such as montaged images when the artwork is reduced, are some of the problems faced by the designer. As a key element of recorded music concerns visual image, this is quite a handicap.

Alternative packaging systems have been developed for the CD, such as the gatefold cardboard container. Although a variation on the jewel box theme, it harks back to the LP cover in its materials and texture, without the dirty-looking glass effect of the plastic jewel case. Jewel boxes have been made with different coloured plastics to stand out from the mass, and tins and boxes have been used to provide visual differentiation. The Pet Shop Boys took differentiation to dramatic heights with their Very album that was presented in a bright orange, pimpled box that gave no reference to the act.

Spiritualized is an alternative band that functions on the fringes of popular music. Often hypnotically melodic with haunting vocals, the band switches from a guitar-based to an electronic-based sound. Farrow Design's packaging for Spiritualized's Let it Come Down CD, featured in this chapter, is even more of a departure from the typical approach to CD packaging. It possesses innovation, a striking visual presentation, coherence of design elements and is an objet d'art in its own right. Spiritualized have a history of using innovative packaging design, from the Ladies and Gentlemen We are Floating in Space album that was a facsimile of a pharmaceutical package (from the style of the graphics to the cardboard carton) to their earlier Pure Phase album, packaged in a glow-in-the-dark case.

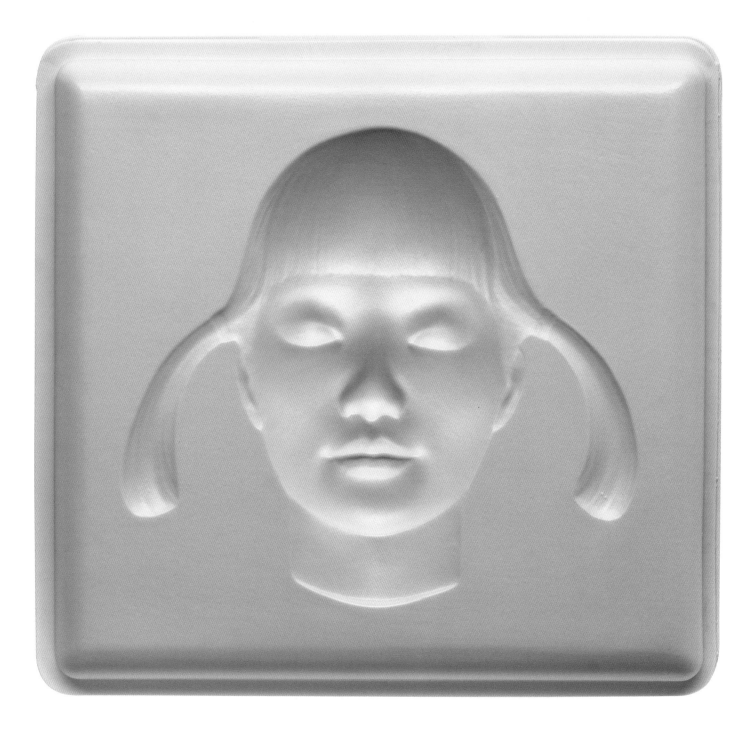

0.1 materials ↗

The album Let it Come Down does not look like a CD box. It is roughly the same shape and slightly bigger, but that is the only clue. Its initial strangeness begs you to pick it up and examine it further. It features the image of a serene-looking woman moulded into the plastic that creates a ghostly three-dimensional optical illusion as she appears from the shadows and highlights. This striking image is a reproduction of a sculpture, Yoko, by Don Brown that utilises this optical illusion. Mark Farrow had used a photo of this sculpture previously for an invite for Brown's Sadie Coles Gallery.

The package is a little taller, wider and thicker than the generic jewel case in order to obtain the relief, which cannot have pleased retailers whose fittings are geared to a standard size. The box and the girl's face almost demand room to breathe.

The packaging is made from a different type of plastic that gives it a softer feel and hollowness due to the nature of its construction. This adds to the overall effect and makes the product a tactile item. Brown, who usually works with acrylics, says the choice of plastic was difficult as it had to meet the requirements of the moulding process. "It is not a material I would use myself, as it is not as matt or sharp as I would like," he says, "but I am pleased with the result. I enjoy seeing it around. It is an odd sensation, it is familiar but a little detached".

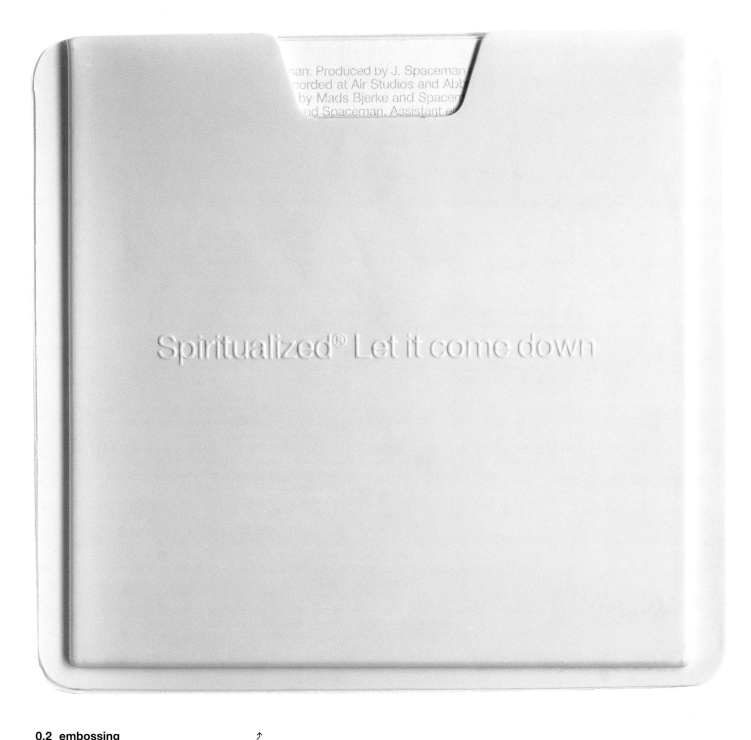

0.2 embossing ↗

Flip the package over and the three-dimensional motif is continued.
The name of the artist and title are picked out in raised lettering across
the centre of a rather nondescript pocket that contains the CD. This
spartan package, in contrast with the typical image-jammed CD cover,
may lead the customer to wonder whether they're holding a CD at all.

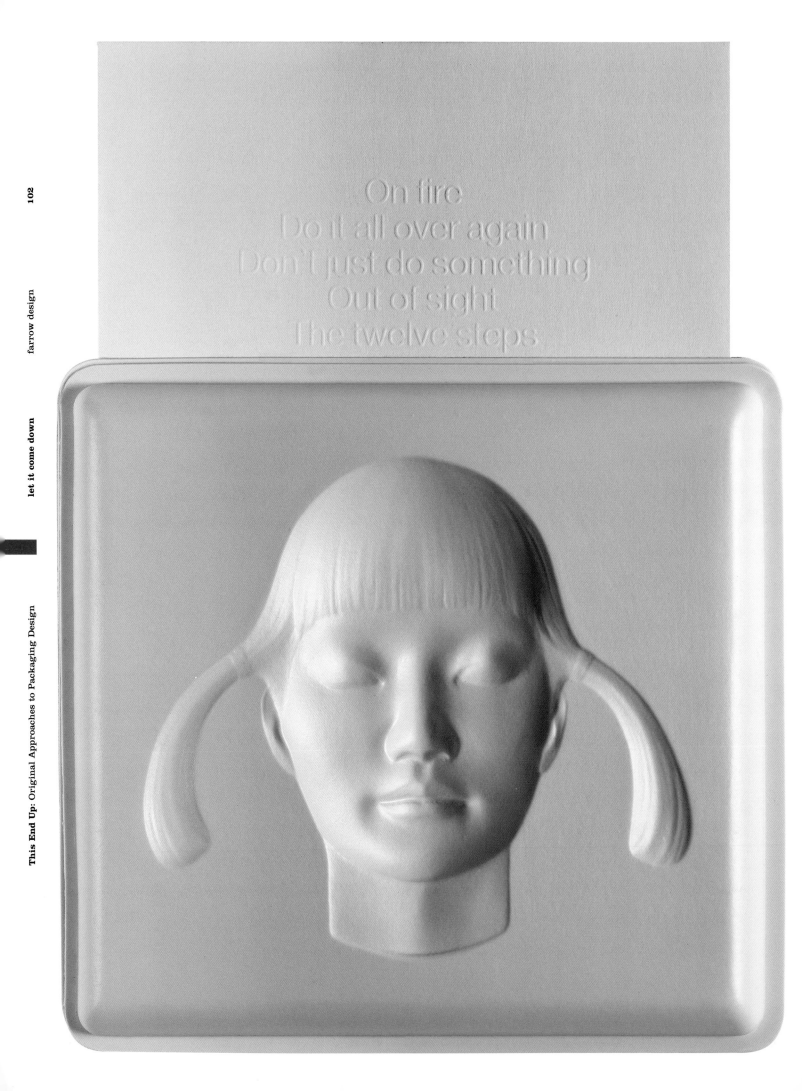

On fire
Do it all over again
Don't just do something
Out of sight
The twelve steps

On fire
Do it all over again
Don't just do something
Out of sight
The twelve steps
The straight and the narrow
I didn't mean to hurt you
Stop your crying
Anything more
Won't get to Heaven (the state I'm in)
Lord can you hear me

Written and arranged by J. Spaceman. Produced by J. Spaceman and J. Coxon. All tracks published by Redemption Songs Limited. Recorded at Air Studios and Abbey Road by Mads Bjerke and Guy Massey. Mixed at Olympic Studios by Mads Bjerke and Spaceman. Post production and editing at Innovations Studio by Mads Bjerke and Spaceman. Assistant engineers: Chris Clark, Ricky Graham, Lorraine Francis, Andy Saunders, Dan Porter. All string and horn parts composed by Spaceman. Music scores and conducting by Martin Schellard. Orchestral contraction by Edmund Coxon. Orchestral administrator: Alice Hills. Mastered by Bob Ludwig at Gateway Mastering, Vacationland, U.S.A. Spaceman: Fender Thinline, Fender Jaguar, Epiphone Olympic, Vox Starstreamer XII, Martin Acoustic, banjo, Vox Continental, Farfisa Compact, piano, harmonica, vocals. Thighpaulsandra: Hammond C3, Vox Continental, Farfisa Compact, VK7, Kurzweil K2000, Minimoog, Fender Rhodes, piano. Doggen Foster: Gibson Les Paul Gold Top, Gibson Les Paul Custom, Fender Telecaster, Vox Bulldog, Martin Acoustic, harmonica. John Coxon: Fender Telecaster, Fender Jaguar, Gibson Firebird, Vox Continental, Farfisa Compact, piano, Juno 106, Martin Acoustic. Martin Schellard: Fender Jazz Bass, Fender Musicmaster, Fender Bass VI, Burns Bass, Fender Telecaster, banjo, piano. Tom Edwards: Vibraphone, marimba, timpani, tubular bells, percussion. Kevin Bales: Gretsch drum kit. Raymond Dickaty: Soprano and baritone saxophone. Pete Whyman: Saxophones, clarinet, Mimi Parker: Vocals. Chris Clark: Piano. David O'Carroll: Tuba. Ben Edwards – Trumpet. Nick Smart – Trumpet. James Adams – Trombone. Tamar Osborn – Saxophone, Clarinet. David Temple – Saxophone, Clarinet. First Violins: Edmund Coxon (Leader), Cathy Thompson, Jackie Shave, Everton Nelson, Patrick Kiernan, Steve Morris, Ian Humphries, Christina Emanuel, Laura Malnuish. Second Violins: Jonathan Rees, Dai Emanuel, Sonia Slaney, Perry Montague-Mason, Miffy Hirsch, Jeremy Morris, Ann Morfee. Viola: Roger Chase, Philip Dukes, Bruce White, Kate Musker. Cello: David Daniels, Tony Pleeth, Cathy Giles, Jonathan Tunnell. Double Bass: Mary Scully, Diane Clarke. Cor Anglais: Jane Marshall. Bassoon: Gavin McNaughton, Celia Birkenshaw. French Horn: Hugh Seenan, Richard Bissel, Nigel Black, Paul Gardham, Dave Lee, Martin Owen, Richard Ashton, Michaela Betts. Trumpet: Andy Crowley, Ian Balmain, Bob Farley, Paul Archibald, Paul Beniston. Trombone: Graham Lee, Colin Sheen, Peter Davies, Mike Hext, Roger Brenner. Bass Trombone: Dave Stewart, Roger Argente, Andy Waddicor. Flute/Alto flute and Bass flute: Dave Heath, Andy Findon. Contra-bass flute: Andy Findon. Oboe: Chris Cowie, Margaret Tindale. Clarinet: Anthony Pike, Richard Addison. Bass Clarinet: David Fuest. Harp: Helen Tunstall, Nigel Short – Counter tenor. Erner McPartland – Alto. Sarah Eyden – Soprano. Simon Grant – Bass. Andrew Busher – Tenor. Michael Dore – Bass. Heather Cairncross – Alto. Andrew Gray – Tenor. Jacqueline Barron – Soprano. Rachel Weston – Alto. Gerard O'Belrne – Tenor. London Community Gospel Choir: Wendi Rose, Wayne Hernandez, Jenny Graham, Donovan Keith Lawrence, Vernetta Meade, Jenny La Touche, Aaron Paul Sokell, Travis Jae Cole, Vimbai Shire, Samantha Smith, Irene Forrester, Carmen Smart, Michelle John-Douglas, Jasette Barratt, Choir Director: Daniel Thomas. ℗ 2001 the copyright in these sound recordings is owned by BMG Entertainment International UK and Ireland Limited. © 2001 BMG Entertainment International UK and Ireland Limited. All label copy and sleeve notes © 2001 BMG Entertainment International UK and Ireland Limited. All trademarks and logos are protected. Distributed by the local BMG company. A unit of BMG Entertainment. A Spaceman Recording. Made in the EU. LC03484. OPM001. 74321 878 532. Spaceman/Arista. www.spiritualized.com. Sleeve concept and design by Farrow Design/Spaceman. Sculpture: Yoko by Don Brown, courtesy of Sadie Coles HQ, London, © Don Brown. Management: Frank Gironda, Lookout Management. Special thanks to Richard Griffiths. Dedicated with all my love and life to Juliette. For Poppy.

0.3 printing ↖ ↑

The track listing is also embossed on the cardboard inner sleeve. In fact, the only printing on the packaging is the liner notes, though these are printed in silver and appear and disappear from the cream-coloured background as it is tilted in the light.

0.4 disk ↓ ↙

The final surprise is literally right at the heart of the product. When you remove the CD from the sleeve your first reaction is to turn it over to find the playing side. Let it Come Down has nothing printed on the non-playing side of the disk. This is a radical departure given that printing technology allows ever more complex CD artwork. Looking closely at the CD in addition to your own smudged fingerprints, all you will find is some type discreetly circling the centre hole. This is unprecedented and is reminiscent of artists inscribing oblique messages in the run-out groove of a vinyl record. It is a little unfortunate that this progression was used for something as bland as copyright information and catalogue number. Perhaps other artists will in future use this space as run-out grooves were used in the past.

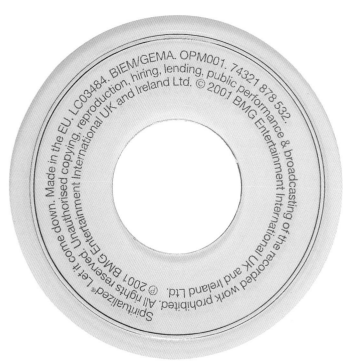

project 1.1 dyrup

In 2000, Denmark's leading paint and woodcare treatment company, S. Dyrup & Co, undertook a comprehensive design strategy review. Having built its business through acquisition, the portfolio of brands and their associated sub-divisions was disparate, with varying degrees of recognition and consumer understanding. The organisation had no clear brand values or message, no guidelines or approval process to ensure consistent and accurate communication. The intention was to rationalise existing brands, develop a clear and consistent image, and to implement the revised 'identity' on communications, shop interiors, point-of-sale, packaging and literature across all European markets.

Rodneyfitch, the international retail consultancy, was approached to develop a cohesive design solution including a visual language, photographic style and packaging. The perceived vision called for a new identity to 'enrich and inspire their customers' life through colour and style'. Addressing the master marque, Rodneyfitch removed the Danish crown, increasing international recognition, and was responsible for simplifying the name to Dyrup – changes that modernised the identity, aligning it closer to the brand proposition.

The creative solution defined a cohesive and consistent hierarchy that structured products in different market sectors. Furthermore, a singular determined look, feel, and philosophy for each product brand ensured a consistency across the whole group's activities, locally, nationally and globally. An homogeneous range of brands now operates simultaneously within a variety of market sectors. The photographic style was developed, bringing sophistication and aspirational qualities to the brand.

Throughout this book we have tried to critique the many facets of packaging: design innovation, consumer appeal, material usage, function... but what about effectiveness? Can packaging produce quantifiable and intended results?

How do we measure the effectiveness of a piece of packaging? Awards could be one benchmark of success, with several of the projects featured in this book having received various accolades. But is this more a reflection of design trends and less an indication of 'true' effectiveness? To be truly effective, packaging must fulfil the client's needs, be they economic, profile- or design-based; to be remarkable, one could argue that packaging must surpass these. A crucial part of Rodneyfitch's work for Dyrup was to quantify design changes and their effect on business, which was a major reason for the redesign. Post-launch research revealed a 30 per cent increase in sales figures, far exceeding the expectations of the retailer, with shop-in-shop business targets exceeding forecasts by 20 per cent. Research also showed that consumers' awareness of the revised branding had significantly increased, with the scheme's colour palette rating highly as a contributory factor to this overall success.

A packaging scheme that has increased sales (economic), raised consumer understanding (profile), while being visually progressive (design) – the axiom 'good design is good business', (attributed to Thomas Watson Jr., former IBM CEO), has never been more appropriate.

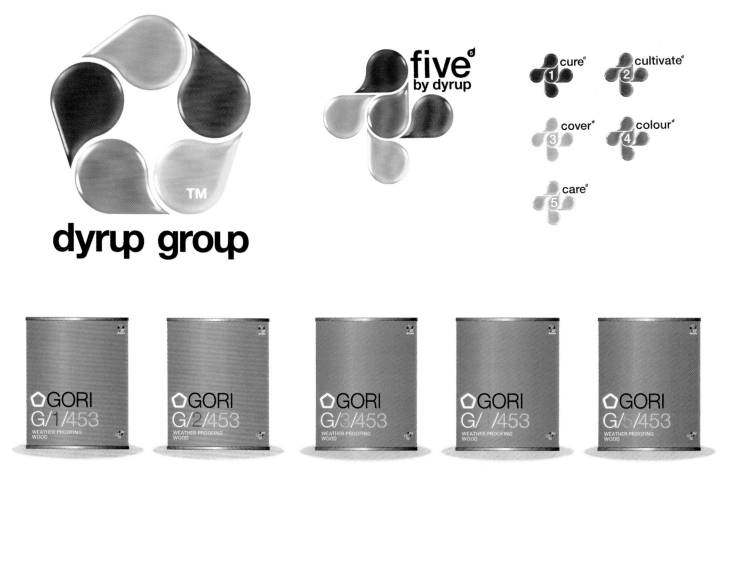

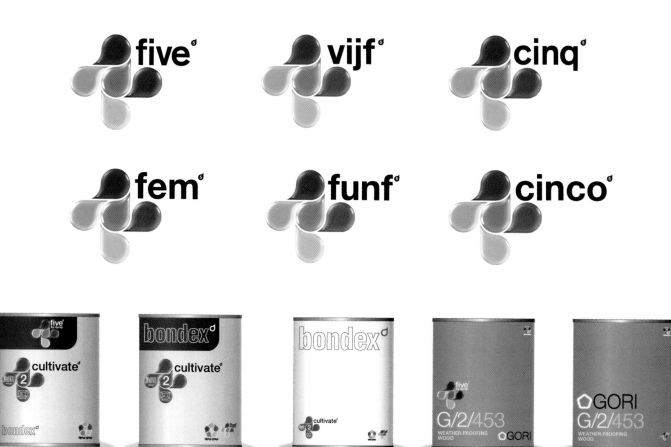

the holding company

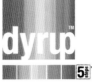

the holding company incorporating
the 5 step system

0.1 development

Early development sketches based on colour and unification, showing the thematic use of tones and shapes to convey colour, the nature of the business the marque is to represent.

0.2 identity types

Development of different types of packaging structures. A single master marque applied across an entire range of products (above) – often called a monolithic identity. Country-specific marques (trade names) linked by typographic and colour unity (below top) – a branded identity. And country-specific trade names, supported by a single master marque (below bottom) – an endorsed identity.

There are definite benefits to employing different identity structures. A monolithic identity is generally considered the easiest to implement. All manifestations receive identical visual treatment, for example a high street bank, where we would expect visual conformity.

The branded system, where operations appear unrelated to one another, or to a master company, is considered the hardest to control. This system is often used by consumer goods manufacturers who want to create unique product propositions for niche markets. It is generally used in areas where it would be incongruous for a manufacturer of one type of product to be endorsing another, ie. a chemicals producer endorsing a food product.

The endorsed system, where different products are linked through visual association, is generally employed by companies who have grown through acquisition. Nestlé would be an example of this system, where new products, in a crude sense, are bought and 'made' Nestlé through the endorsement their logo offers.

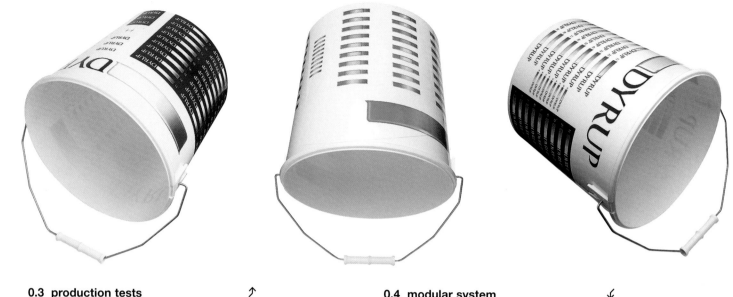

0.3 production tests ↑

Printing onto metal and plastic substrates involves variation in colour- and quality-control. The complex colour spectrum of the Dyrup master logo increases the difficulties of guaranteeing print production results. Shown above are production optimising tests where the same logo is printed using various techniques: duotone, one-, two- and four-colour, both positive and reversed out of solid backgrounds, to establish a print standard for all markets to adhere to.

0.4 modular system ↓

Key elements of typographic detailing – photographic style, colour usage, logo placement and safety information – have all been rationalised. Local agencies 'bolt' these units together, guaranteeing unified and consistent packaging style. Localised selection of imagery completes the synthesis and enables the branding to be targeted to specific market requirements.

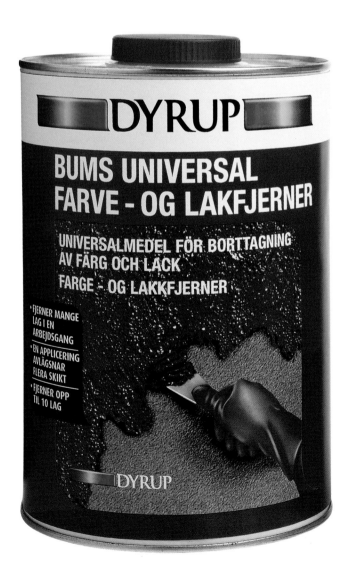

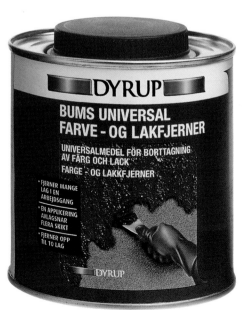

0.5 guidelines ↑ ↘

Detailed, easy-to-use guidelines assist localised manufacture, ensuring
a synchronous approach to design consistency. The integrity of the
master marque, with manifestations ranging from a single business
card to shop façade and interiors, is carefully controlled.

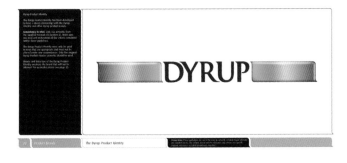

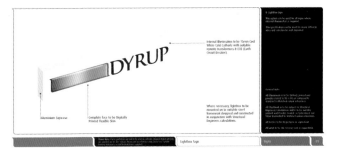

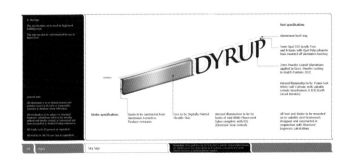

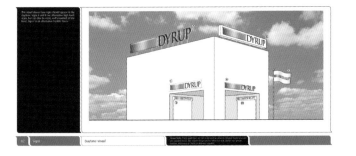

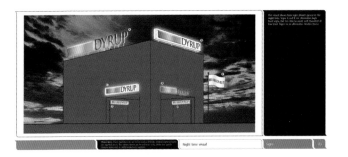

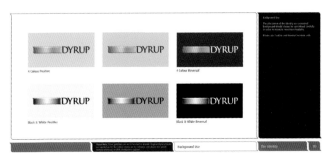

This End Up: Original Approaches to Packaging Design

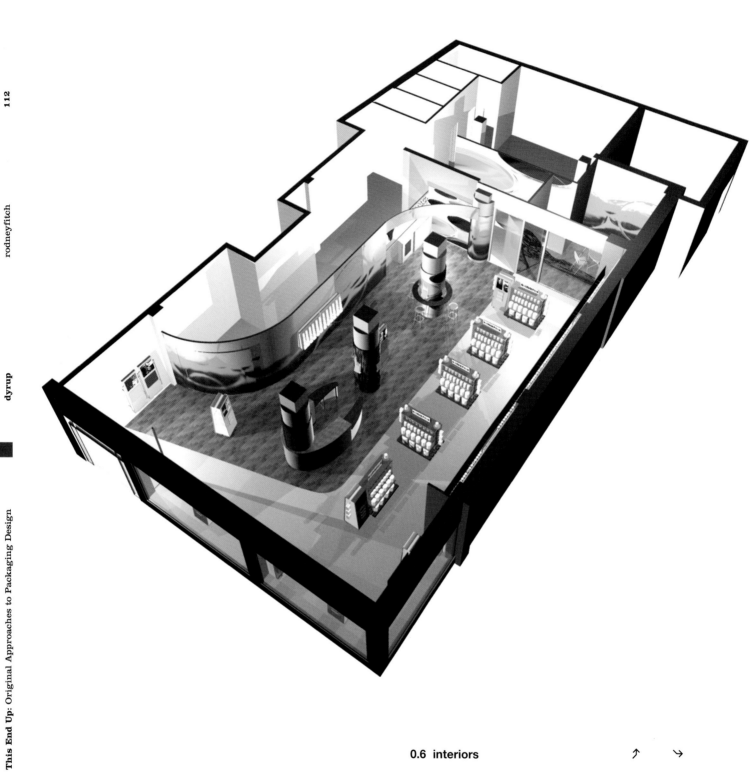

0.6 interiors ↑ ↘

Rodneyfitch's strong visual approach is integrated into the interior design, creating a seamless retail outlet. Display gondolas group product by type, with the environment being enhanced by aspirational photography, reinforcing the client's vision of 'enriching their customers' life through colour and style'.

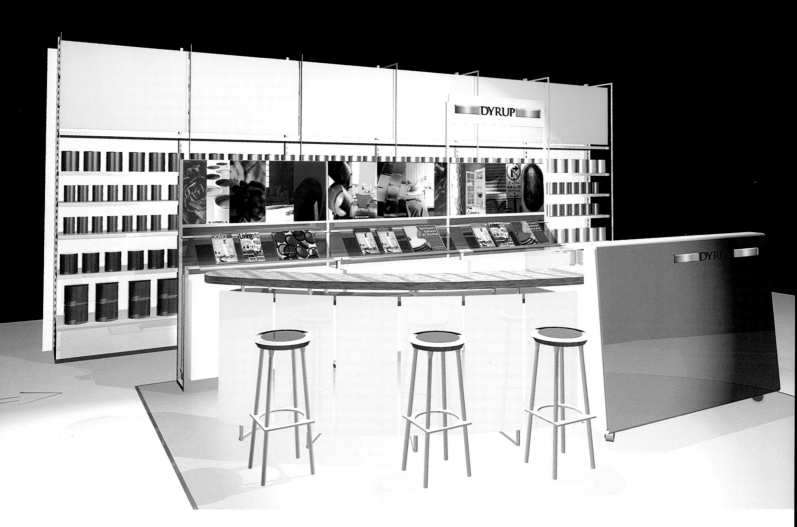

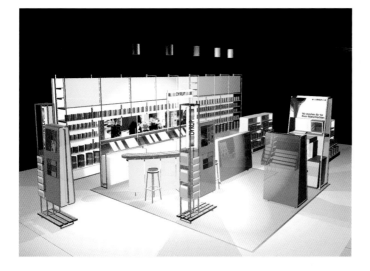

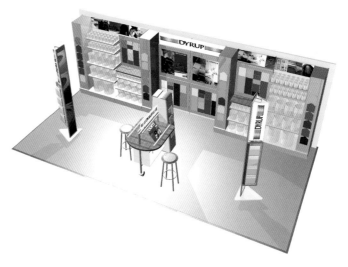

project 1.2 furious angels

A key function of music packaging is communication, the ability to attract the consumer and arouse interest through the visual presentation in the hope of generating a sale. Spiritualized (see pages 98–103), and here the singer/songwriter/composer Rob Dougan, attempted to achieve this through their CD designs without using the generic jewel case. But whereas Spiritualized sought to expand upon and evolve the CD case into something with a greater visual impact, the Blue Source (a contemporary London-based design agency renowned for work within the music industry) book concept for Dougan's album Furious Angels demonstrates a succinct approach to the use of packaging for a product with multi-function requirements.

Blue Source were commissioned to create a series of images to accompany the Furious Angels soundtrack. Their image production process was to result in a book (a limited-edition promotional sale item) and exhibition imagery, including a moving image sequence and accompanying catalogue.

Inspiration has clearly been drawn from gatefold LP record sleeves; the resulting A4 package contains a CD, a mini-book of images and lyrics, and a catalogue. Think of The Who's LP album Quadrophenia, for example. If we view Furious Angels from this perspective, the product is quite delightful, offering evocative imagery to gaze at while listening to the music.

The way in which it was produced and the stock used for the cover are both similar to an LP, being folded and glued like a gatefold format. This method also provided an ideal mechanism to secure the central 34-page booklet to the outer 'sleeve'.

The 34-page booklet is standard album fare of song lyrics and striking visual imagery that centres on the artist's face. There are various portrait photographs and a ceramic bust of the artist that is captured as it explodes, to great effect. This booklet is sewn together, a stronger method than the simple stitching that is common for CD booklets (and LP booklets of the past), which reinforces the high production values.

Blue Source has created a visually distinctive piece of packaging that stands out from the myriad of CDs available in-store. It also provides some satisfaction for consumers nostalgic for the vanquished visual treat of LP records. The clean, confident use of typography, combined with the visually arresting simplicity of the imagery, creates strong visual appeal. The considered design and high production levels of the package make for a product that looks wonderful upon purchase and will undoubtedly become a treasured addition to many a CD collection.

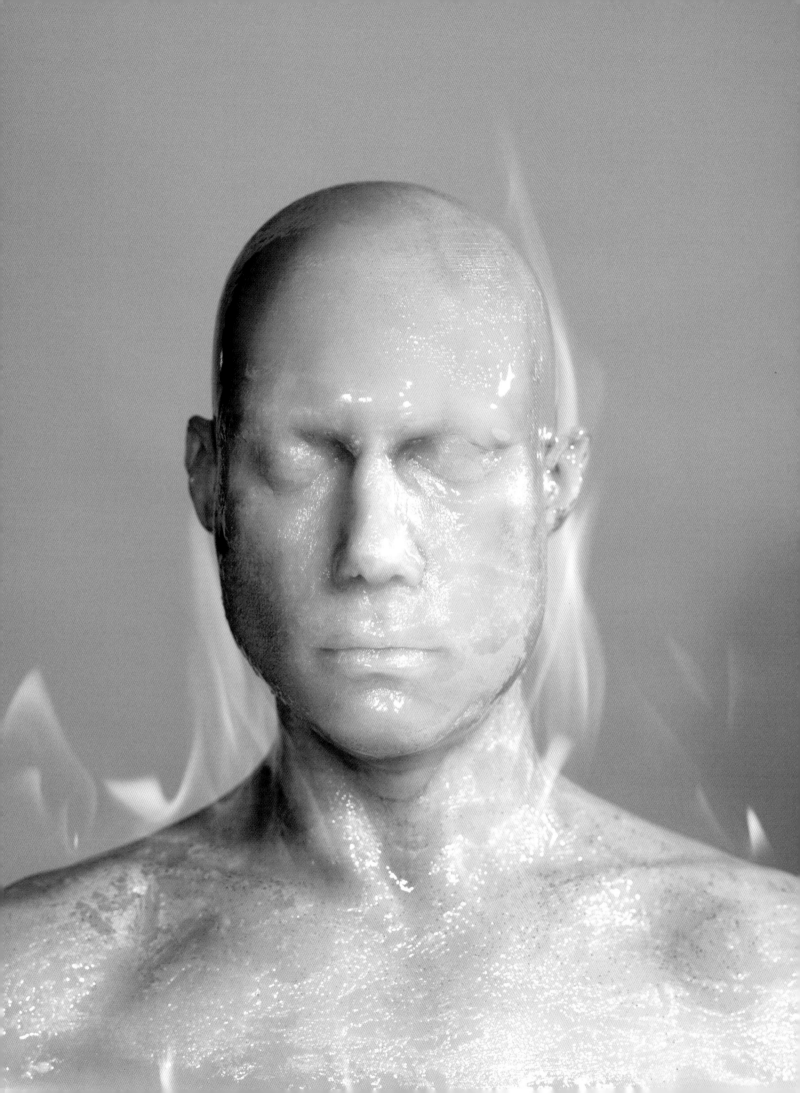

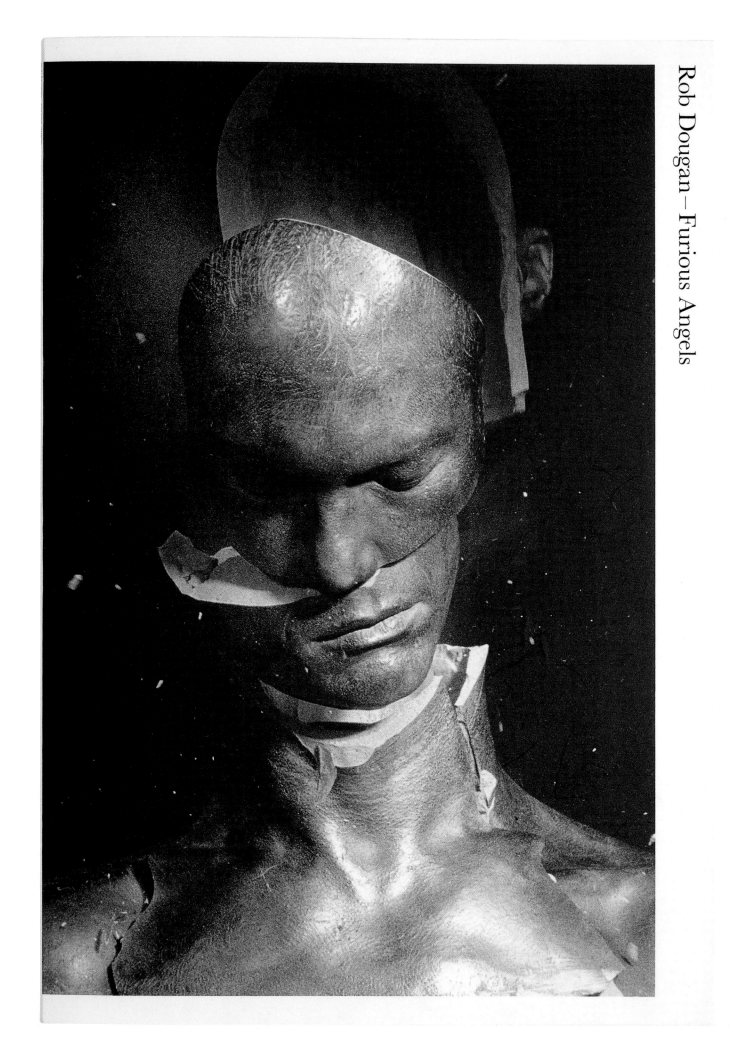

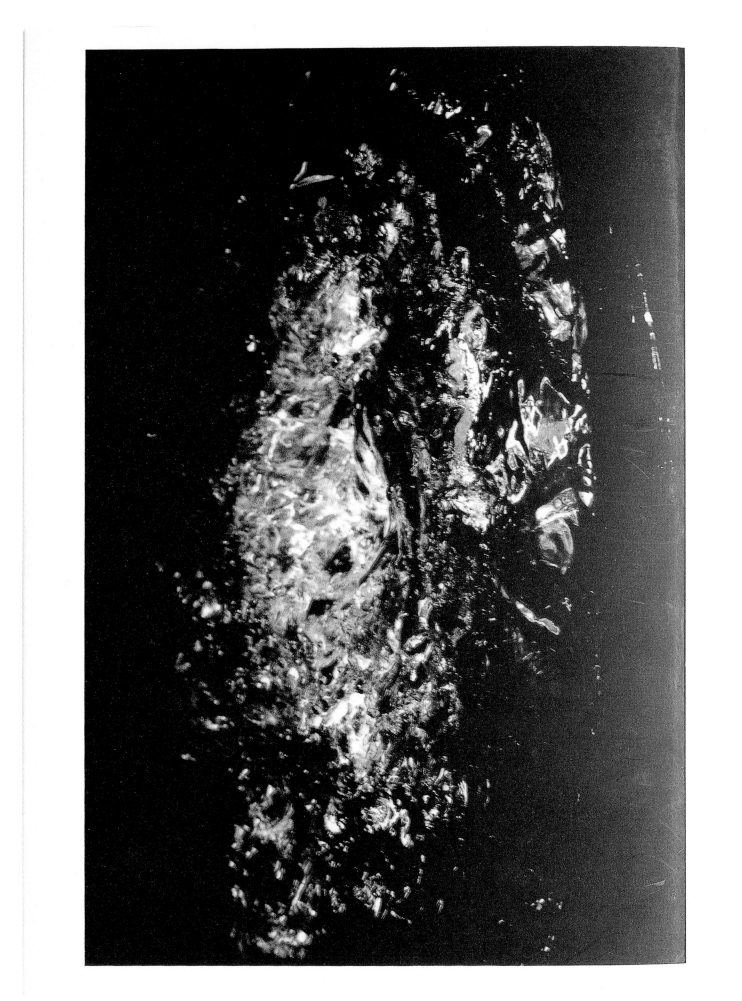

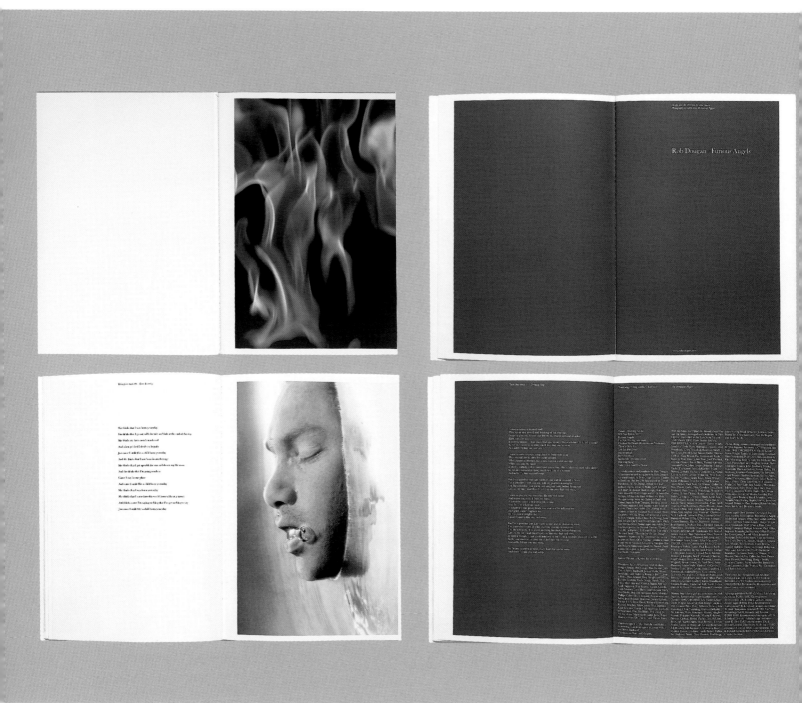

0.1 spreads ↑ ↘

The spreads on these and the preceding pages show the bold images that adorn the pages of the accompanying booklet to Dougan's album. The artistic photography derived from the moving image exhibition sequence; an integral part of the art direction and image production process is juxtaposed with song lyrics. The opening spread is pictured above top left. At the centrefold of this one can see where the cover has been folded and glued.

At the centrefold of the title page (above top right) the sewn binding can clearly be seen. The sublime, stop-motion imagery of yellow flames against a black background (above top left) and the face of Rob Dougan 'appearing' through water (above bottom left) contrast with the typographic purity of the lyric sheets (above bottom right). The CD is positioned onto the foam nodule at the centre of the inside back cover (opposite below), and the inside back cover passes over the last page of the central section and holds it in place.

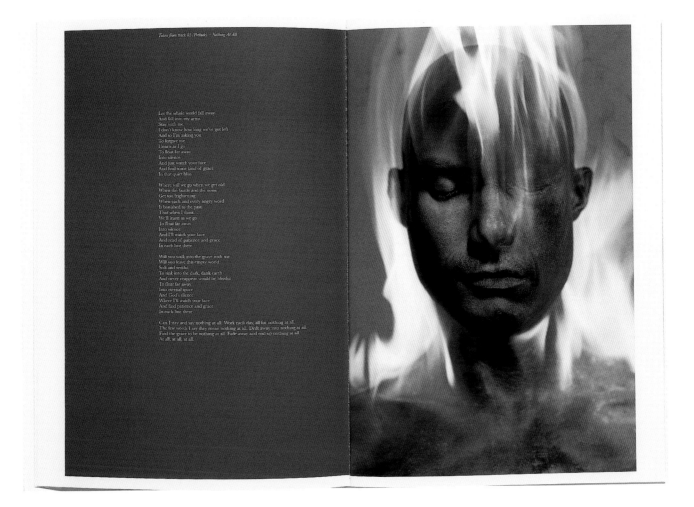

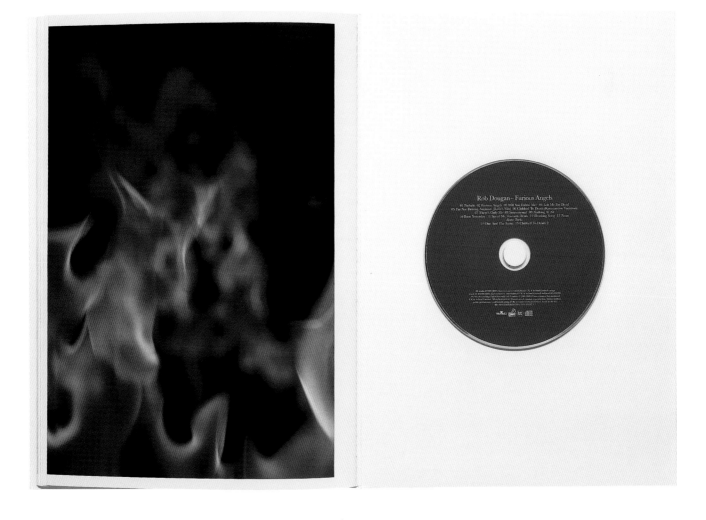

project 1.3 durex

Condom, preservativo, sheath, prophylactic, whatever your term for it, the latex contraceptive, like many packaging items, is used for its protective properties. The packaging for a condom typically involves a coated foil inner that contains the product, and a cardboard outer pack. Long gone are the days when a sheep intestine or tortoise shell was used as a sheath, and market segmentation and product development have produced an array of different condom products. These need to be clearly and easily identified given that they are used to facilitate and enhance pleasure while minimising the risk of pregnancy or disease.

Challenges for packaging designers to resolve can involve any element of the package, or the absence of packaging (see pages 58–67). All the case studies in this book are of packaging that enables the product to stand out visually from its competitors' careful design manipulation. In the following case study from Durex, the problem at first appears to be one of branding. However, one of the main aspects of the brief was improve the packaging and reduce the cost of production, not how to better transport or contain the product.

SSL International, the world's leading condom manufacturer, owns the only global condom brand, Durex. The company wanted to migrate its local sub-brands to the Durex master brand to consolidate global identity and cut costs by rationalising packaging, advertising and other costs into a single global communication.

The brief for Landor was to find a differentiated brand proposition that would help Durex stand out from its competitors while ensuring it was relevant to consumers in all cultures. The brand proposition had to work across all media and elements of the marketing mix, and transfer strong local brands to the Durex name without losing sales. In addition, the design had to segment the product portfolio while catering for multi-lingual communication, and work on a wide variety of pack formats in different retail outlets such as grocery, vending and pharmacy stores.

0.1 identity ↗

As part of the roll-out of the Durex brand to its worldwide markets, SSL International took the opportunity to update the Durex logo, giving it a visual make-over suitable for the diverse cultural markets within which it would be used. Due to the brand's strong heritage and prominence (among certain markets) the overall identity is consolidated rather than redesigned. Several variants of the Durex logo are explored, with the final resolve appearing consistently on all packets.

0.2 durex medium ↙

The specially cut and aptly named Durex Medium typeface used for the labelling was created to unify the overall brand identity. It is used on all internal leaflets, additional legal packaging information and serves as a product identifier. Several variations of type, colour and image were tested out before the final combinations were arrived at, as can be seen on the final product shots below and on the following pages.

0.3 colour coding ↘

The wide range of sub-brands available is differentiated by colour schemes, making them quick and easy to identify. A unique colour was chosen for each, that would be central to the packaging of that sub-brand. Product types are now globally recognised through their colour application, except for anomalies for exceptional markets, such as the US and Italy.

Durex Medium

ABCDEFGHIJKLM NOPQRSTUVWX YZ abcdefghijklmn opqrstuvwxyz

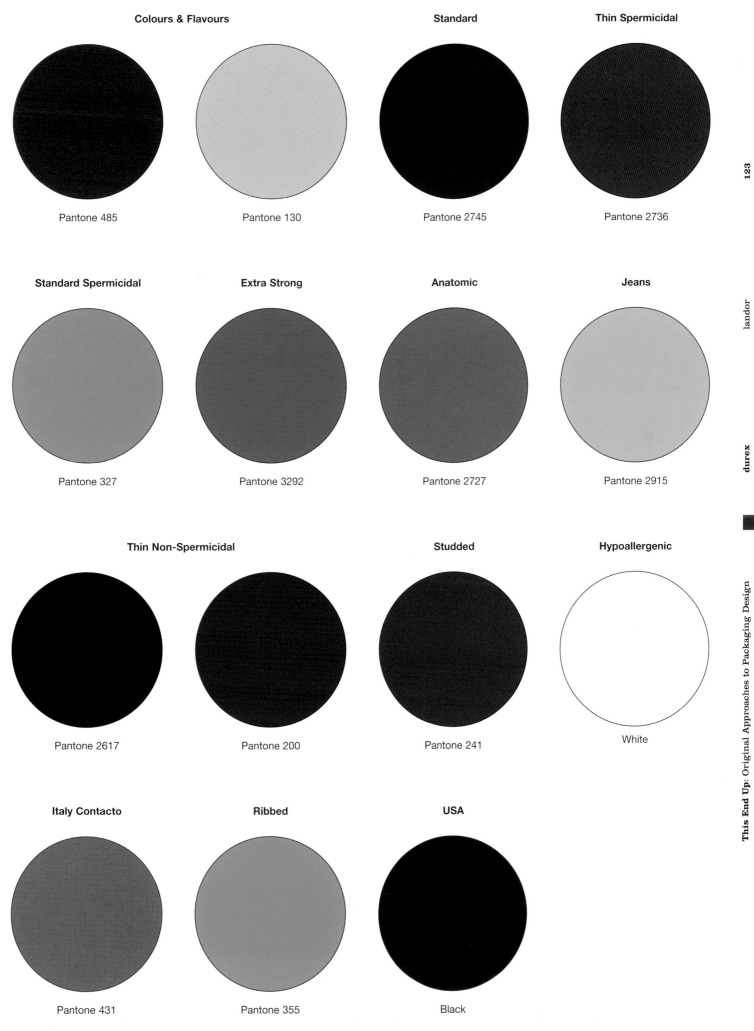

Colours & Flavours

Pantone 485

Pantone 130

Standard

Pantone 2745

Thin Spermicidal

Pantone 2736

Standard Spermicidal

Pantone 327

Extra Strong

Pantone 3292

Anatomic

Pantone 2727

Jeans

Pantone 2915

Thin Non-Spermicidal

Pantone 2617

Pantone 200

Studded

Pantone 241

Hypoallergenic

White

Italy Contacto

Pantone 431

Ribbed

Pantone 355

USA

Black

landor

durex

This End Up: Original Approaches to Packaging Design

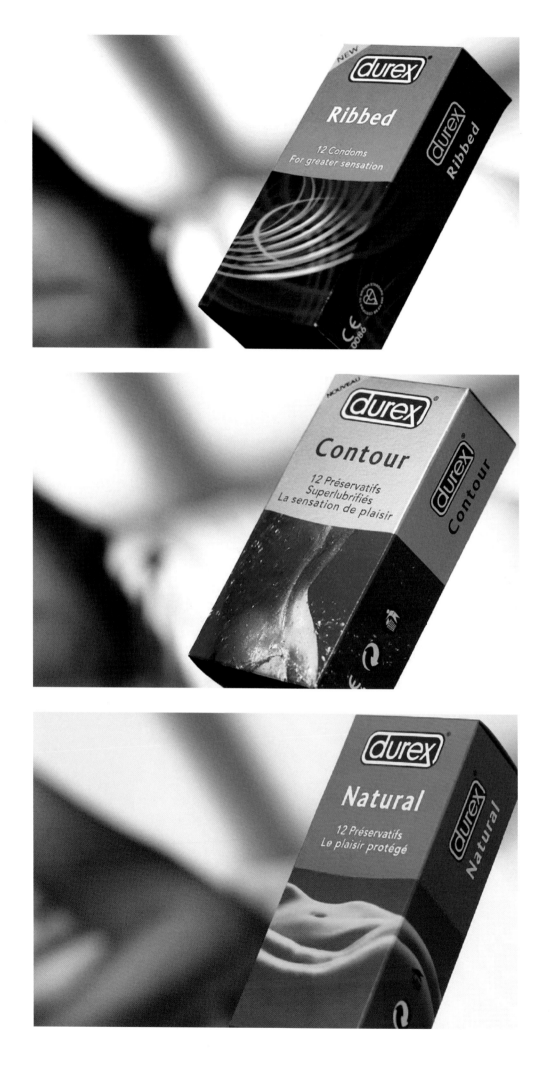

0.4 master marque ↗

The final master marque is a prominent feature on the redesigned global packaging. As a universal identity the marque is both recognisable (without being language-specific), and descriptive (visually representing the appearance of the packaged item).

0.5 inner packaging ↙

The individual prophylactic packaging uses the colour-coding system to create distinctive branded packaging that also serves as a product identifier. The result, through use of sympathetic, complementary colours, is both identifiable (branded) and approachable (unintimidating to the user). Furthermore, it adds a sense of fun to the business of stopping pregnancy or the spread of sexually transmitted diseases, which is surely the primary intent behind the demand for the product.

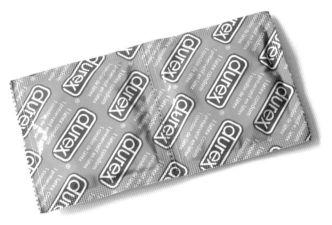

project 1.4 plan b

Design inspiration comes from many sources. Designers beg, borrow and steal from nature, popular culture and other products. This can result in inspired interpretations that appear in unexpected places. The L'Atelier In-Seize agency of Montreal provided a novel adaptation of packaging used by another industry for the Plan B CD album by Okoumé. The agency created a parody of the flat-pack furniture concept that has been popularised by retail chains such as Ikea.

The packaging comprises several elements. The consumer is faced with a brown card box in the record store, a little wider and about twice as deep as the standard jewel case. These dimensions do not cause compatibility problems with record store display gondolas. Like flat-pack furniture, this is secondary packaging that protects the contents during shipment from the store to the home. It even has a 'This end up' arrow, while also indicating access to the CD via the annotation MACD 5838 (the product's catalogue number). There are no graphics as such, but information is provided in the shape of a sticker that holds the name of the band and album, a track listing printed in black on the reverse side, and a list of what the package contains. At first, listing everything contained within the package seems slightly pedantic, but upon opening the package the list is revealed to be a manifest of parts rather than a mere list of contents.

The consumer is surprised on opening the package by the various elements of the CD, which all come separately. The box contains a transparent jewel case in a cellophane wrapper, a transparent CD tray, an audio CD in an anti-static bag, a 16-page do-it-yourself booklet, a back cover sheet, 13 songs, and a set of self-adhesive stickers with an instruction booklet to be used to assemble the cover booklet. The booklet contains spaces for these stickers in much the same way that Panini football sticker albums contain shaded squares upon which to place stickers of footballers. After assembly, the secondary packaging has served its purpose and can be discarded.

The parts are the standard type one would expect to find in a jewel CD case, with the exception of the stickers for the homemade booklet. These are on the reverse side of the plan that instructs the consumer in product assembly, in a parody of what we would expect for a self-assembly piece of furniture. The artwork reflects the do-it-yourself theme as it presents empty rooms of a building that are being decorated. The stickers are of the five band members posing with an assortment of home-improvement tools. The consumer places the band members in the 'house' represented in the booklet in the rooms in which they will work. This packaging begs the question: 'Who would actually bother to self-assemble a CD package?' It may be a little ridiculous, but it adds to the interactivity of the product and pushes the boundaries of CD packaging even further.

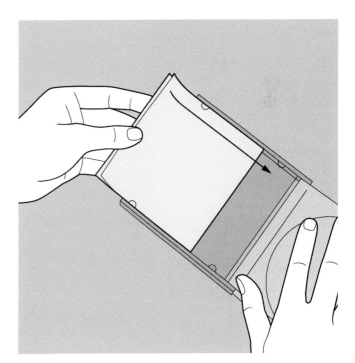

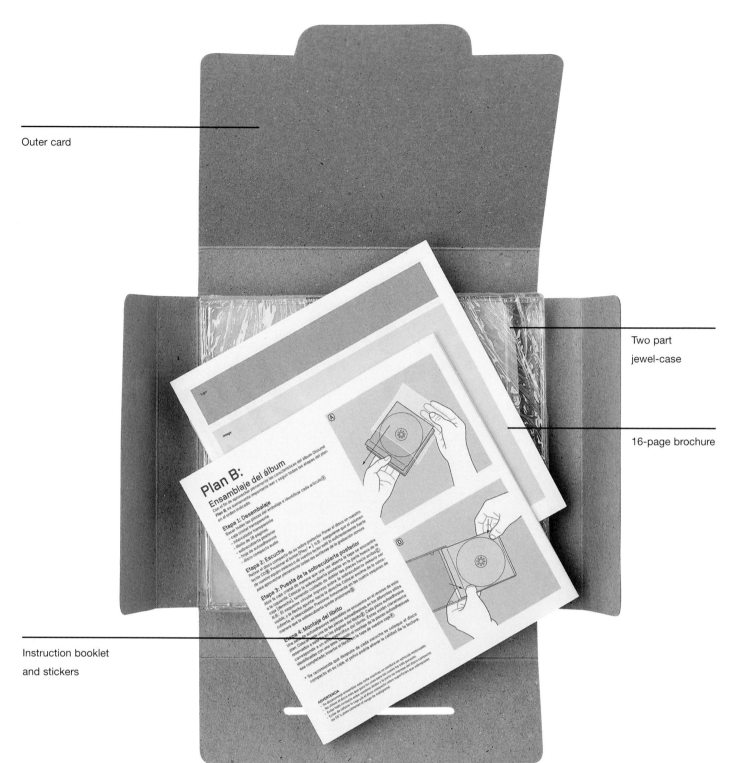

Outer card

Two part
jewel-case

16-page brochure

Instruction booklet
and stickers

0.1 kit of parts (stage 1) ↑

Inside the brown box are all the components necessary to 'build' your
own CD. Firstly, remove the two parts of the jewel case from their
cellophane wrapper, insert the inlay card and snap together. The
brochure included has a designated space for the 'logo' and an 'image',
which will form the front cover. These need to be removed from the
enclosed 'sticker' pack and positioned in their correct places, or,
alternatively, positioned wherever you choose.

To complete your CD please refer to **0.3** (see page 130).

0.2 template ↗

The cutting and print guide that formed the brown card outer
packaging. The typography is intentionally utilitarian, and the
considered application of transportation care logos completes a
convincing pastiche of flat-pack furniture packaging.

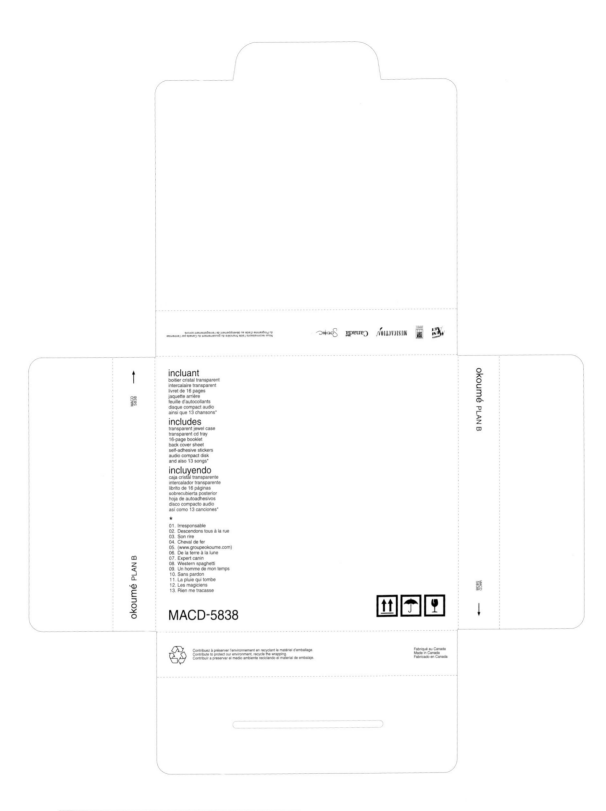

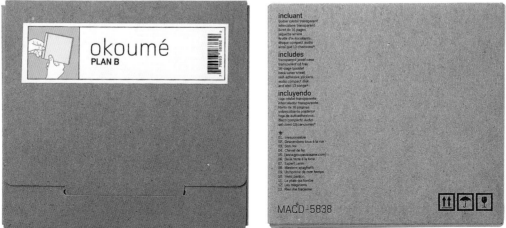

l'atelier in-seize

plan b

This End Up: Original Approaches to Packaging Design

Plan B:

Ensamblaje del álbum

Con el fin de aprovechar plenamente las características del álbum *Okoumé Plan B*, es sumamente importante leer y seguir todas las etapas del plan en el orden indicado.

Etapa 1: Desembalaje

Sacar todas las piezas del embalaje e identificar cada artículo (A).
- caja cristal transparente
- intercalador transparente
- librito de 16 páginas
- sobrecubierta posterior
- hoja de autoadhesivos
- disco compacto audio

Etapa 2: Escucha

Retirar el disco compacto de su sobre protector. Poner el disco en vuestro lector CD (B). Presionar el botón (Play/ ▶). *N.B. : Asegurarse que el volumen de vuestro equipo estéreo o de vuestro lector esté lo suficientemente fuerte para aprovechar plenamente todas las sutilezas de la grabación sonora.*

Etapa 3: Puesta de la sobrecubierta posterior

Abrir la caja cristal de manera que una vez abierta la tapa se encuentre a la izquierda. Colocar la sobrecubierta posterior en la parte hueca de la caja (derecha), teniendo cuidado de doblar las placas hacia arriba (C). *N.B.: El esquema circular impreso sobre la sobrecubierta debería ser visible, y la flecha apuntar hacia la derecha.* Colocar encima de la sobrecubierta, el intercalador. Presionar firmemente en las cuatro esquinas de manera que la sobrecubierta quede prisionera (D).

Etapa 4: Montaje del librito

Una serie de autoadhesivos separables se encuentra en el reverso de este plan. Colocar cada una de las piezas autoadhesivas, en los diferentes sitios reservados a este fin en las páginas del librito (E). Cada pieza autoadhesiva corresponde a un sitio específico del librito. Éstas están claramente identificadas con una letra. Cuando el montaje de las piezas autoadhesivas sea completada; insertar el librito en la tapa de vuestra caja (F).

* Se recomienda que después de cada escucha se coloque el disco compacto en su caja, el polvo podría alterar la calidad de la lectura.

ADVERTENCIA
- Se desaconseja ensamblar este cofre mientras se conduce un vehículo motorizado.
- No utilizar el disco más que para los usos para los cuales ha sido previsto.
- Evitar todo contacto entre vuestros dedos y la parte no impresa del disco compacto.
- Evitar de colocar la caja y/o el disco compacto sobre superficies que sobrepasen los 55°c, pues correrían el riesgo de malograrse.

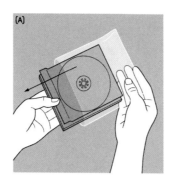

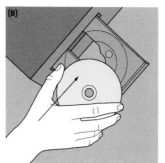

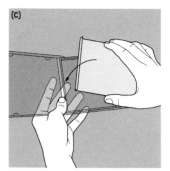

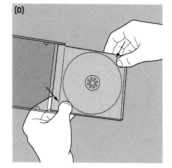

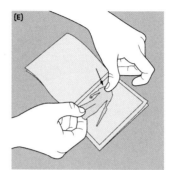

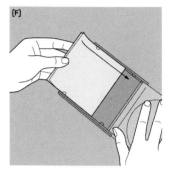

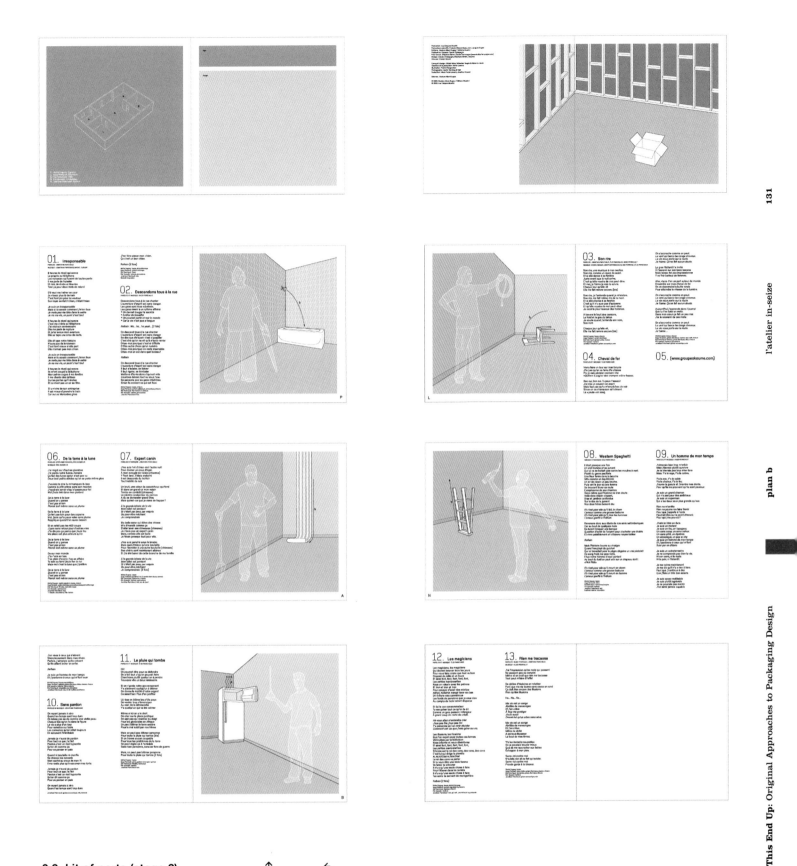

0.3 kit of parts (stage 2) ↗ ↖

The inside pages of the booklet can now be completed by applying stickers of the band members to the relevant pages. Ghost images are conveniently printed as guides to avoid unnecessary mistakes. Insert the booklet into the front of the jewel case and the CD is complete.

The completed CD (opposite below). Please refer to this in case of problems.

This End Up: Original Approaches to Packaging Design

Plan B:

Assemblage de l'album

Afin de profiter pleinement des caractéristiques de l'album d'Okoumé *Plan B*, Il est extrêmement important de lire et de suivre toutes les étapes du plan dans l'ordre.

Étape 1: Déballage
Sortez toutes les pièces de l'emballage et identifiez chaque article (A).
- boîtier cristal transparent
- intercalaire transparent
- livret de 16 pages
- jaquette arrière
- feuille d'autocollants
- disque compact audio

Étape 2: Écoute
Retirez le disque compact audio de son enveloppe protectrice. Placez le disque dans votre lecteur numérique (B). Appuyez sur la touche jouer (Play/ ►). *N.B.: Afin d'apprécier à leur juste valeur toutes les subtilités de l'enregistrement sonore, assurez-vous que le volume de votre chaîne stéréo soit suffisamment élevé.*

Étape 3: Mise en place de la jaquette arrière
Ouvrez le boîtier cristal de façon à ce que le couvercle soit à votre gauche. Repliez avec soin les tranches de la jaquette arrière vers le haut. Insérez la jaquette arrière dans la partie creuse du boîtier, à droite (C). *N.B.: Le schéma circulaire imprimé sur la jaquette arrière devrait être visible et la flèche devrait pointer vers la droite. Installez l'intercalaire par-dessus la jaquette arrière. Appuyez fermement aux quatre coins pour emprisonner la jaquette arrière (D).*

Étape 4: Montage du livret
La série d'autocollants détachables se trouve à l'endos du plan. Chaque autocollant est identifié par une lettre et correspond à un espace précis dans le livret. Apposez les autocollants dans les espaces prévus (E). Une fois le montage terminé, insérez le livret dans le couvercle du boîtier cristal (F).

* Après chaque écoute, rangez le disque compact dans son boîtier pour éviter que la poussière altère la qualité de lecture.

MISE EN GARDE
- Il est déconseillé d'assembler le coffret en conduisant un véhicule motorisé.
- N'utilisez le disque que pour l'usage pour lequel il a été conçu.
- Évitez de toucher avec vos doigts la partie non-imprimée du disque.
- Évitez d'exposer le boîtier cristal ou le disque compact à des températures supérieures à 55°c, la chaleur pourrait les endommager.

Plan B:

Assembling the a

In order to fully appreciate the chara album, it is important to follow the as

Step 1: Unpacking
Remove all items from package and i
- transparent jewel case
- transparent cd tray
- 16-page booklet
- back cover sheet
- self-adhesive stickers
- audio compact disk

Step 2: Listening
Remove the compact disk from its p compact disk in your cd player (B). Pres *make the most of the recording sub volume high enough.*

Step 3: Installling back cov
Open the jewel case so the cover is back cover edges toward the top. Ins hollow part of the jewel case, on the *pattern printed on the back cover sh should point to the right.* Place the cd Press firmly on the four corners to loc

Step 4: Assembling the 16-
A series of self-adhesive stickers can b Each sticker is lettered and correspon booklet. Install each sticker in its respe insert the booklet inside the jewel case

* After each listening, put away the co prevent dust from damaging the sou

WARNING
- Assembling the jewel case while driving is not
- Use the compact disk solely for the purpose it
- Do not touch the unprinted portion of the com
- Do not place the jewel case or compact disk o beyond 55°c, the heat could damage them.

Plan B:

Ensamblaje del álbum

Con el fin de aprovechar plenamente las características del álbum *Okoumé Plan B*, es sumamente importante leer y seguir todas las etapas del plan en el orden indicado.

Etapa 1: Desembalaje

Sacar todas las piezas del embalaje e identificar cada artículo Ⓐ.
- caja cristal transparente
- intercalador transparente
- librito de 16 páginas
- sobrecubierta posterior
- hoja de autoadhesivos
- disco compacto audio

Etapa 2: Escucha

Retirar el disco compacto de su sobre protector. Poner el disco en vuestro lector CD Ⓑ. Presionar el botón (Play/ ►). *N.B.: Asegurarse que el volumen de vuestro equipo estéreo o de vuestro lector esté lo suficientemente fuerte para aprovechar plenamente todas las sutilezas de la grabación sonora.*

Etapa 3: Puesta de la sobrecubierta posterior

Abrir la caja cristal de manera que una vez abierta la tapa se encuentre a la izquierda. Colocar la sobrecubierta posterior en la parte hueca de la caja (derecha), teniendo cuidado de doblar las placas hacia arriba Ⓒ. *N.B.: El esquema circular impreso sobre la sobrecubierta debería ser visible, y la flecha apuntar hacia la derecha.* Colocar encima de la sobrecubierta, el intercalador. Presionar firmemente en las cuatro esquinas de manera que la sobrecubierta quede prisionera Ⓓ.

Etapa 4: Montaje del librito

Una serie de autoadhesivos separables se encuentra en el reverso de este plan. Colocar cada una de las piezas autoadhesivas, en los diferentes sitios reservados a este fin en las páginas del librito Ⓔ. Cada pieza autoadhesiva corresponde a un sitio específico del librito. Éstas están claramente identificadas con una letra. Cuando el montaje de las piezas autoadhesivas sea completada; insertar el librito en la tapa de vuestra caja Ⓕ.

* Se recomienda que después de cada escucha se coloque el disco compacto en su caja, el polvo podría alterar la calidad de la lectura.

ADVERTENCIA
- Se desaconseja ensamblar este cofre mientras se conduce un vehículo motorizado.
- No utilizar el disco más que para los usos para los cuales ha sido previsto.
- Evitar todo contacto entre vuestros dedos y la parte no impresa del disco compacto.
- Evitar de colocar la caja y/o el disco compacto sobre superficies que sobrepasan los 55°c, pues correrían el riesgo de malograrse.

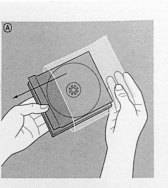

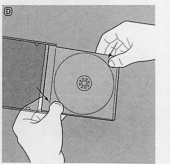

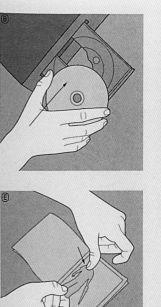

project 1.5 nascent

Until recently, the fact that a product was manufactured from organic raw materials constituted a key selling point that was reflected in the packaging design. Now, the manufacturers of green ink are worried; what was once a characteristic that differentiated a product has been reduced to a market qualifier, as the use of organic materials has become more widespread. For the new generation of consumers, rather than viewing organic products as something special, something extra, they are now slowly becoming part of the mainstream, and consequently, that the product is organic does not have to be explained in the packaging. For the packaging designer this has resulted in a move away from the use of 'organic' as a theme around which to base a design. It may be more beneficial not to focus a consumer's attention on the fact that a product is made with organic materials at all, but to have it compete with established brands on its excellence as a product rather than its organic credentials.

That was the rationale of the Danish agency e-Types when it was commissioned to design the packaging for Nascent, a range of 100% organic skin care products manufactured in Denmark. E-Types decided to create packaging that would make the range look like cosmetics first and foremost. Christian Madsbjerg of e-Types said that as the product would have to compete against large, international competitors it was crucial to create a design that could be integrated into the existing visual world of cosmetics. This is something of a departure from the other examples of cosmetics contained within this book, which have striven to be very different. But, as Madsbjerg says, "a radical break with the defining characteristics of the packaging of skin-care products would not be beneficial for the product's chances in a highly competitive marketplace." The agency was attempting to design packaging that would draw consumers away from other brands.

The packaging design that resulted was more 'classic' than 'organic'. It used a circle as the key visual image that, apart from gaining attention, represented what the agency describes as the "cyclical connection many people associate with recycling and ecology". The use of a circular image against a clean white background is a good attention-grabber, as also seen in the Dragonfly Tea chapter (see pages 38–43). Supporting information is prevented from intruding on the white space where possible in order to maximise its effectiveness, though it is here that the product's organic credentials are hidden. In addition to anchoring the visual identity of the range, the circle also signifies the functionality of certain products in the range. On the box of tissues, the circle is positioned on the top and has a removable centre through which the consumer can pluck the tissues. In the same vein, a test product dispenser has the circle with a removable centre on the front of the box through which consumers can take samples of face moisturising lotion. The gift wrap is a slight departure, as it has circles in a light shade running riot over the substrate, but with a solitary dark circle and the Nascent brand name at the centre to continue the dialogue with the consumer and maintain the spirit of the prominent circle.

NASCENT™
Organic Vitality

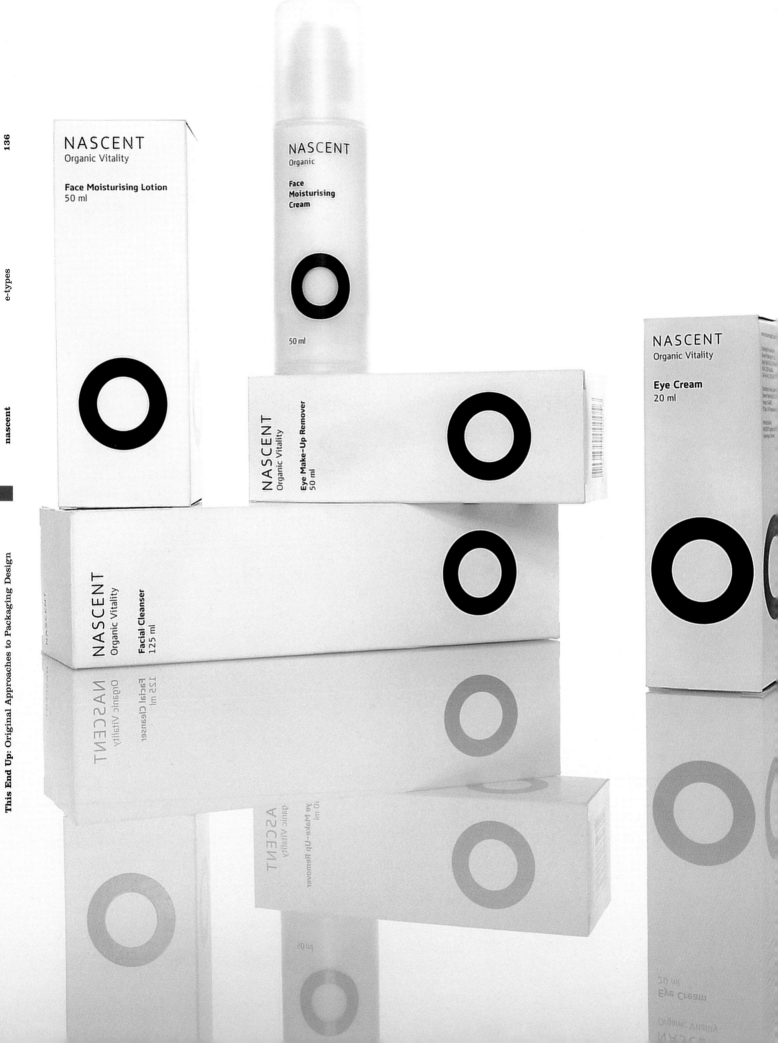

NASCENT
Organic Vitality

Face Moisturising Lotion
50 ml

NASCENT
Organic

Face
Moisturising
Cream

50 ml

NASCENT
Organic Vitality

Eye Make-Up Remover
50 ml

NASCENT
Organic Vitality

Facial Cleanser
125 ml

NASCENT
Organic Vitality

Eye Cream
20 ml

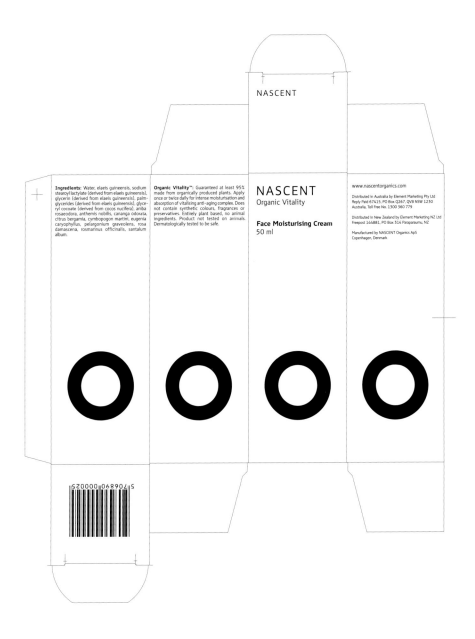

Ingredients: Water, elaeis guineensis, sodium stearoyl lactylate (derived from elaeis guineensis), glycerin (derived from elaeis guineensis), palmglycerides (derived from elaeis guineensis), glyceryl cocoate (derived from cocos nucifera), aniba rosaeodora, anthemis nobilis, cananga odorata, citrus bergamia, cymbopogon martini, eugenia caryophyllus, pelargonium graveolens, rosa damascena, rosmarinus officinalis, santalum album.

Organic Vitality™: Guaranteed at least 95% made from organically produced plants. Apply once or twice daily for intense moisturisation and absorption of vitalising anti-aging complex. Does not contain synthetic colours, fragrances or preservatives. Entirely plant based, no animal ingredients. Product not tested on animals. Dermatologically tested to be safe.

NASCENT
Organic Vitality

Face Moisturising Cream
50 ml

www.nascentorganics.com

Distributed in Australia by Element Marketing Pty Ltd
Reply Paid 67415, PO Box Q267, QVB NSW 1230
Australia, Toll Free No. 1300 360 779

Distributed in New Zealand by Element Marketing NZ Ltd
Freepost 144881, PO Box 314 Paraparaumu, NZ

Manufactured by NASCENT Organics ApS
Copenhagen, Denmark

0.1 packaging

The final packaging is strikingly simple and effective, to the extent that the designs feature heavily in the product catalogue shown below. Traditional images of models are forsaken in favour of illustration. The 'o' device is key to the longevity of the product and allows for a degree of playful humour (the 'o' forming a washing-machine door or having tissues pulled through it), something usually lacking in the image-conscious world of cosmetics.

0.2 net

The printed flat sheet, or net, that when folded and glued together forms the structure of the package for one of the final products in the cosmetic range.

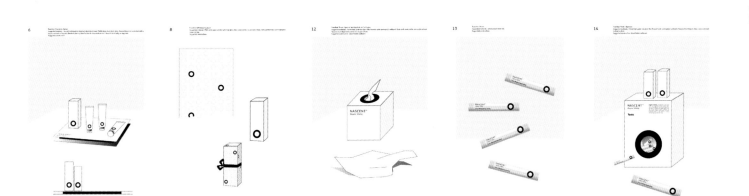

project 1.6 t-26

All products have packaging of one sort or another. The majority of the projects included in this book are about products that one would find in a retail environment. The packaging solutions created for these are largely dictated by the physical properties of the product to be contained and the retail environment in which they are offered for sale. But what of a product that does not have physical properties per se? Suppliers of computer software are renowned for using packaging that exponentially inflates the physical presence of the product contained to proportions that bear little resemblance to its actual dimensions. Unlike a music CD, which generally has the size of its packaging determined by in-store display constraints, software does not. Software is boxed up to the size of a breakfast cereal packet to make it more noticeable. As computer software is a relatively high-value item, retailers that provide the shelf space accept this enlargement.

The Segura Inc. design firm, in addition to providing design services, creates and packages branded typefaces for sale under the T-26 Digital Type Foundry brand. Other than the CD upon which the typefaces are digitally stored, there is no physical manifestation to the product. Typography is essentially packaged and sold like computer software.

Before it can be used it has to be installed onto a computer in the same way that software does. With outsized packaging typical for typography/software products, this provides the opportunity to be more creative with the packaging solutions in general. Segura Inc. took advantage of this to create packaging for its T-26 typeface brand that creates a strong visual impression matching that of the product, while surrounding it with an air of fun, a characteristic of the typefaces produced by the company.

The packaging for T-26 contains a CD with the typeface files that are to be installed on the purchaser's computer system, a book that shows examples of the typography contained on the CD, and one of a range of T-shirts that depicts an example of the typography/T-26 brand. As well as being attractive, the T-shirt serves as an example of how the typeface can be used. All these elements are contained in a transparent ziplock bag labelled 'T-26' in one of the company's typefaces.

T26 **TOTALLY TWENTY SIX**
SOME MATERIAL MAY NOT BE SUITABLE FOR CHILDREN.

T26 DIGITAL TYPE FOUNDRY
1110 NORTH MILWAUKEE AVENUE, FIRST FLOOR, CHICAGO, ILLINOIS 60622-4017 USA 1 800 700 TONT (US TOLL FREE)
TELEPHONE 773 862 7211 FACSIMILE 773 862 7214 E-MAIL INFO@T26.COM WEB WWW.T26.COM

0.1 t-shirts ↑

The varied nature of the typefaces sold through the T-26 brand is demonstrated through their striking application on the everyday white T-shirt. Reminiscent of the graphic language developed by skateboarding brands, the packaging feels more akin to street culture than to the traditional delivery of a typeface on an unbranded floppy disk.

0.2 icons ↗

Each T-shirt is emblazoned with an interpretation of the T-26 brand, demonstrating different uses of the stylised type designs.

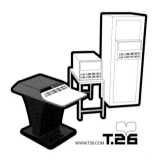

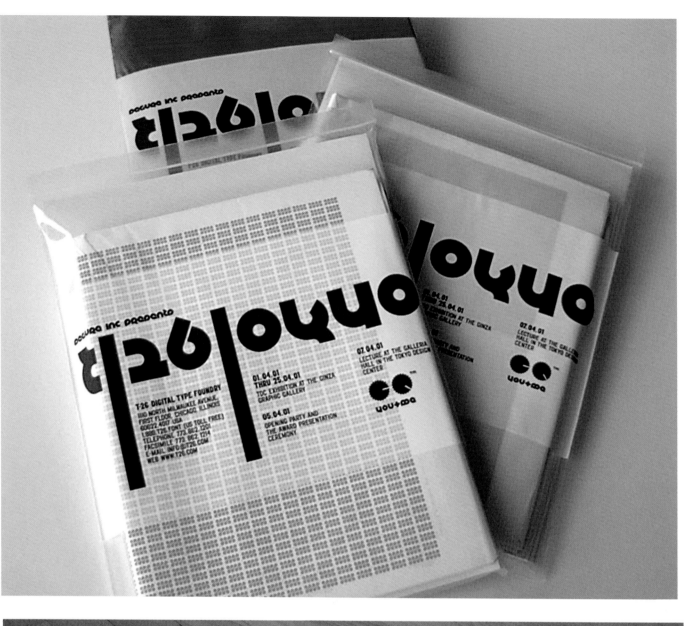

0.3 font kit – tokyo / girl

Based on a variety of themes, the font kits, containing posters, T-shirts and a disk of typefaces, arrive in transparent plastic bags. Exploiting the variety of the foundry's typefaces, each 'edition' is graphically unique.

0.4 jewel cases

The vernacular of the music industry is appropriated by the many font CD jewel cases, with each seemingly having no relation to its stable-mates. The varied graphical treatments work well as individual CD covers, and together form a collectable branded series.

0.5 cd

Segura Inc. developed a new container for their fonts, a plastic casing containing a 'trigger' that when pressed ejects the CD through the use of a lever mechanism.

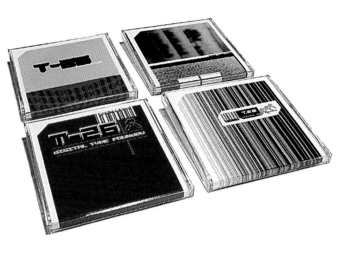

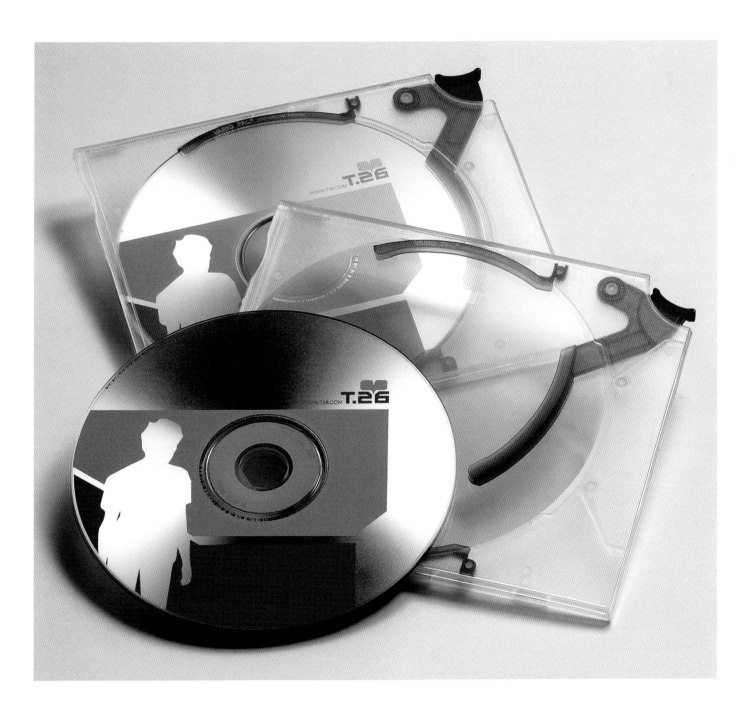

project 1.7 dubmatique

Reworking packaging systems for compact discs is a common activity for designers. In most product categories, if a product line is carried by a store it will have at least a minimal chance of display, and thus the communicative aspects of its packaging will have some chance to work on the consumer. A music CD, however, has to compete with thousands of other music CDs in a store full of CDs packaged in a similar manner, the ubiquitous jewel case. Use of new and innovative packaging systems to create visual differentiation without sacrificing the other packaging functions of containment, protection and convenience, is a challenge that has been approached in many ways. Trying to make the packaging reflect the music it contains increases the difficulty of that challenge.

Époxy, a design agency based in Montreal, Canada, achieved just that with the CD packaging it created for Dubmatique's latest CD album. As you may guess from the name, the French-Canadian group makes rap music, a form of music that traditionally draws its influences and reference points from the streets. Rap is a music genre that is open to all comers. One does not need to be a virtuoso musician, as the emphasis of the music is on the expression of thoughts and feelings through the lyrics rather than the instrumentation. Thus, it has a home-made quality, and it is this that Époxy latched onto. The packaging that Époxy created is simplicity itself, managing to be crude, 'home-made' and yet highly functional at the same time. The main packaging elements are common household items, or appear to be.

The cover is made from coroplast, a plastic substrate that looks and functions like corrugated board, although it is translucent and impervious to water. The coroplast is scored on the back to enable it to open as a gatefold. When closed, it has the same area dimensions as a jewel case CD box. A velcro fastener at the centre of each inside surface locates the CD so that both leaves of the packaging cover it. The choice of velcro as the means to secure the CD is quite ingenious, as it utilises the hole at its centre. Both pieces of velcro are cut to the dimensions of this hole so that they are able to connect. A thick rubber band contains the whole package, providing extra security.

The home-made feel is maintained throughout the communicative aspects of the packaging. The booklet is printed in black on white as though it has been produced on a home PC. It has six pages with two folds that are die-cut to the shape of a CD, complete with a central hole so that it can also be located upon the velcro 'spindle' in the cover. The cover itself is without adornment except for a sticker on the reverse side that contains the bare minimum of information, i.e. the bar code, the name of the group, the catalogue number and record label. A consumer would not see this until they have picked it up and turned it over. The only indication of who made the music is carried on the black elastic band. 'Dubmatique' is printed simply in upper-case white letters, as though it were a stock item from a stationery store.

In the image-rich, even saturated, field of music promotion, the simplicity of this packaging is striking. Working testimony to the Modernist creed: 'Simple is better than complicated. Quiet is better than confusion' (Dieter Rams, 1997).

DUBMATIQUE

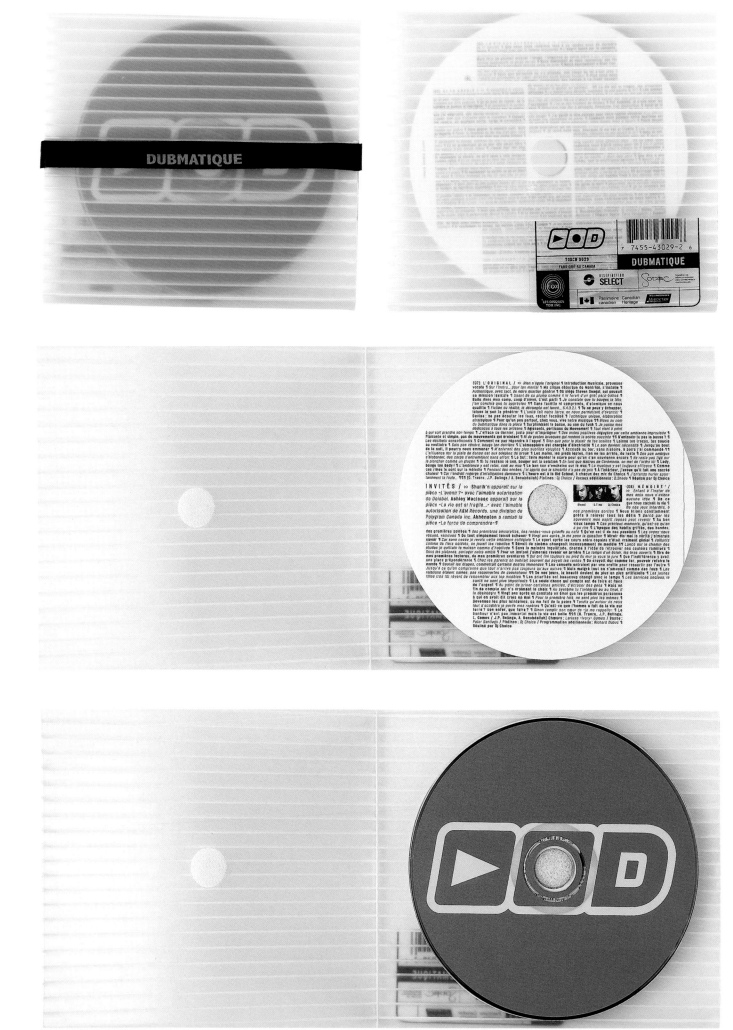

époxy

dubmatique

This End Up: Original Approaches to Packaging Design

DUBMATIQUE

0.1 holding device ↖ ↗

The velcro spindle holds the CD in place through transportation, fully releasing it upon opening the coroplast outer. Although simple, this mechanism is more innovative than it appears – gone is the sometimes precarious 'snapping' of a CD from its protective jewel case.

The spindle also keeps the fold-out booklet in place, conveniently stored behind the printed CD on-body, a design in keeping with the rest of the package, which is noticeably absent of information. No track listing, artist details or record company information appears, instead a simple yet effective graphic device.

0.2 booklet ↘

The simple single-colour booklet, produced without using imagery, makes maximum use of innovative typography. The constrained grids form abstract shapes and patterns as the columns of type are forced to avoid the central die-cut hole.

fig-1

project 1.8 fig-1

When we talk about art, we traditionally think of paintings hanging in a gallery or a sculpture sitting in the foyer of a public limited company. Art is not something we generally consider to involve packaging per se. Yet art is packaged, or labelled – Impressionist, Post-Modern or Brit-Art, for example – it is thematic grouping used to market art to the public. If we broaden the concept of packaging to include the overall means of presentation then Fig-1, 50 projects in 50 weeks, is a very novel approach to packaging art.

Fig-1 was born of a desire to show contemporary art in new ways, somewhere between the studio, gallery and museum. It was a series of exhibitions and events in a small space in the centre of London – 50 projects in 50 weeks. Each lasted for a week and was presented throughout the calendar year, designed to reveal multiple facets of the vital cultural life of the capital city in 2000. The experimental nature of the project meant that invited artists could show a work-in-progress or unexpected collaboration, whatever they chose. The name was perfectly suited to encompass the broad array of contributions, using different media and with varied results. "Fig-1 suggests an image, but one that might be many different things, something singular, mysterious and unknown," says Mark Francis of the Fig-1 team. The roster of artists that contributed represented a snapshot of contemporary art in 2000. Designer Bruce Mau, who saw the ongoing exhibition several times during the year, described it as being like a pack of playing cards, a comment that informed Bruce Mau Design's treatment of the book commemorating the event as a pack of playing cards.

Fig-1, the book, contains an A1 poster featuring photographs by Maurits Sillem of all the artists who took part in Fig-1, 50 A2 posters documenting each project with images and text, and a 32-page A4 booklet detailing the Fig-1 experience.

A principle function of a box is containment and protection; 50 loose-leaf posters could easily spill onto the floor, be creased and otherwise damaged. At £50 a volume (£500 for the artist-signed edition), buyers of the book would not be happy if this were to occur. The product is one that will also be continually referenced, opened and closed, over a number of years. The box therefore had to be robust and provide total containment. The original idea for the packaging of the cards was to enclose them in a glass box with clear overtones of a display case. As this would have added a considerable chunk to the price tag, this idea fell by the wayside. The end result is a fairly straightforward box made from thick containerboard. It is solid, will survive for several years, and with raised sides from both covers, provides a secure pocket in which the posters can nest.

The communication aspects of the package are sharply defined, if less visually obvious. Fig-1 (the book) is an imposing tome at 32x23x6cm and needs a strong wrist to pull it down from a shelf. In contrast to the colourful panoply of visual delights it contains, the box itself is unsullied and virginal, bearing no printed marks at all. It is a large white heavy object. It is clear that someone has gone to a great deal of trouble to ensure that what it contains will not get out by accident. Like Pandora's box, it begs to be opened. Reference to the fine art contained within is made solely by the brutish skill of the embosser: the cover bears the title, and the spine lists the 50 artists that contributed to the Fig-1 project. The minimalist exterior of this A4 white rectangle is perhaps homage, or thanks, to staff at London's White Cube gallery who were actively involved at various stages of the project.

The book was created to be a commercial product, and a little more information needed to be presented than the austere white box, if only the price, catalogue number and bar code. A wrap-around label was designed that provided this information and a brief description of the contents. In contrast to the box, the label benefited from the gamut of custom artist colours created for the posters in a line design that also appears in the A4 booklet and on the A1 poster.

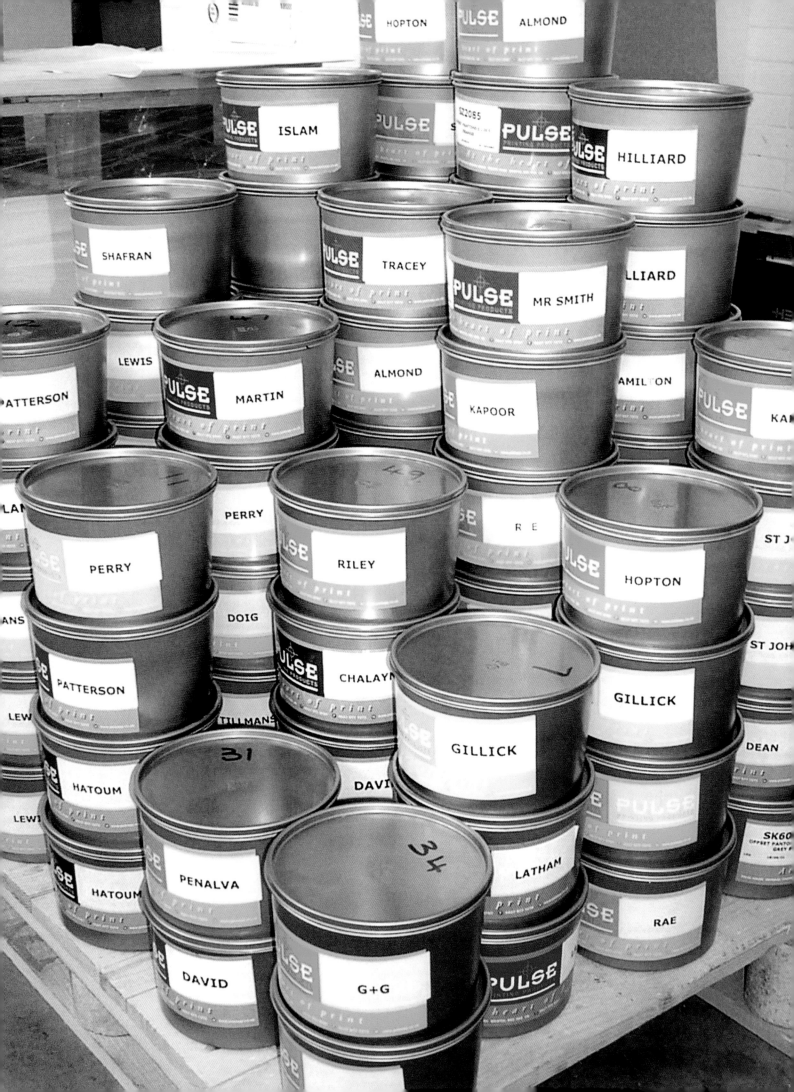

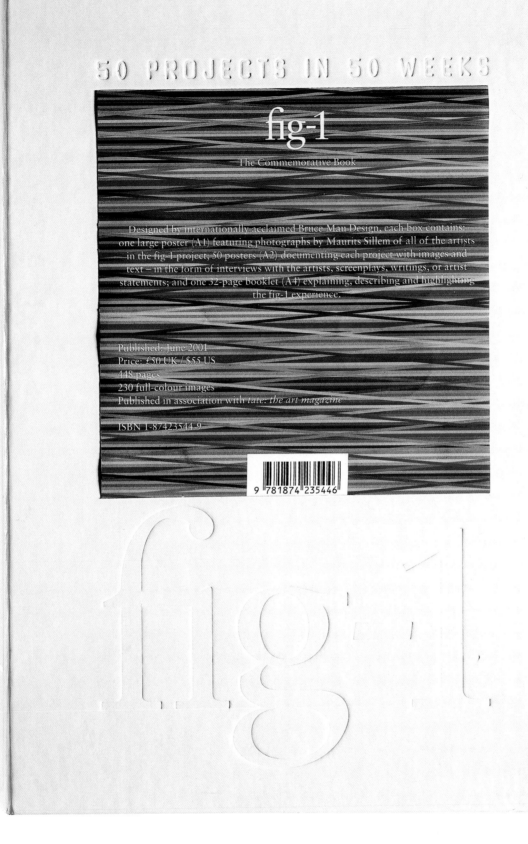

50 PROJECTS IN 50 WEEKS

fig-1

The Commemorative Book

Designed by internationally acclaimed Bruce Mau Design, each box contains: one large poster (A1) featuring photographs by Maurits Sillem of all of the artists in the fig-1 project; 50 posters (A2) documenting each project with images and text – in the form of interviews with the artists, screenplays, writings, or artist statements; and one 32-page booklet (A4) explaining, describing and highlighting the fig-1 experience.

Published: June 2001
Price: £50 UK / $55 US
448 pages
230 full-colour images
Published in association with *tate: the art magazine*

ISBN 1-87423544-9

9 781874 235446

0.1 outer graphics

The final design uses contrasting graphical techniques, from the subtle embossing of all the artists' names running down the spine of the package, to the brazen multi-coloured label, indicative of the contents. The austere white-on-white design not only feels luxurious and precious (care has to be taken to preserve the finish), it is also a strong visual link to the White Cube (the London art gallery where the work was undertaken).

0.2 prototype and contents

Earlier versions of the outer packaging included a grey-board box (pictured), and alternatives as diverse as glass which, unsurprisingly, proved too expensive. Contained within the box are two books and 50 loose-leaf posters.

bruce mau design

fig-1

This End Up: Original Approaches to Packaging Design

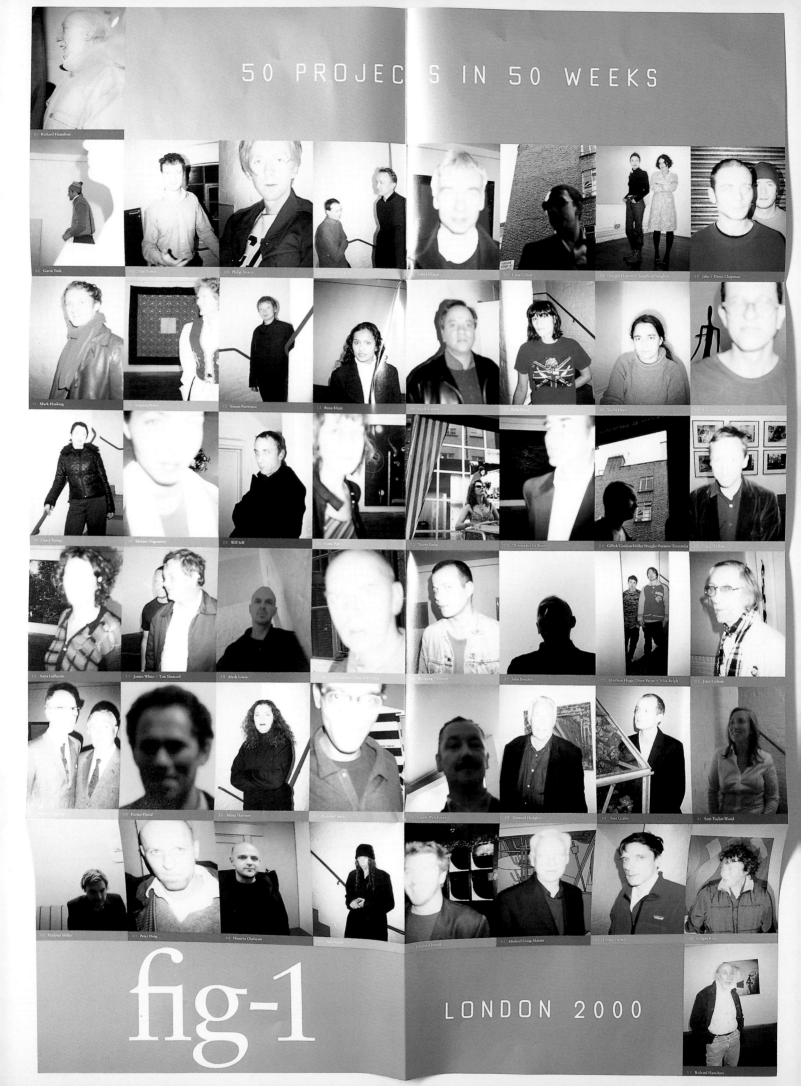

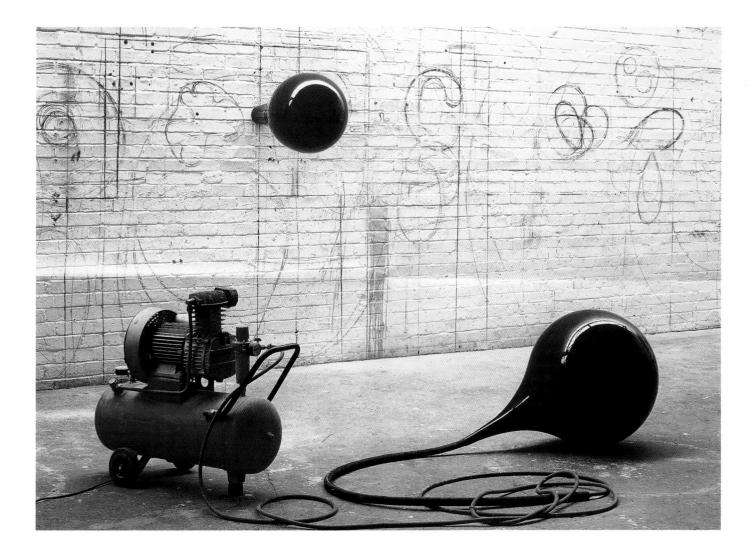

0.3 printing ↰ ↑

Each A2 poster depicts a specific work, numbered with the week in which it was exhibited, which also features biographical information about the artist and communication from the artist about the piece. The subject matter is fine art and the artworks are unique and individual. Rather than a mass reproduction in print that may cheapen the currency of each piece, they were given added value by the ingenious use of one-off, custom-made inks especially created for each artist involved in the project. Each paint was given the artist's name: Jake + Dinos Chapman blue, anyone? This ink was used as the background colour of an individual 'card', shown on the following pages. This process created a snapshot of contemporary art more powerful than the A1 poster of the 50 artists – tins of custom-made ink labelled with the artist's name, stacked one atop the other.

Together the 50 posters make up Mau's pack of cards. This is a straightforward way of reproducing the event(s) without condensing the works themselves into a spatially limited book. But think again. A key concept behind the Fig-1 experience was the fact that only one work was displayed in the space at one time.

The incumbent work demanded a viewer's total attention, as that was all there was to view. This is extremely rare in the museum/gallery/studio experience. By creating a poster, each work in the book had to be viewed separately, unencumbered by encroachment from images on facing pages.

fig-1

01 Richard Hamilton — fig-1
02 Gavin Turk — fig-1
03 Tim Stoner — fig-1
04 Philip Treacy — fig-1
05 Caruso St. John — fig-1

06 John Hilliard — fig-1
07 Liam Gillick — fig-1
08 Georgie Hopton + Josephine Soughan — fig-1
09 Jake + Dinos Chapman — fig-1
10 Mark Hosking — fig-1

11 Grayson Perry — fig-1
12 Simon Patterson — fig-1
13 Runa Islam — fig-1
14 Anish Kapoor — fig-1
15 Bella Freud — fig-1

16 Tacita Dean — fig-1
17 Antony Gormley — fig-1
18 Carey Young — fig-1
19 Marine Hugonnier — fig-1
20 Will Self — fig-1

21 Fiona Rae — fig-1
22 Tracey Emin — fig-1
23 Christopher Le Brun — fig-1
24 Liam Gillick / Douglas Gordon / Carsten Höller / Pierre Huyghe / Philippe Parreno / Rirkrit Tiravanija — fig-1
25 Nigel Shafran — fig-1

26 Anya Gallaccio	27 James White + Tim Sheward	28 Mark Lewis	Richard Deacon + Martin Kreyßig	30 Wolfgang Tillmans
31 João Penalva	32 Matthew Higgs + Oliver Payne + Nick Relph	33 John Latham	Gilbert + George	35 Enrico David
36 Mona Hatoum	37 Andrew Lewis	38 Cerith Wyn Evans	39 Howard Hodgkin	40 Tom Gidley
41 Sam Taylor-Wood	42 Harland Miller	43 Peter Doig	44 Hussein Chalayan	Patti Smith
46 Darren Almond	47 Michael Craig-Martin	48 Jeremy Deller	Bridget Riley	50 Richard Hamilton

Project 0.1

Client Rieber & Søn **Job** Mr Lee **Creative Director** Steve Elliott **Design and Illustration** Ian Burren

Agency Design Bridge Ltd., 18 Clerkenwell Close, London EC1R 0QN, UK

Telephone +44 (0)20 7814 9922 **Facsimile** +44 (0)20 7814 9024 **Email** info@designbridge.co.uk **Website** www.designbridge.co.uk

Project 0.2

Client Blue Q **Job** Unavailable **Designers** Stefan Sagmeister, Hjalti Karlsson **Writer** Karen Salmansohn

Agency Sagmeister Inc., 222 West 14th Street 15A, New York, NY 10011, USA

Telephone +1 (212) 647 1789 **Facsimile** +1 (212) 647 1788

Project 0.3

Client Wistbray Ltd. **Job** Dragonfly **Designers** David Hillman (Partner), Liza Enebeis **Photography** Teresa Hayhurst

Agency Pentagram, 11 Needham Road, London W11 2RP, UK

Telephone +44 (0)20 7229 3477 **Facsimile** +44 (0)20 7727 9932 **Email** email@pentagram.co.uk **Website** www.pentagram.com

Project 0.4

Client Vienna Art Orchestra **Job** Little Orchestra **Concept and Design** Elisabeth Kopf **Box Music and Tuning, Recordings and Music Arrangements** Martin Zrost **Creative Co-operation** Werner Korn **CD Production Concept** Elisabeth Kopf, Martin Zrost **Production** Elisabeth Kopf, Martin Zrost, Werner Korn, Richard Wagner

Artist Elisabeth Kopf, Rudopf Zellergasse 34, 1238 Vienna, Austria

Telephone/Facsimile +43 (0)1 889 7866 **Email** e.kopf@netway.at

Project 0.5

Client Levi's® **Job** Levi's® **Designers** Mark Farrow, Jonathon Jeffrey, Gary Stillwell, Nick Tweedie

Agency Farrow Design, 23–24 Great James Street, London WC1N 3ES, UK

Telephone +44 (0)20 7404 4225 **Facsimile** +44 (0)20 7404 4223 **Email** studio@farrowdesign.com **Website** www.farrowdesign.com

Project 0.6

Client Creative Circle **Job** Guldkorn 1999 **Designers** Jan Nielsen, Ole Lund, Jesper Jans

Agency 2GD, Wilders Plads 8A, 1403 Copenhagen K, Denmark

Telephone +45 3295 2322 **Facsimile** +45 3295 2321 **Email** 2gd@2gd.dk **Website** www.2gd.dk

Project 0.7

Client Fruits & Passion **Job** Aroma Sutra **Designers** Daniel Fortin (President and Creative Director)

Agency Époxy, 506 McGill, 5th Floor, Montréal, Québec H2Y 2H6, Canada

Telephone +1 (514) 866 6900 **Facsimile** +1 (514) 866 6300 **Website** www.epoxy.ca

Project 0.8

Client REN Ltd. **Job** REN **Designer** Peter Viksten

Agency REN Ltd., 28 Oldbury Place, London W1U 5PX, UK

Telephone +44 (0)20 7935 2323 **Facsimile** +44 (0)20 7935 1191 **Email** info@ren.ltd.uk **Website** www.ren.ltd.uk

Project 0.9

Client Pacific Place Foodhall **Job** great **Creative Director Interiors** Gabriel Murray **Associate Director Interiors** Paul Stephens **Interior Detailed Drawings** Mark Bowden **Site Production Manager RFHK** Rachael Waddell **Creative Director Graphics** Sean O'Mara **Associate Director Graphics** Mark Harper **Senior Designer Graphics RFHK** Chris Dingkong **Print and Packaging Production Manager** Susanne Mobbs

Agency Rodneyfitch, Northumberland House, 155 Great Portland Street, London W1W 6QP, UK

Telephone +44 (0)20 7580 1331 **Facsimile** +44 (0)20 7580 3661 **Email** info@rodneyfitch.co.uk **Website** www.rodneyfitch.com

Project 1.0

Client Spaceman/Arista **Job** Let it Come Down **Designers** Mark Farrow, Gary Stillwell, Jonathon Jeffrey, Nick Tweedie, J Spaceman

Agency Farrow Design, 23–24 Great James Street, London WC1N 3ES, UK

Telephone +44 (0)20 7404 4225 **Facsimile** +44 (0)20 7404 4223 **Email** studio@farrowdesign.com **Website** www.farrowdesign.com

Project 1.1

Client Dyrup **Job** Dyrup **Associate Director Interiors** Andy Fuller **Creative Director Graphics** Sean O'Mara
Associate Director Graphics Mark Harper **Senior Designer Graphics** Sarah Cromwell **Product Photography** Mathew Shave
Additional Photography Sarah Cromwell, Sean O'Mara

Agency Rodneyfitch, Northumberland House, 155 Great Portland Street, London W1W 6QP, UK

Telephone +44 (0)20 7580 1331 **Facsimile** +44 (0)20 7580 3661 **Email** info@rodneyfitch.co.uk **Website** www.rodneyfitch.com

Project 1.2

Client BMG Entertainment UK/Cheeky Records **Job** Furious Angels **Designer and Art Director** Mark Tappin **Photography** Mert Alas, Marcus Piggott

Agency Blue Source, The Saga Centre, 326 Kensal Road, London W10 5BZ, UK

Telephone +44 (0)20 7460 6020 **Email** mark.t@bluesource.com

Project 1.3

Client SSL International **Job** Durex **Designers** Andrew King, Sophie Le Calvez **Client Director** Philippa Knight

Agency Landor Associates, Klamath House, 18 Clerkenwell Green, London EC1R 0QE, UK

Telephone +44 (0)20 7880 8000 **Facsimile** +44 (0)20 7880 8001 **Email** marketing_info@uk.landor.com **Website** www.landor.com

Project 1.4

Client Les Disques MusiArt **Job** Plan B **Concept and Design** Michel Valois, Sébastien Toupin **Photography** Martin Tremblay @ Volt **Illustration** Patrick Desgreniers

Agency L'Atelier In-Seize, 6560 Esplanade #101, Montréal, Québec H2V 4L5, Canada

Telephone +1 (514) 272 4516 **Facsimile** +1 (514) 272 4596 **Email** info@in16.com **Website** www.in16.com

Project 1.5

Client Nascent **Job** Nascent **Designers** Jens Kajus, Marie Lübecker

Agency e-Types, Vesterbrogade 80B, 1620 Copenhagen V, Denmark

Telephone +45 3325 4500 **Facsimile** +45 3325 4557 **Email** info@e-types.com **Website** www.e-types.com

Project 1.6

Client Segura Inc. **Job** T-26 **Designers** Carlos Segura, Tino

Agency Segura Inc., 1110 North Milwaukee Avenue, Chicago, IL 60622, USA

Telephone +1 (773) 862 1201 **Facsimile** +1 (773) 862 1214 **Email** info@t26.com **Website** www.t26.com

Project 1.7

Client Dubmatique **Job** Dubmatique **Designers** Daniel Fortin (President and Creative Director)

Agency Époxy, 506 McGill, 5th Floor, Montréal, Québec H2Y 2H6, Canada

Telephone +1 (514) 866 6900 **Facsimile** +1 (514) 866 6300 **Website** www.epoxy.ca

Project 1.8

Client Spafax Publishing **Job** Fig-1 **Designer** Bruce Mau Design

Agency Spafax Publishing

Telephone +44 (0)20 7906 2002 **Facsimile** +44 (0)20 7906 2004 **Email** phil@spafax.com